SHOES, HATS AND FASHION ACCESSORIES

A PICTORIAL ARCHIVE
1850–1940

2,020 Illustrations
Selected and Arranged by
Carol Belanger Grafton

DOVER PUBLICATIONS, INC.
Mineola, New York

Published in Canada by General Publishing Company, Ltd., 30 Lesmill Road, Don Mills, Toronto, Ontario.
Published in the United Kingdom by Constable and Company, Ltd., 3 The Lanchesters, 162–164 Fulham Palace Road, London W6 9ER.

Bibliographical Note

Shoes, Hats and Fashion Accessories: A Pictorial Archive, 1850–1940 is a new work, first published by Dover Publications, Inc., in 1998.

DOVER *Pictorial Archive* SERIES

International Standard Book Number: 0-486-40103-0

Manufactured in the United States of America
Dover Publications, Inc., 31 East 2nd Street, Mineola, N.Y. 11501

Note

This book presents more than 2,000 illustrations of shoes, hats, and fashion accessories reproduced directly from now rare periodicals and catalogs from the 1850s to 1940. It comprises an invaluable pictorial survey for the fashion historian, designer, and enthusiast, as well as a practical source of illustrations for permission-free use by artists and craftspeople.

The sources of these illustrations include major American, British, and European fashion periodicals of the times: *Godey's Lady's Book, Peterson's Magazine, Harper's Bazar, La Mode Illustrée, L'Art et la Mode, Der Bazar, The Delineator* and others, as well as such general interest periodicals as *Frank Leslie's Illustrated Newspaper, Harper's Weekly, The Youth's Companion,* and *Life.* Many illustrations come from trade catalogs of such merchants as Montgomery Ward, Sears, Roebuck & Co., Jordan Marsh & Co., N. B. Holden Artistic Footwear, and a score of others.

Arranged chronologically, the plates present an overview of ninety years of fashion evolution of footwear, millinery, and such accessories as gloves, scarves, purses, handkerchiefs, and more.

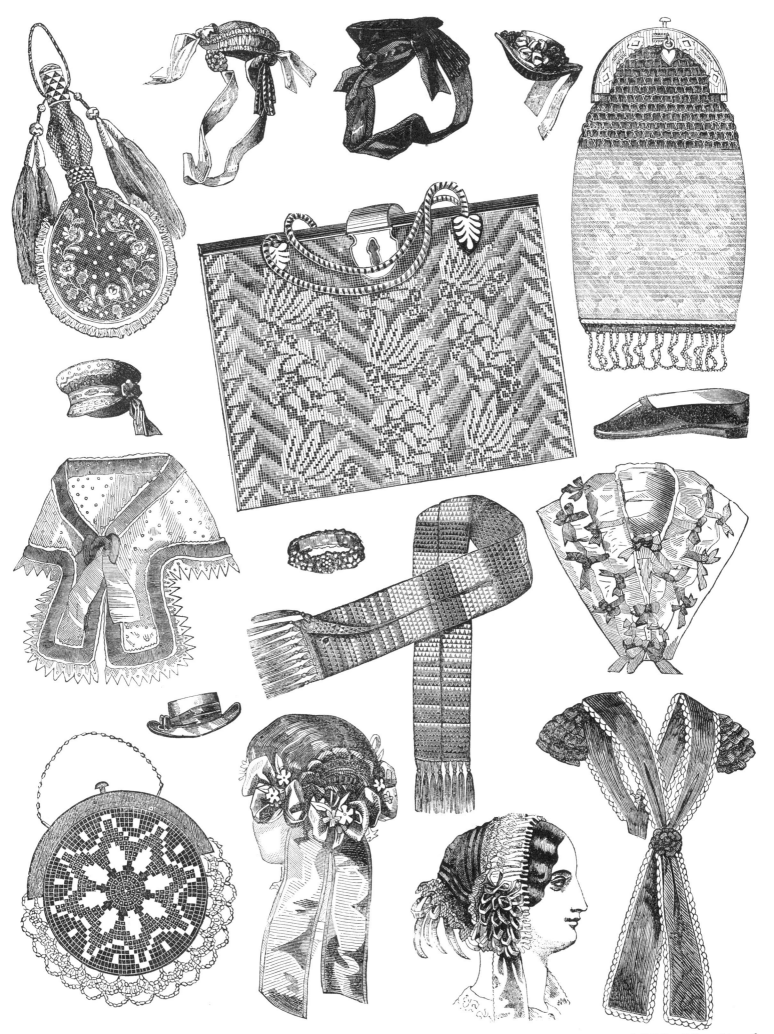

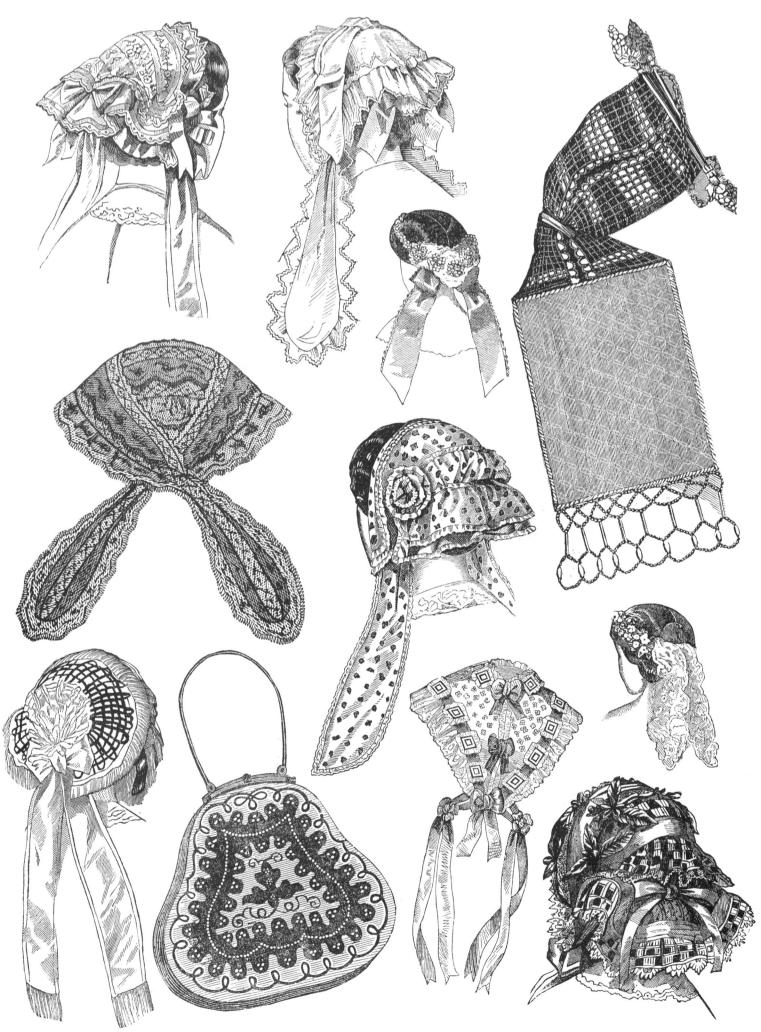

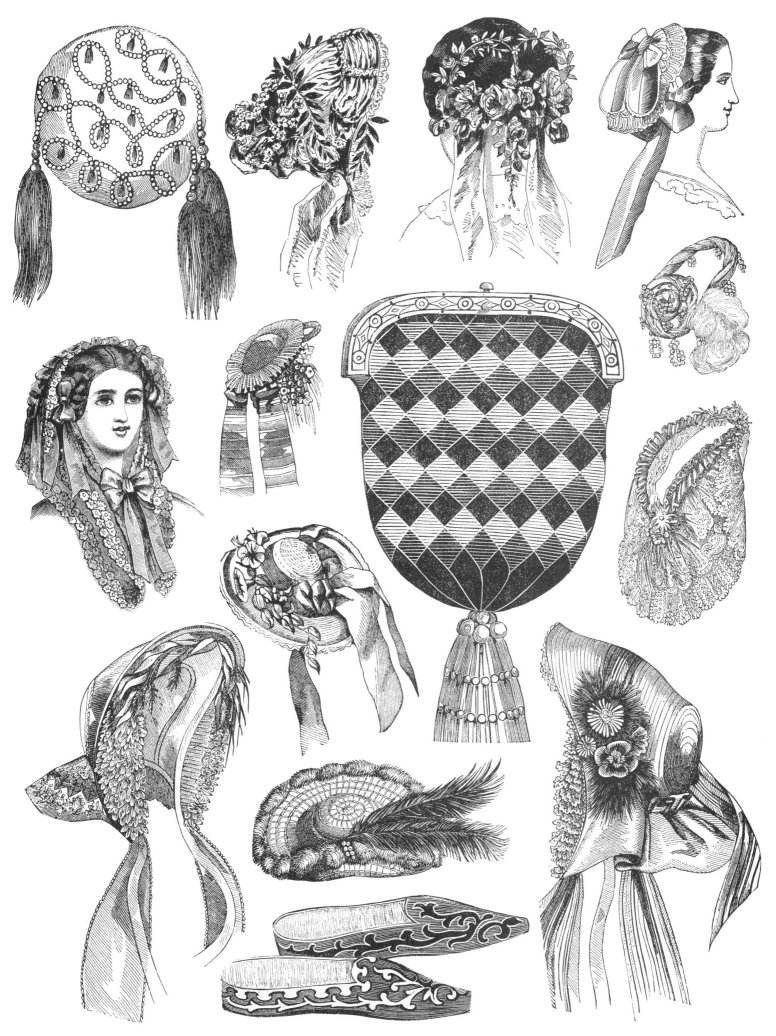

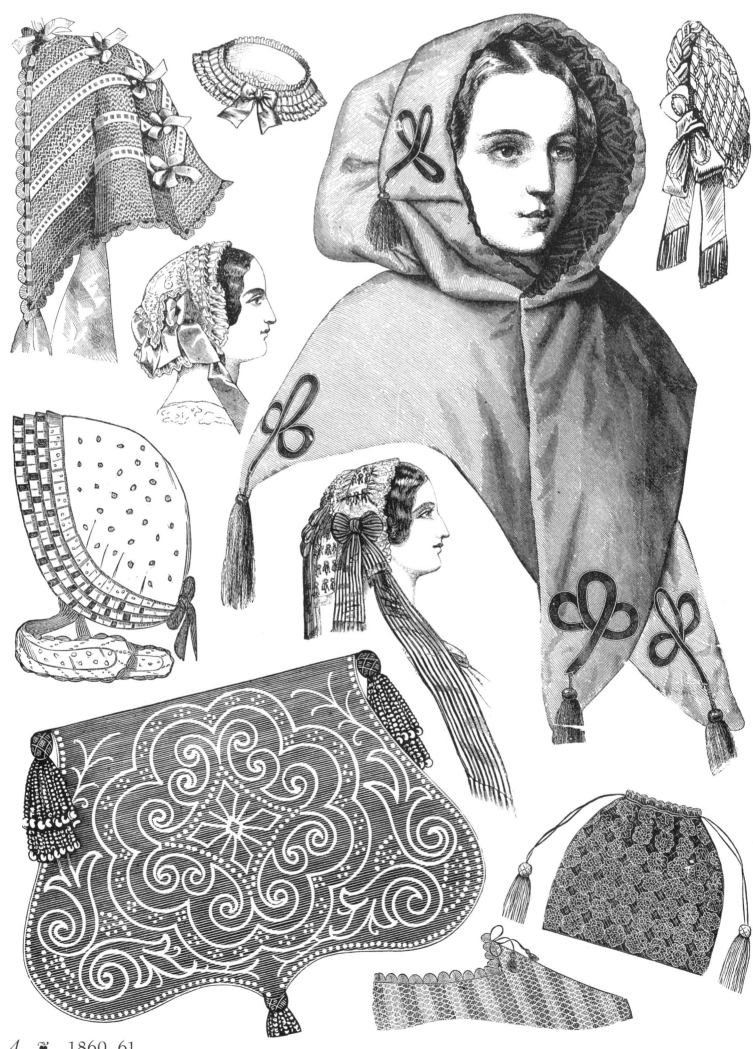

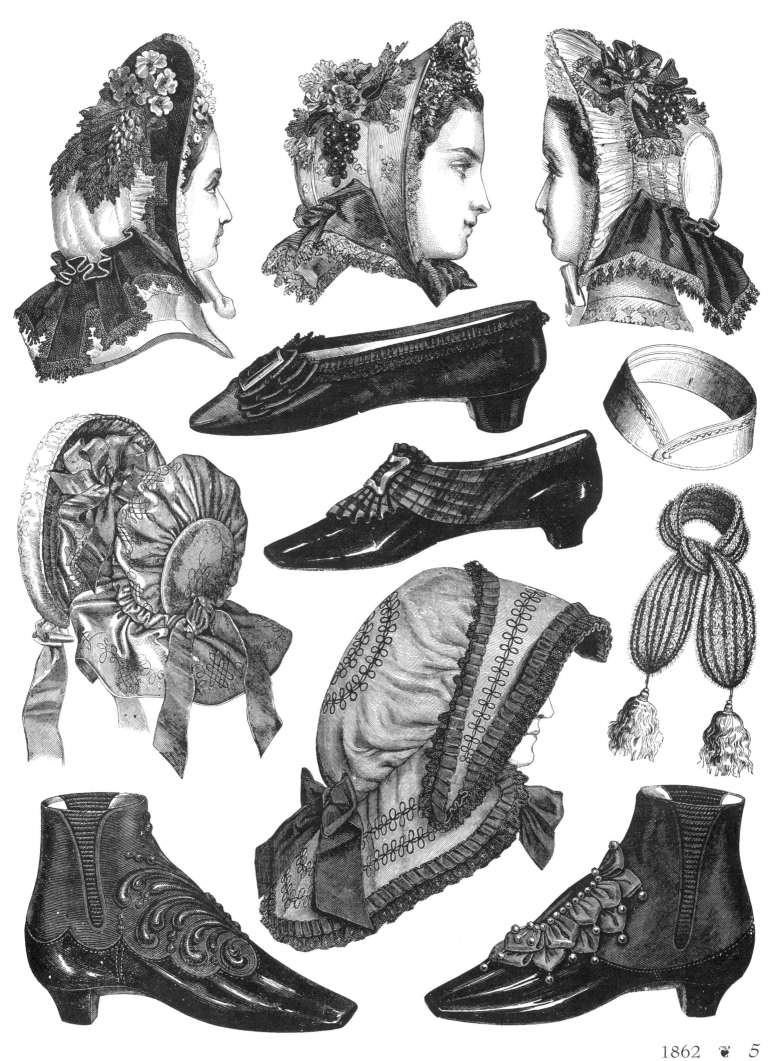

1862 ❧ 5

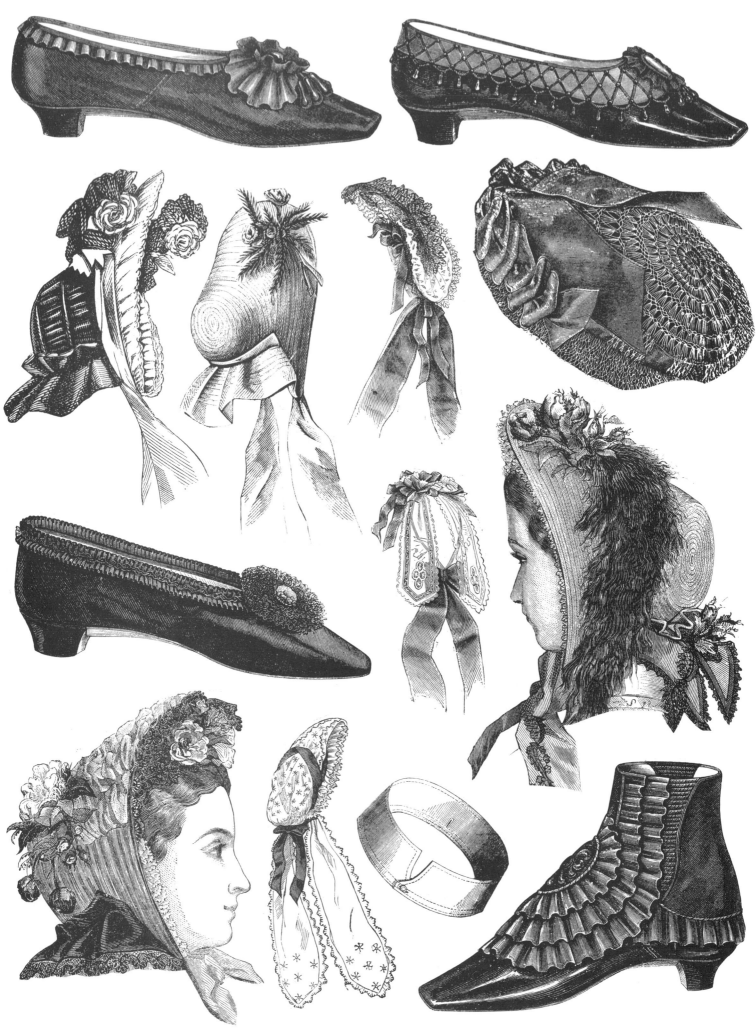

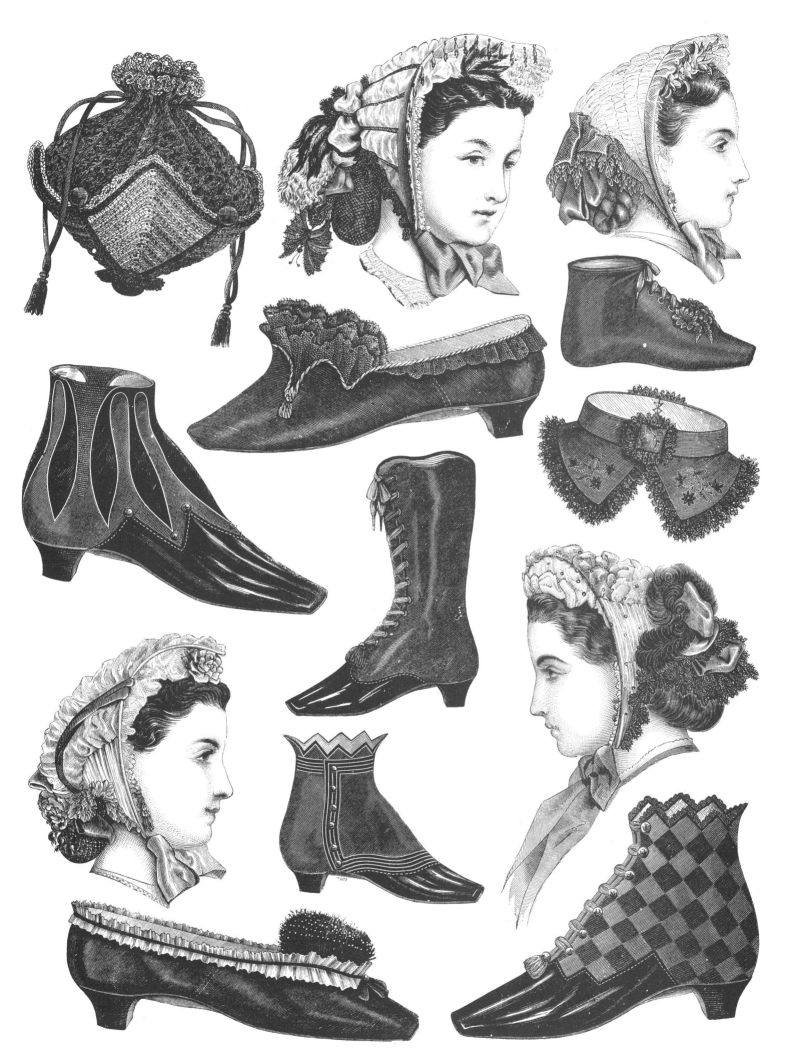

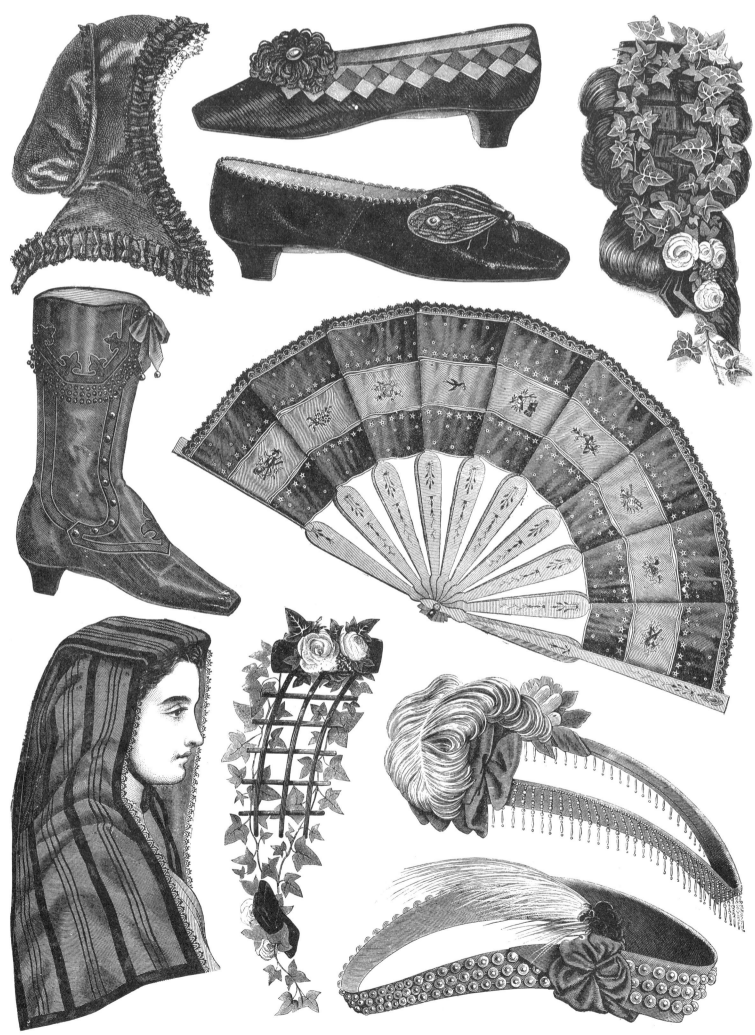

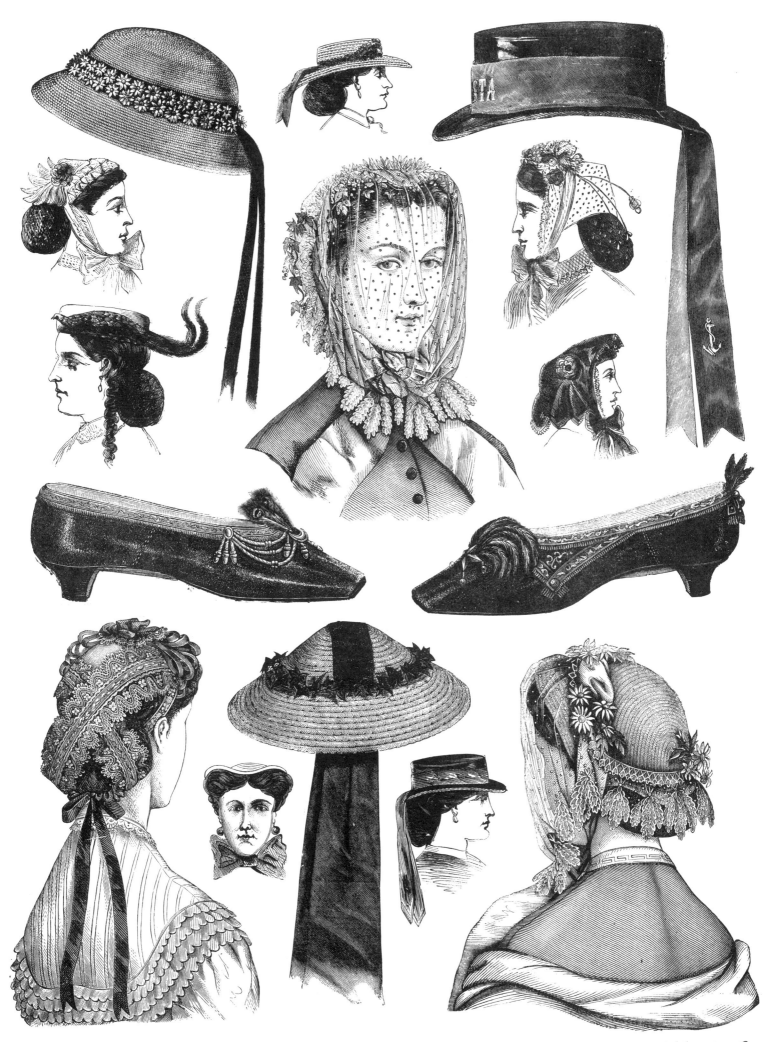

1866 9

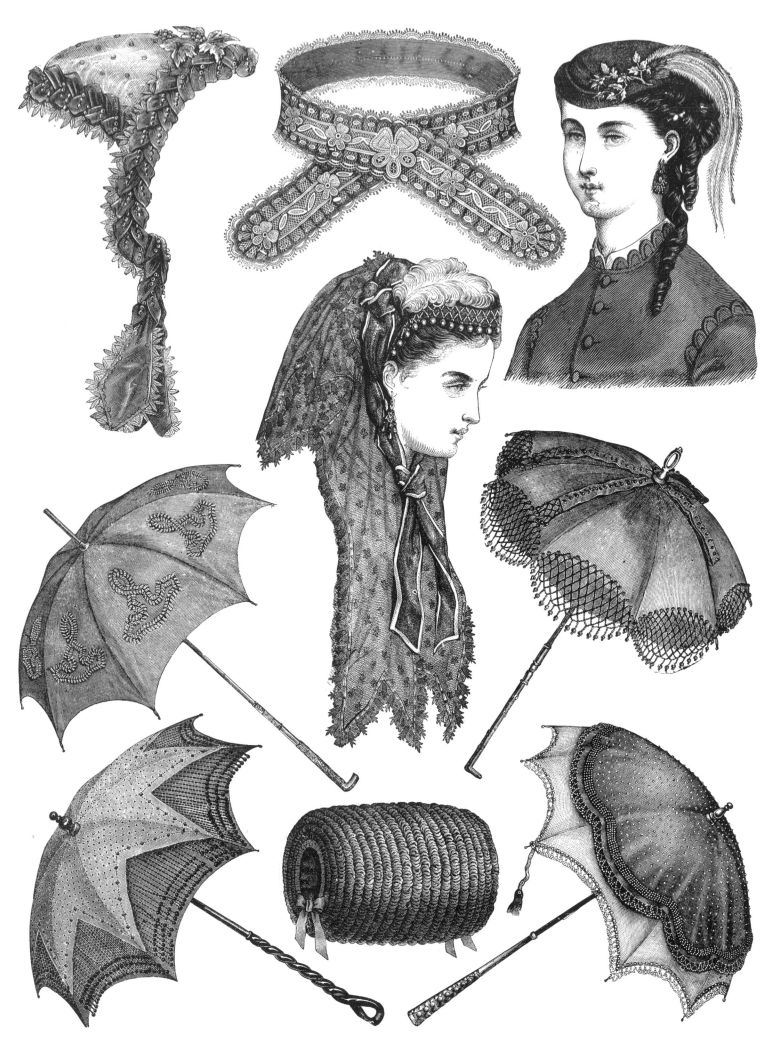

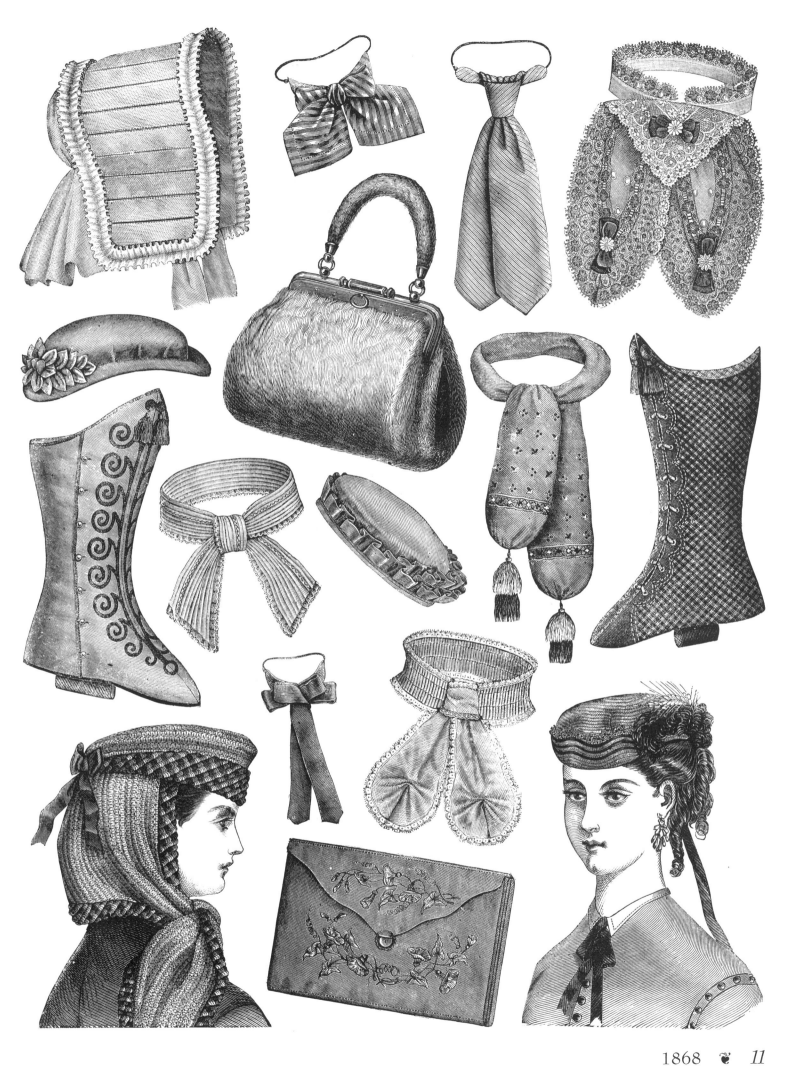

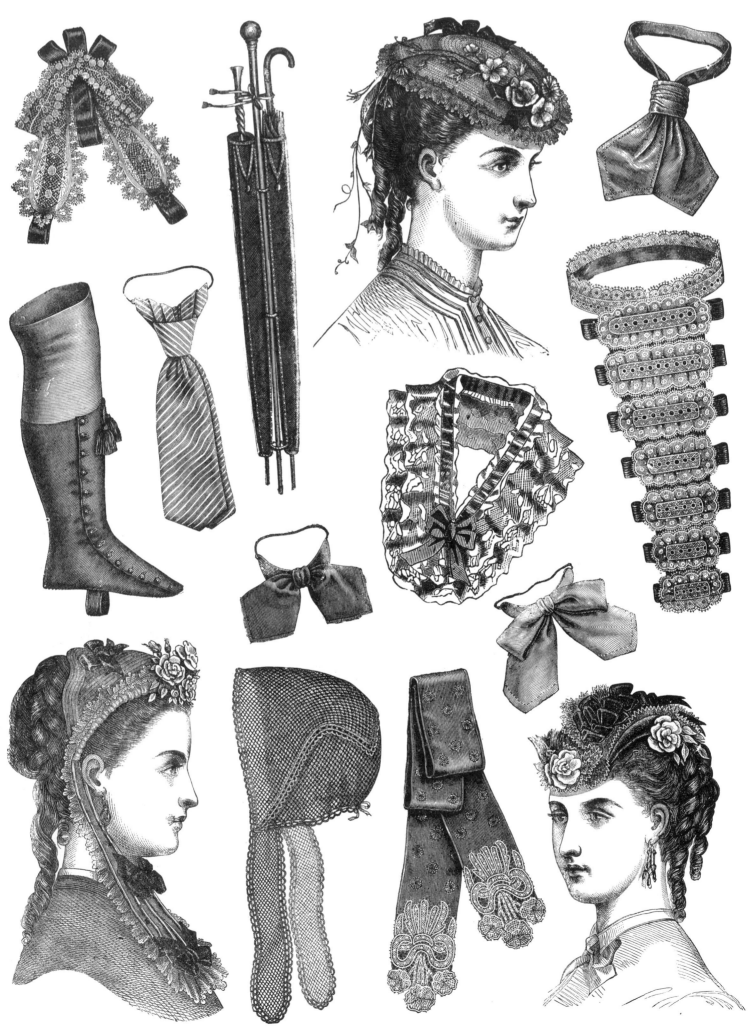

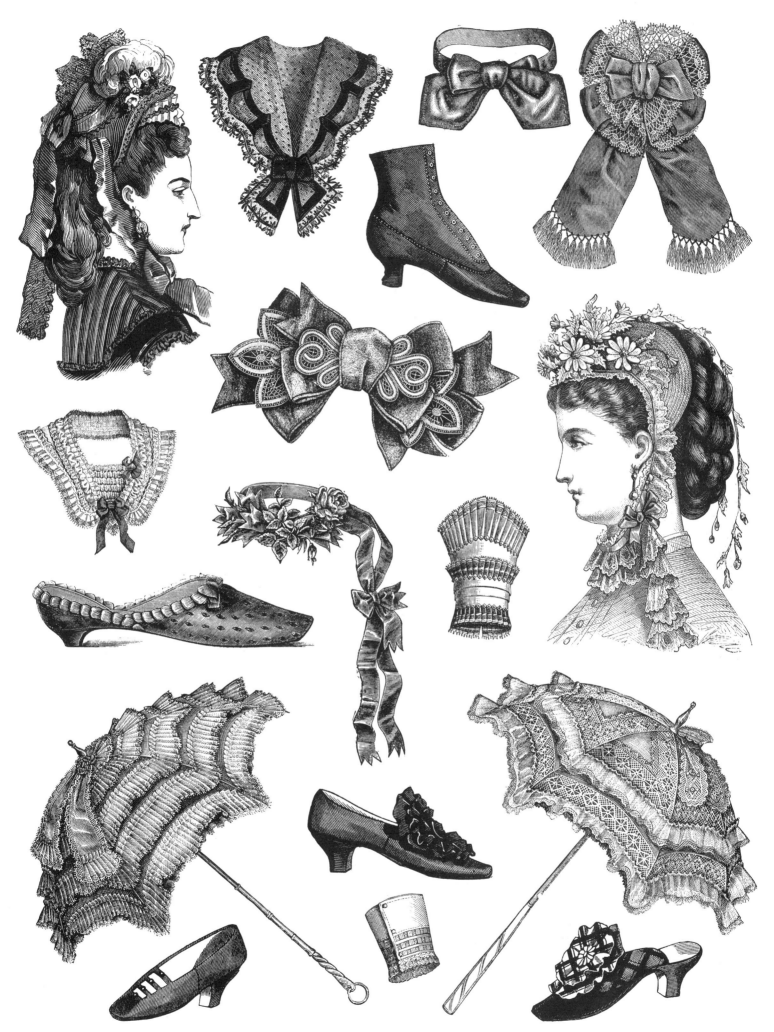

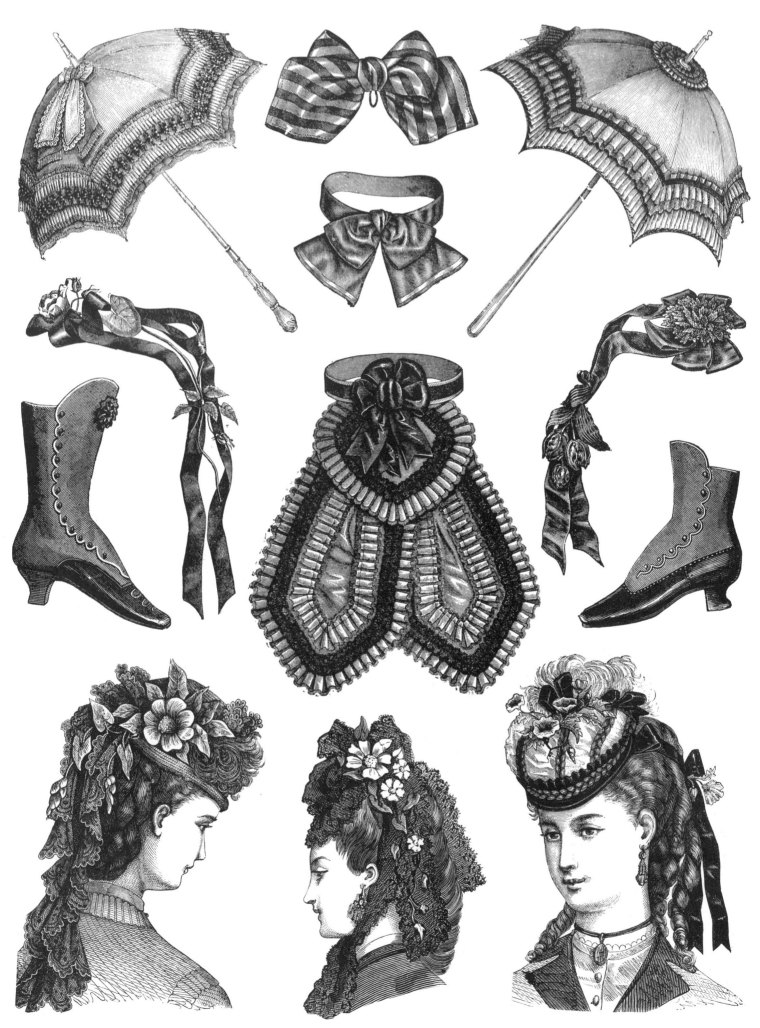

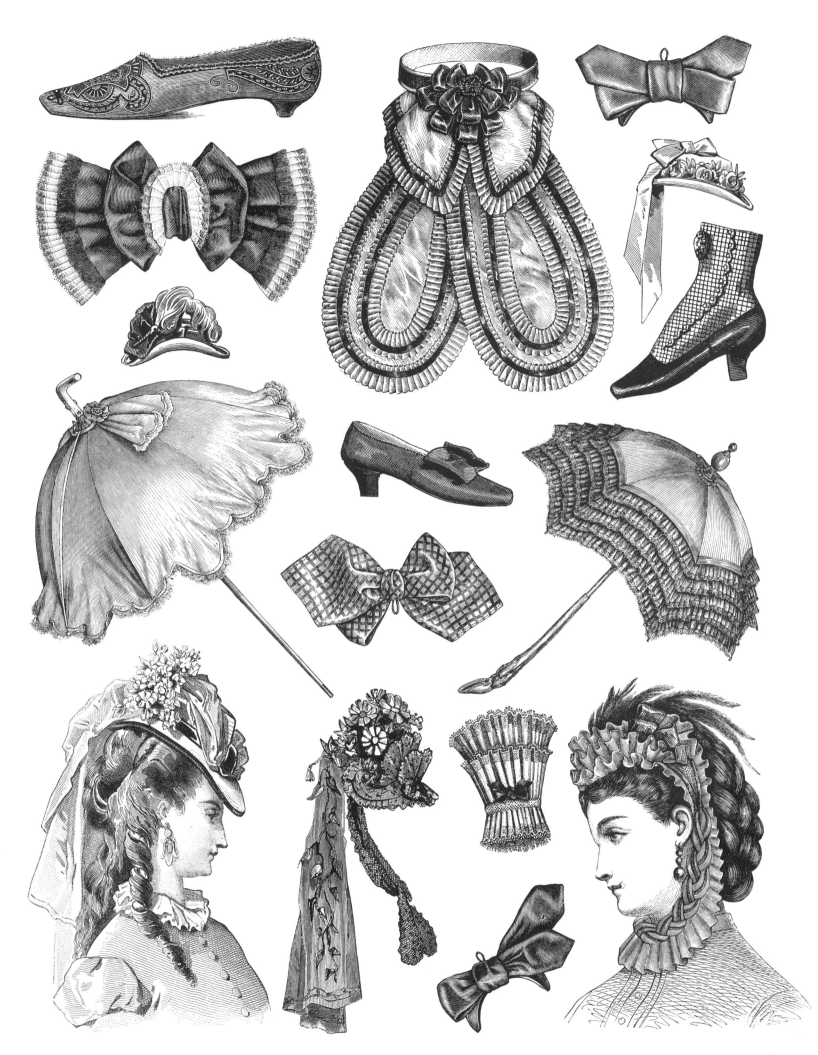

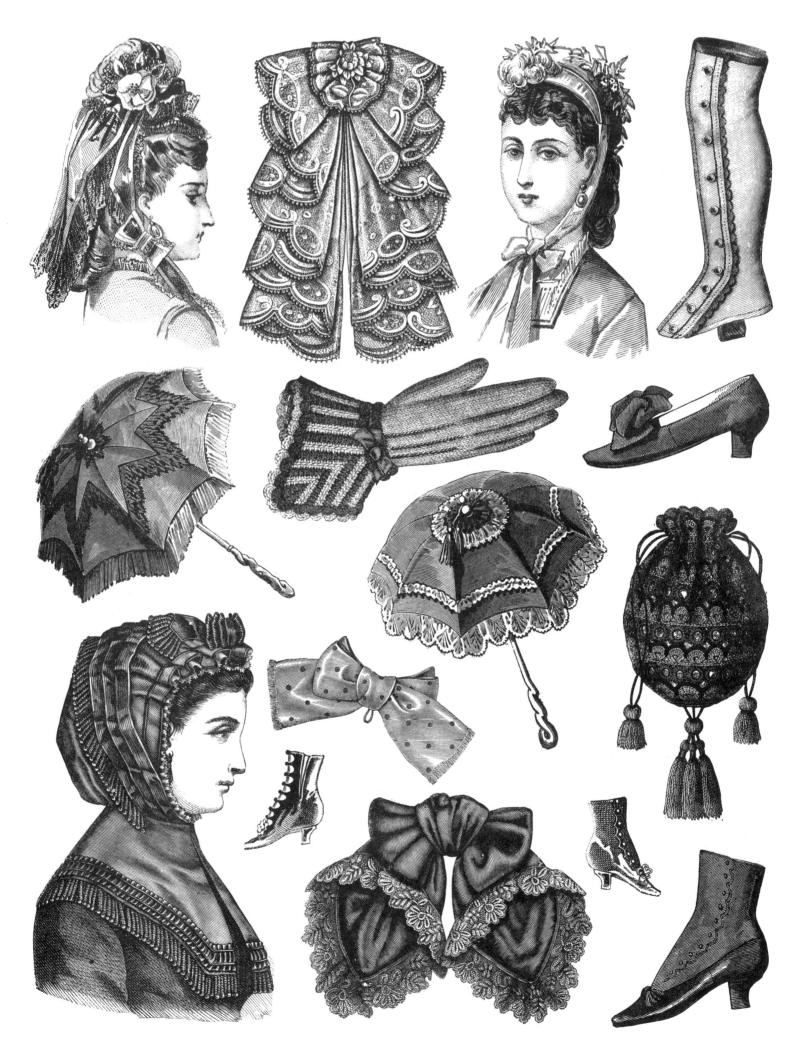

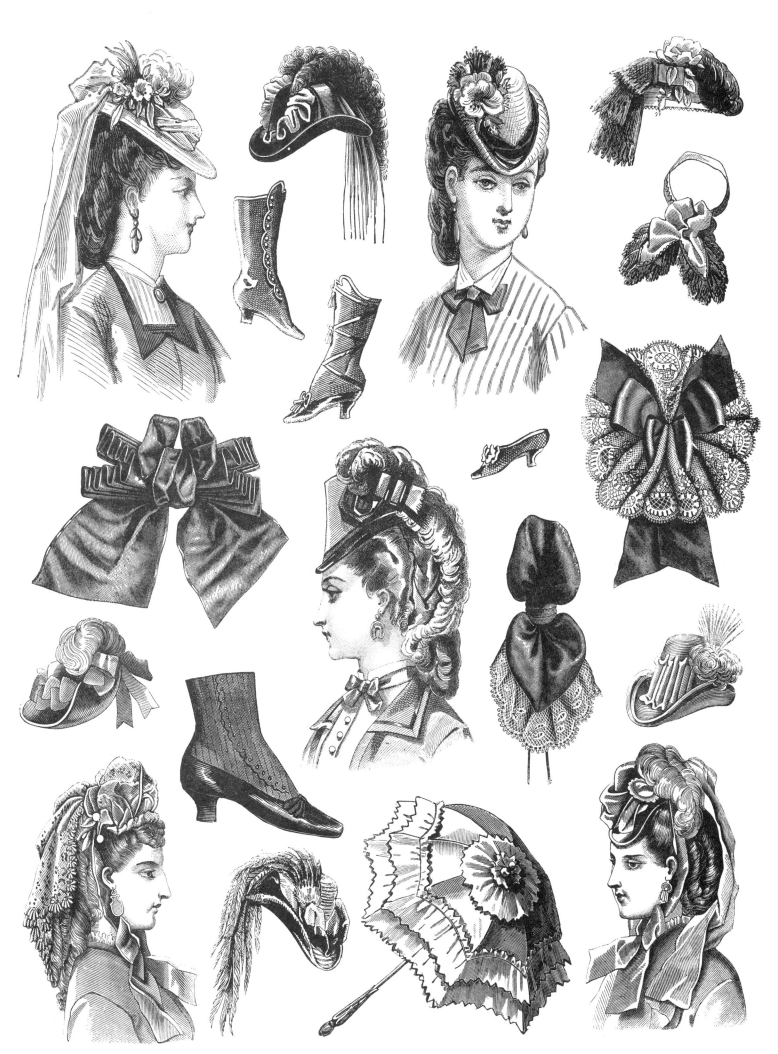

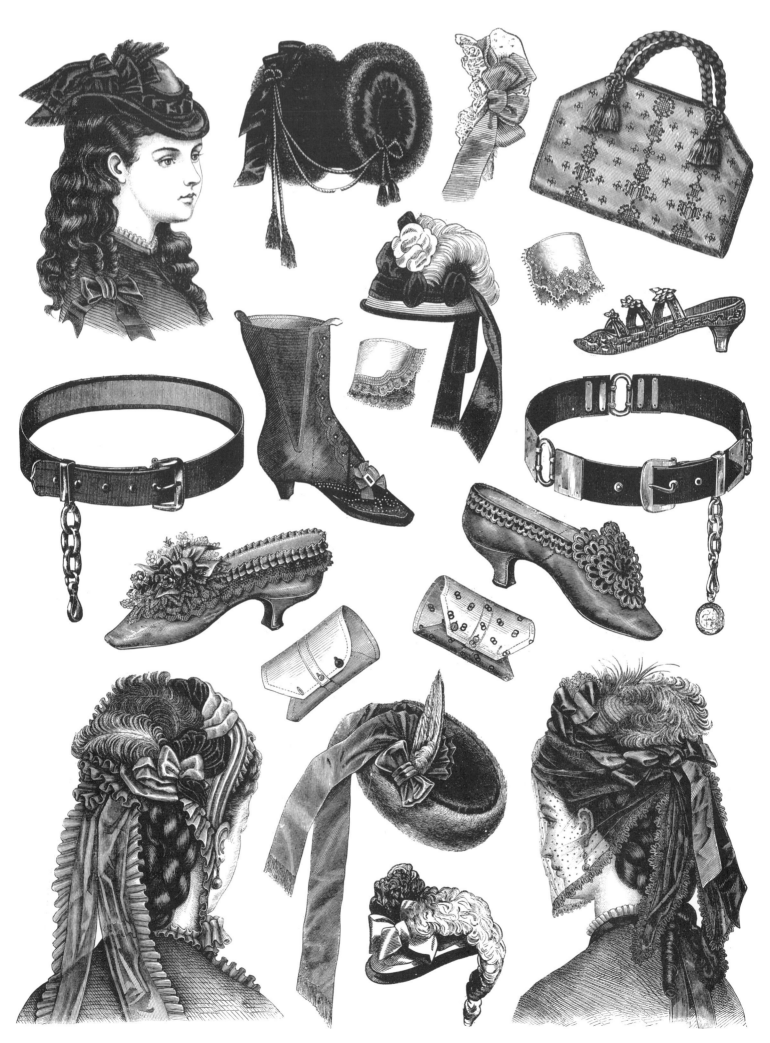

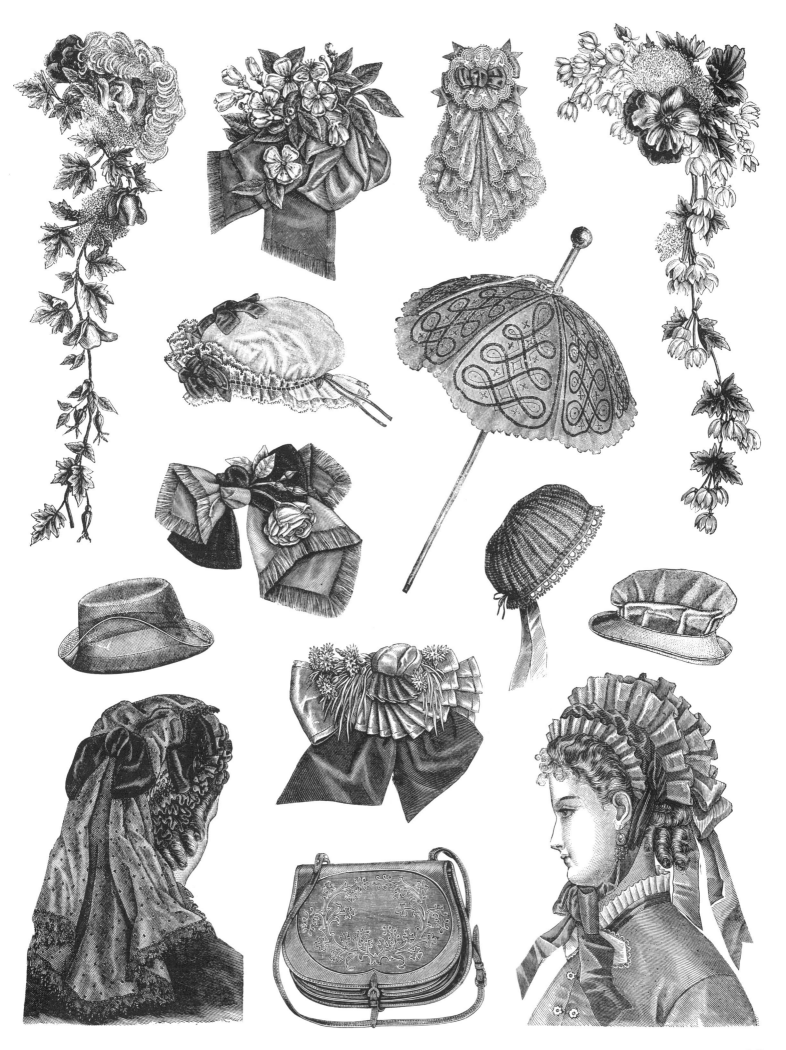

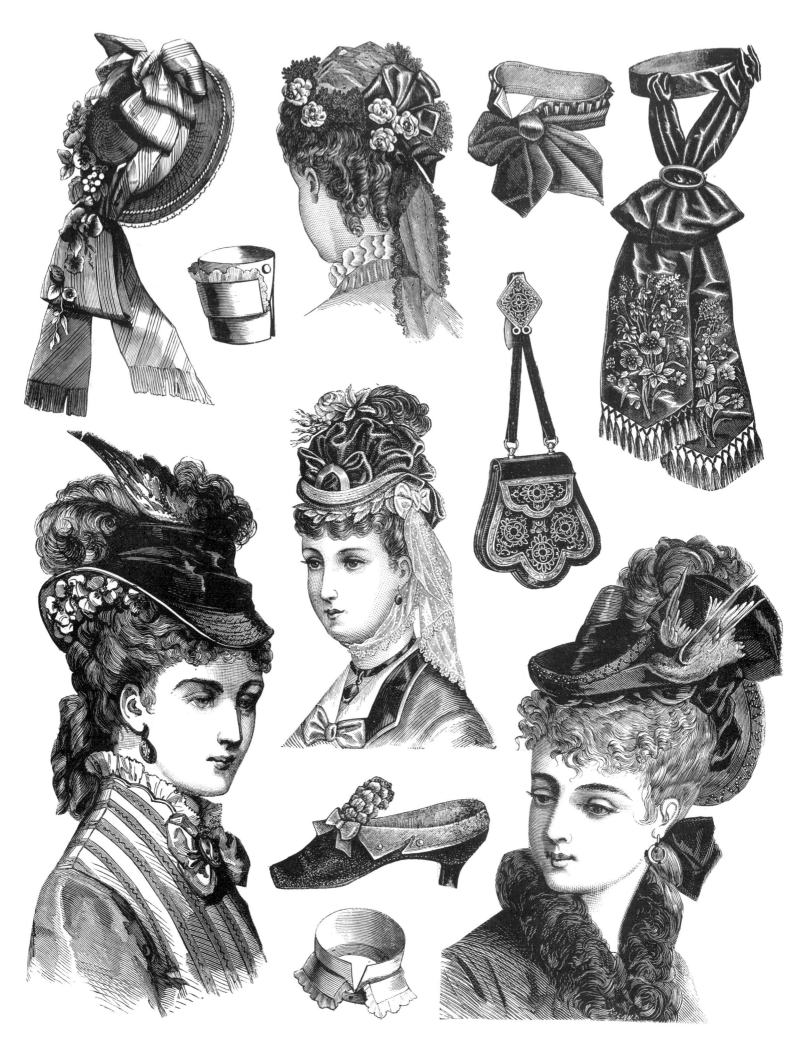

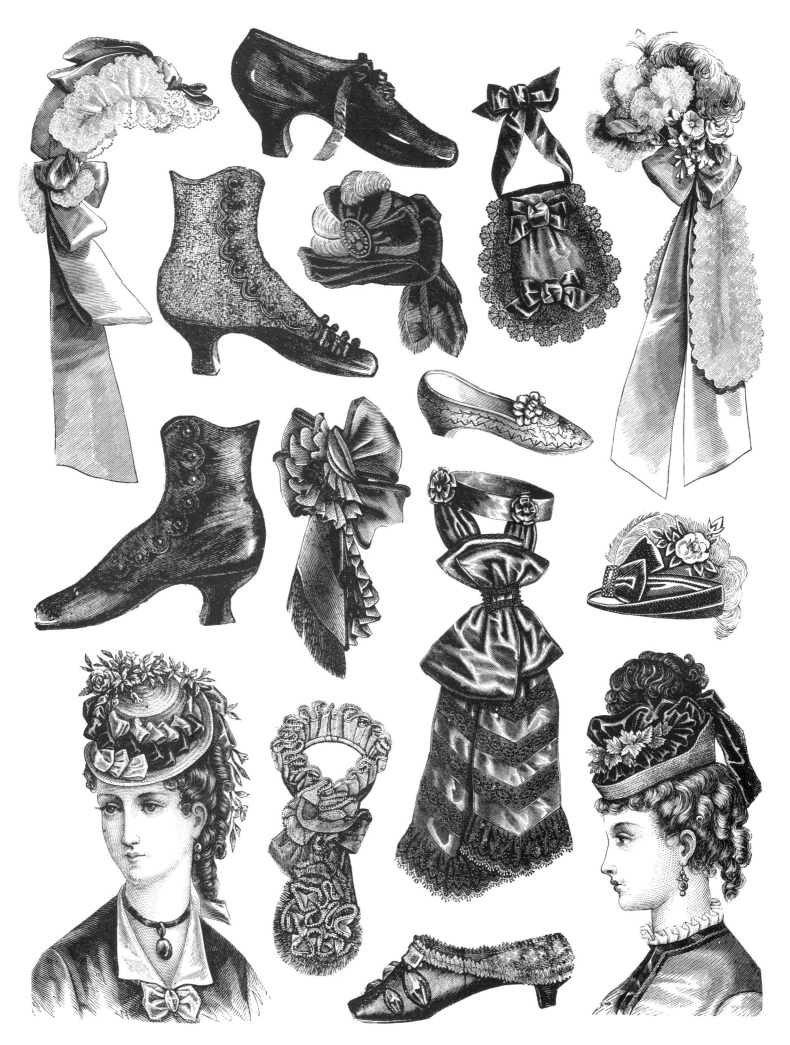

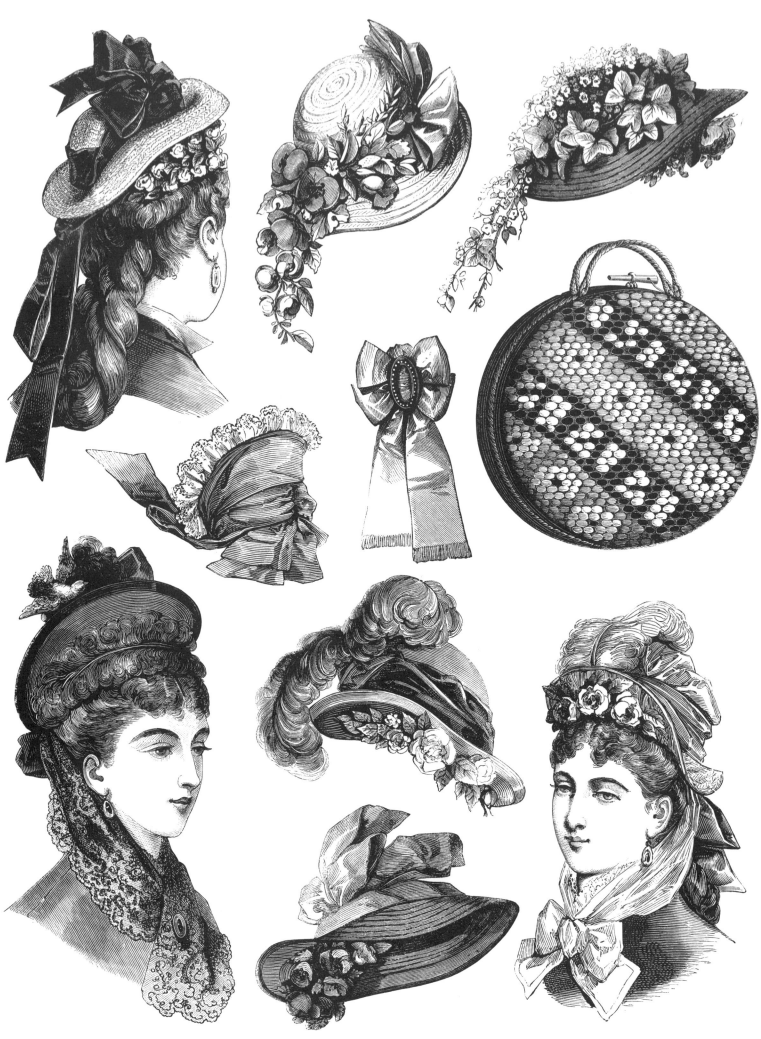

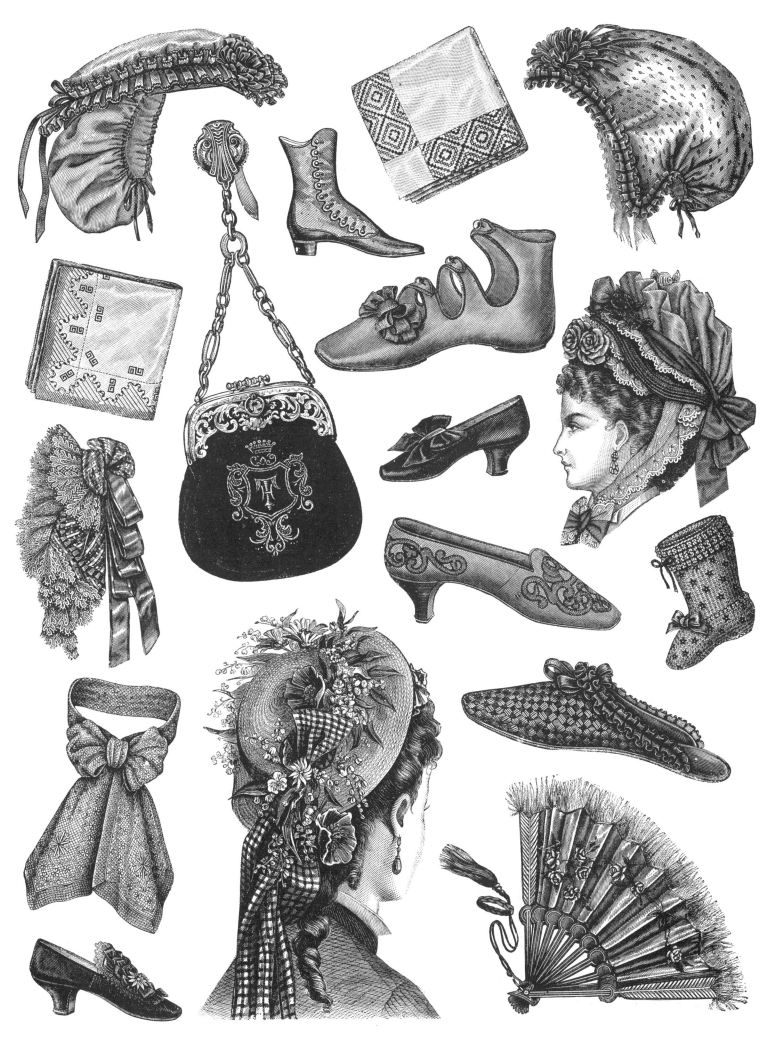

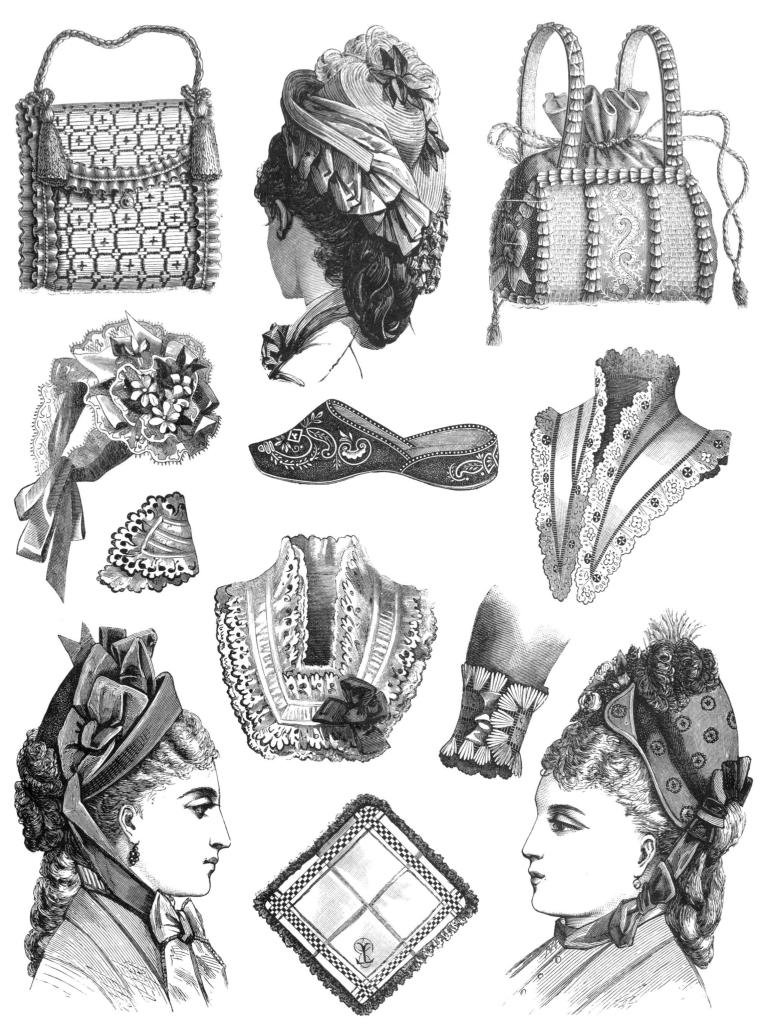

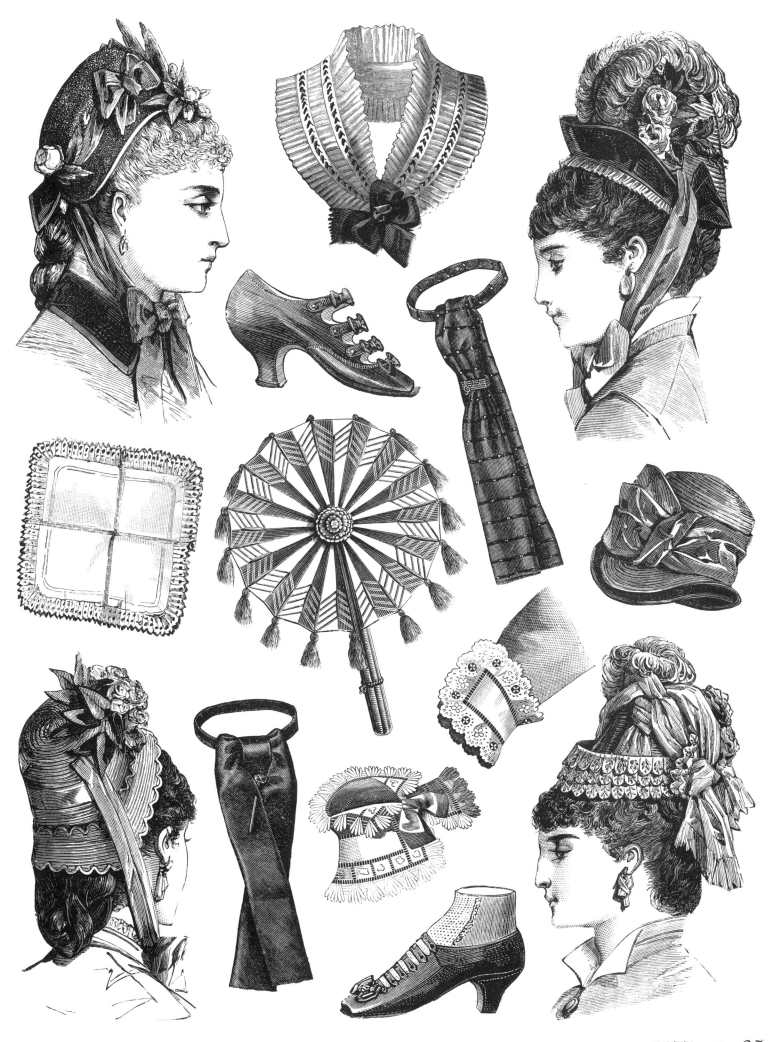

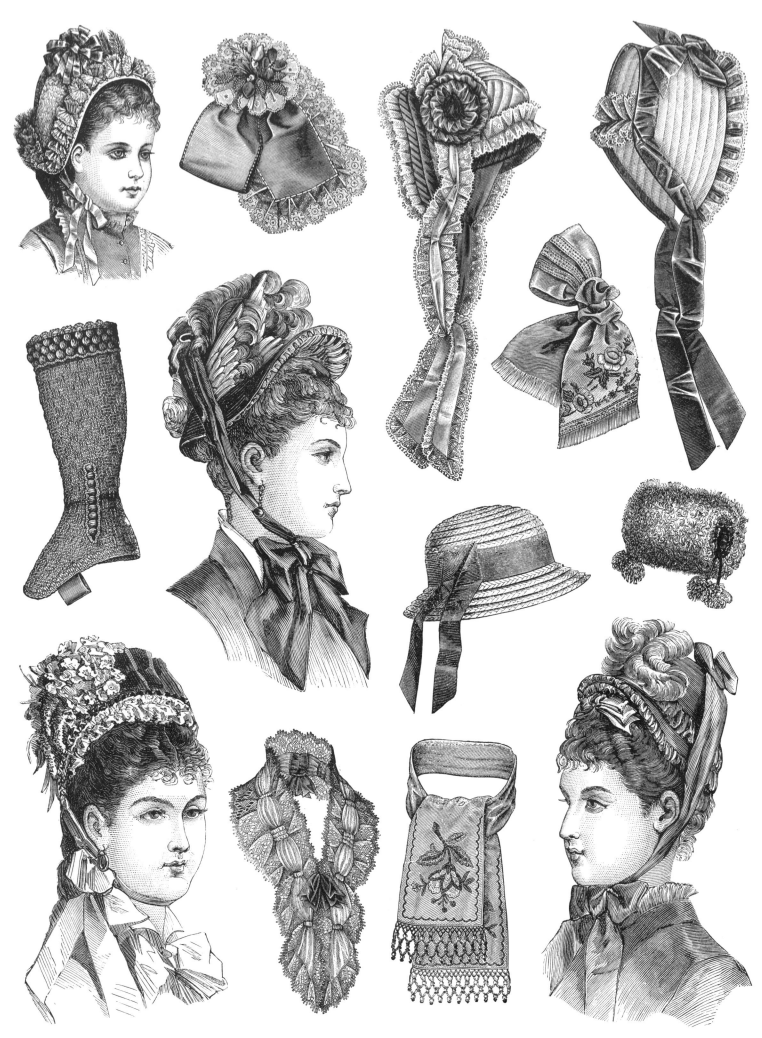

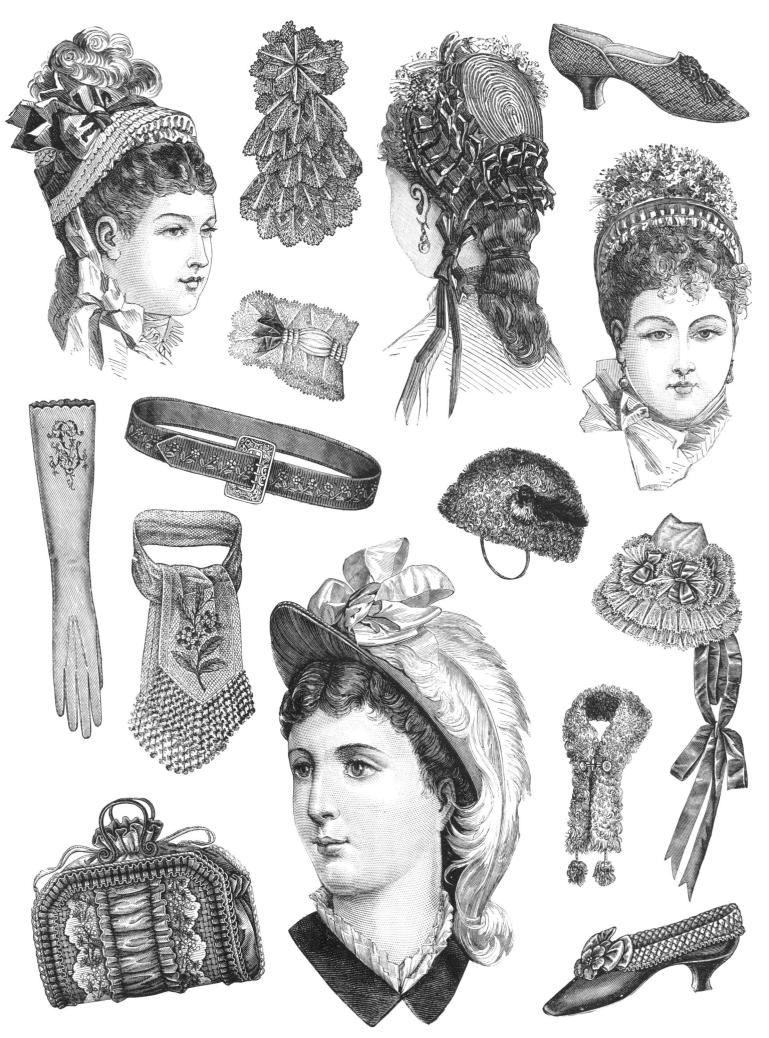

1878 ❦ 27

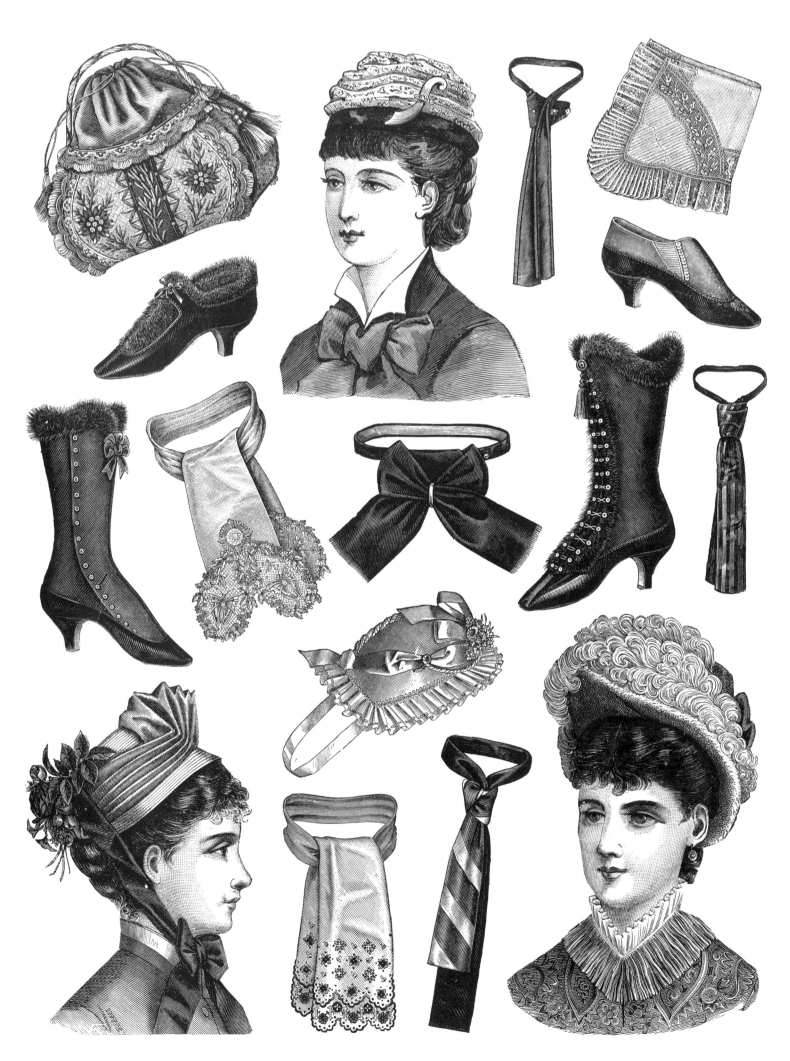

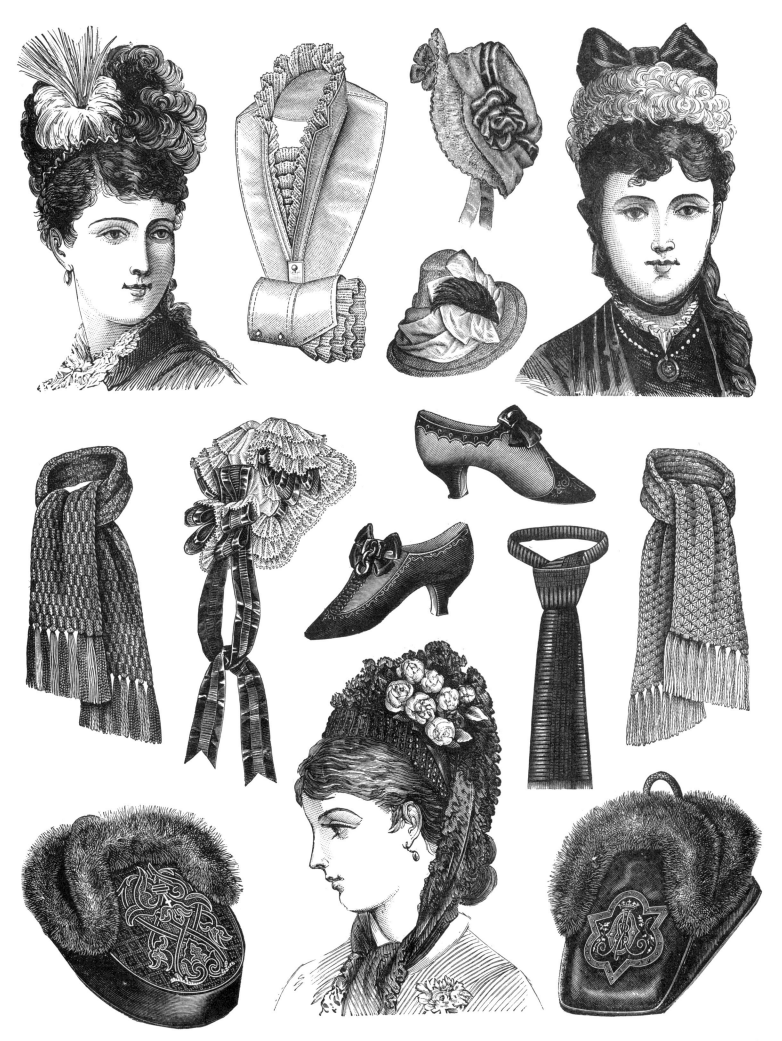

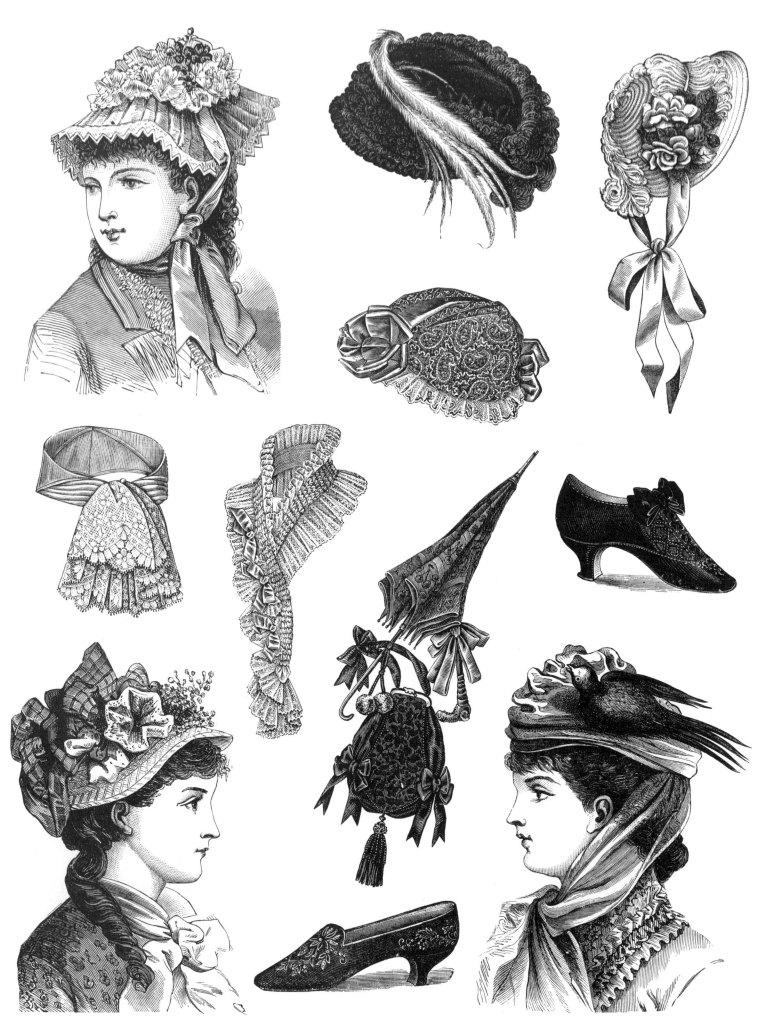

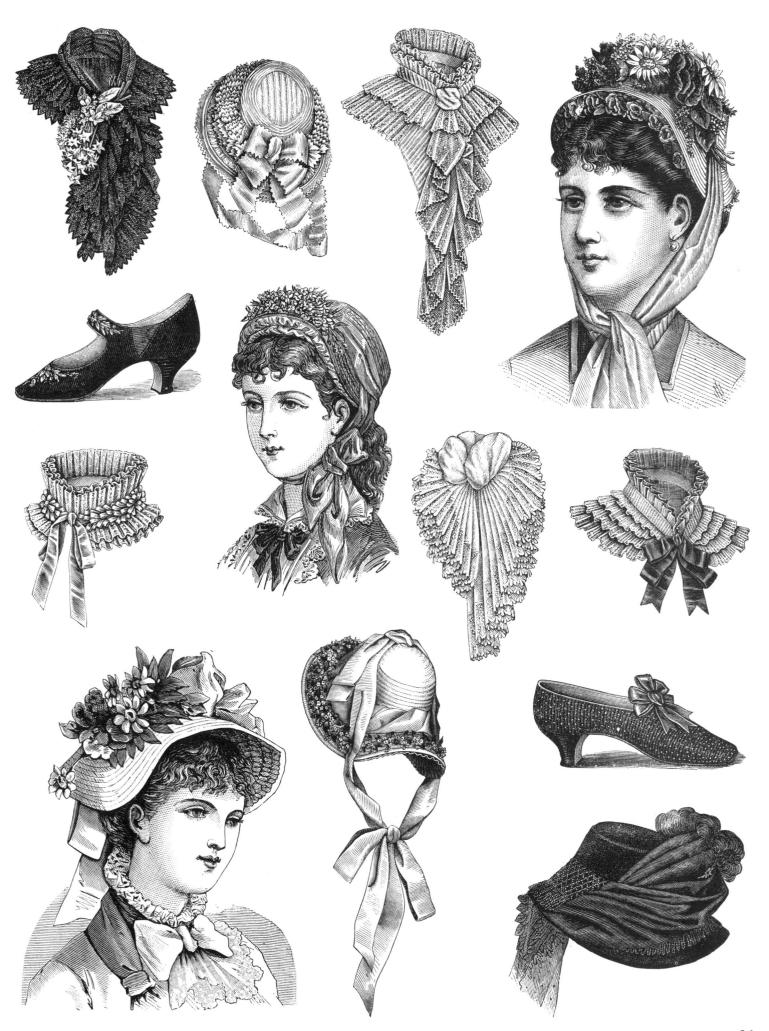

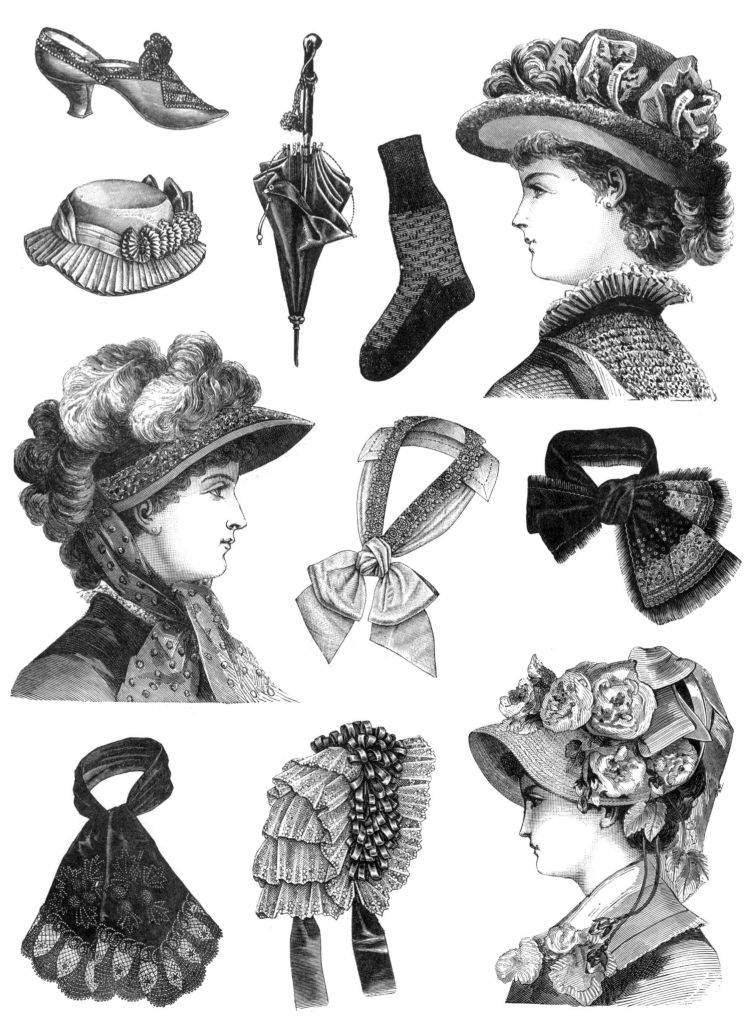

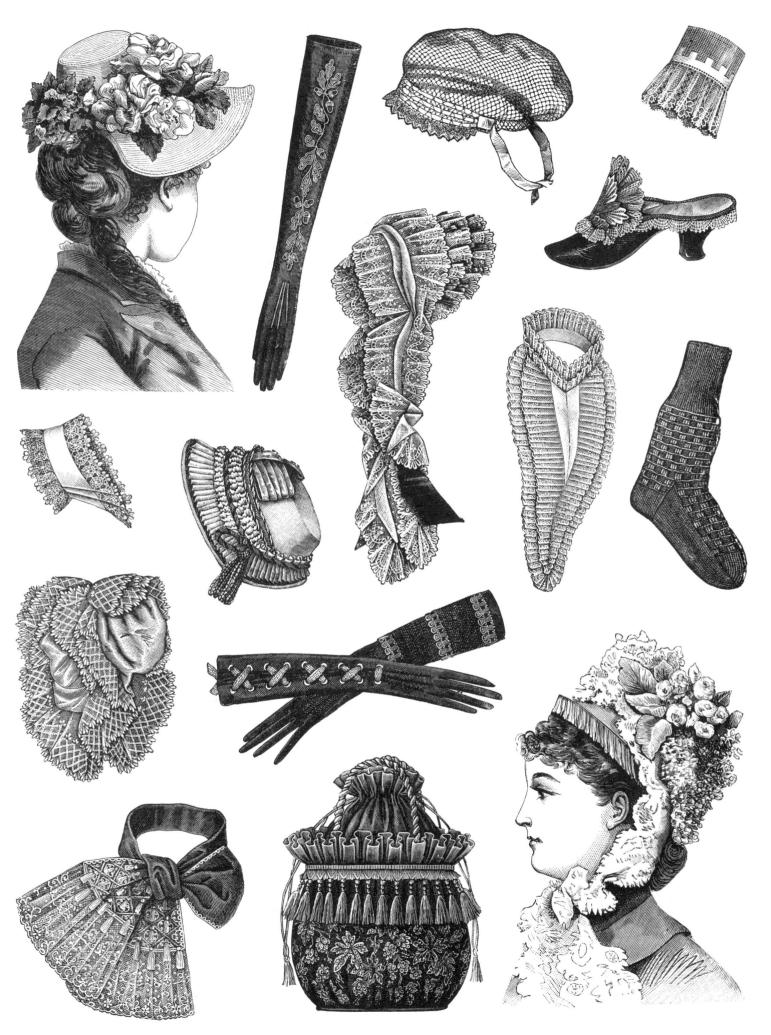

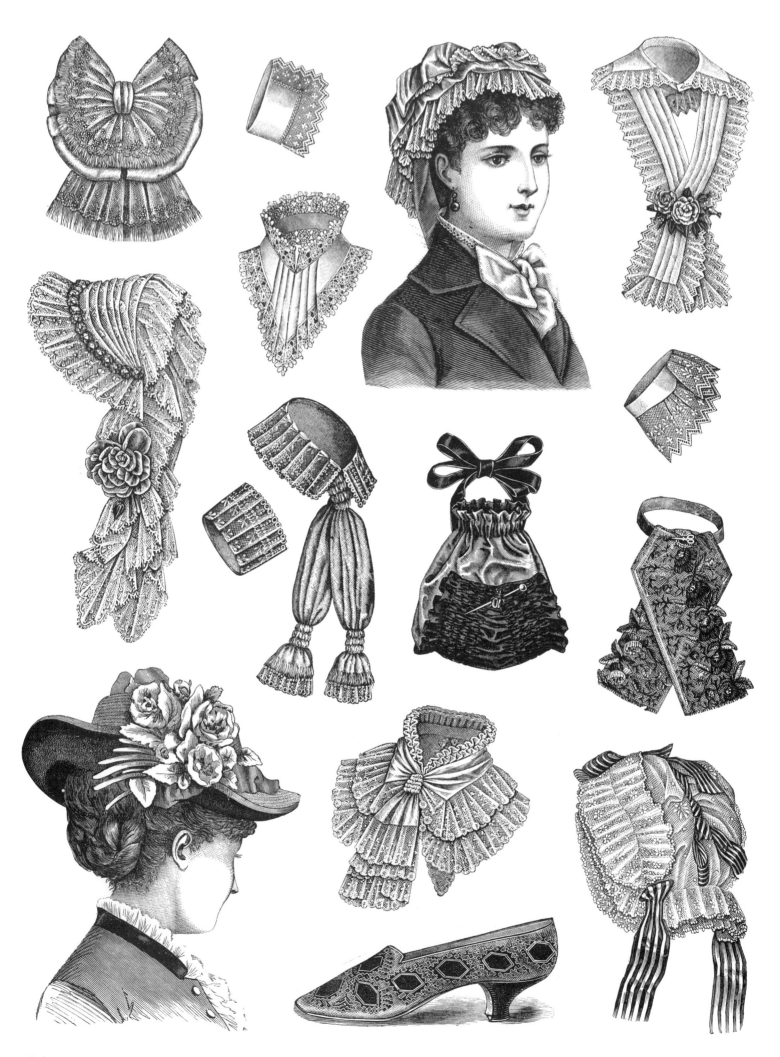

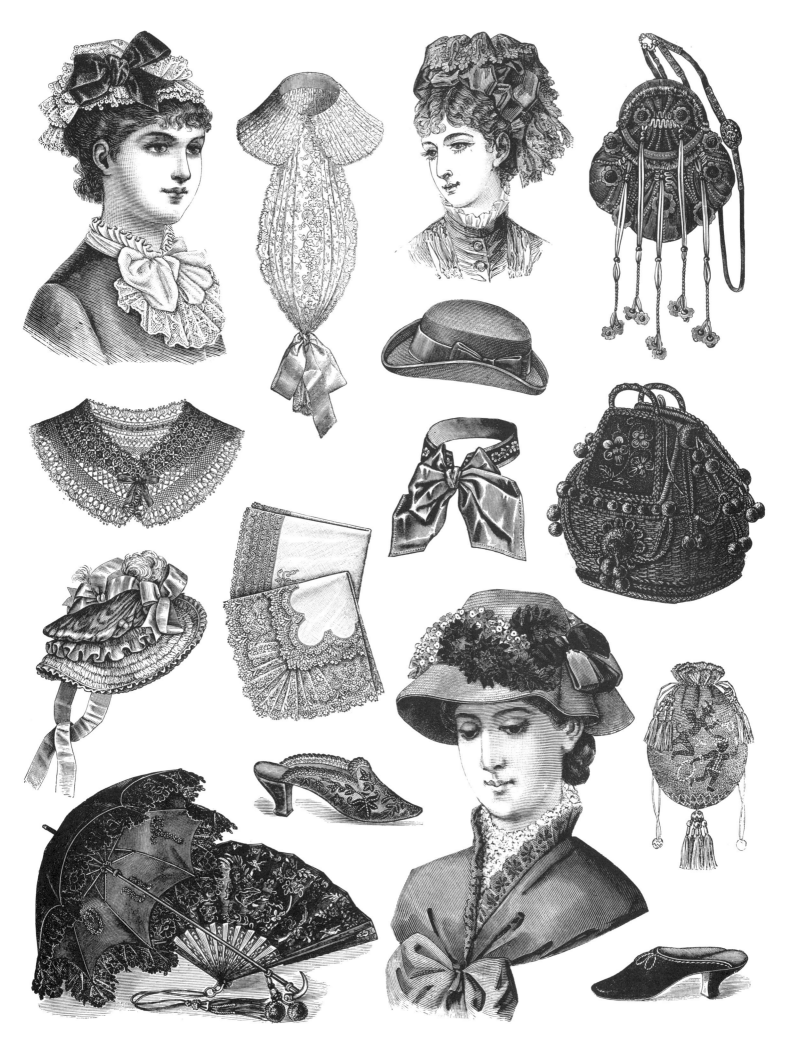

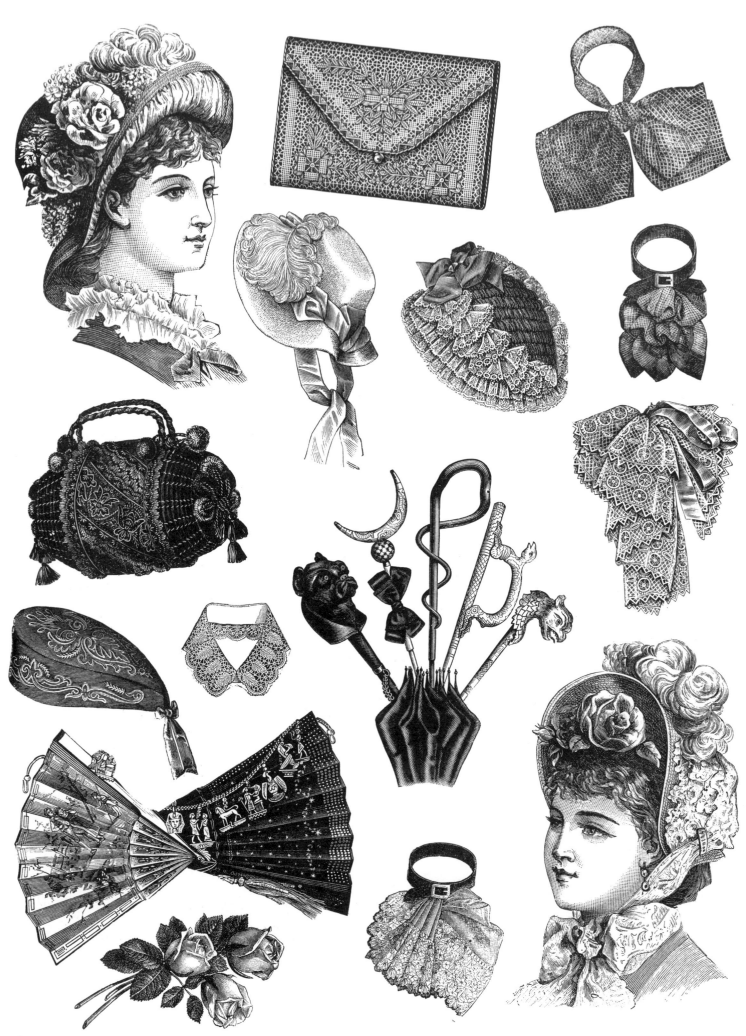

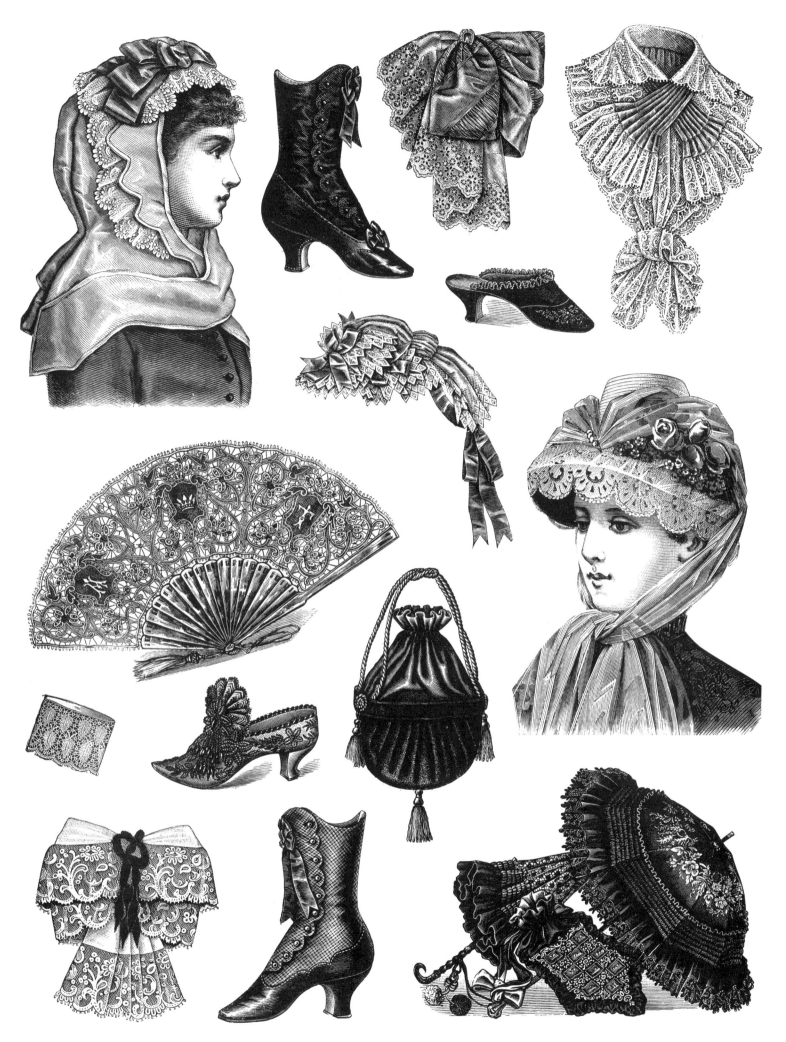

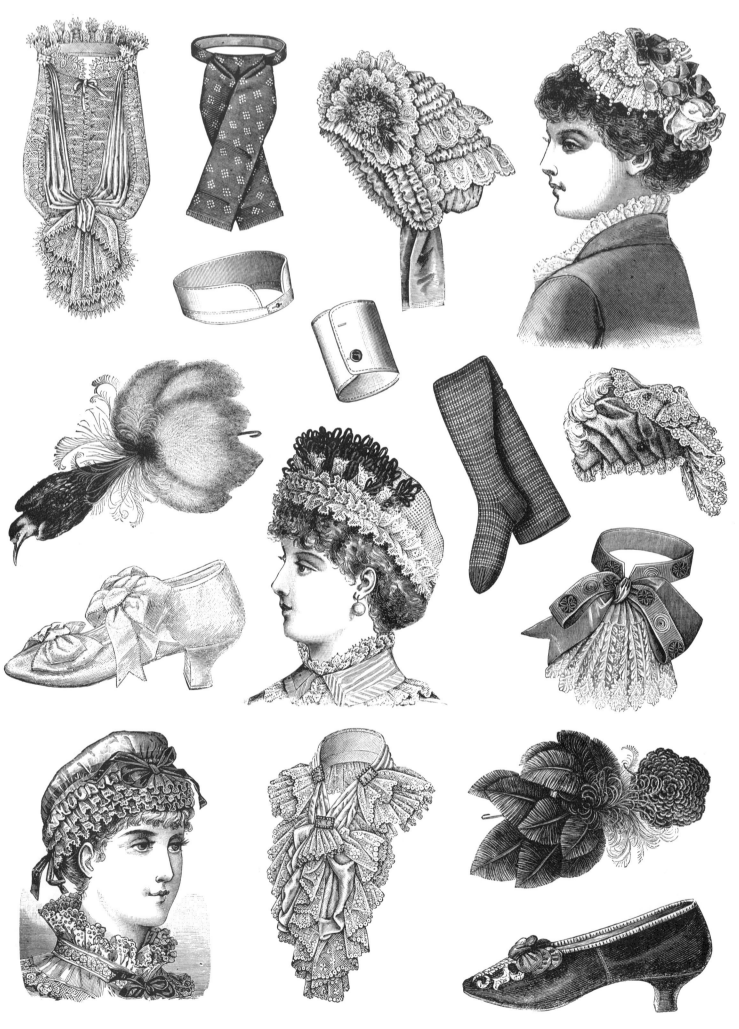

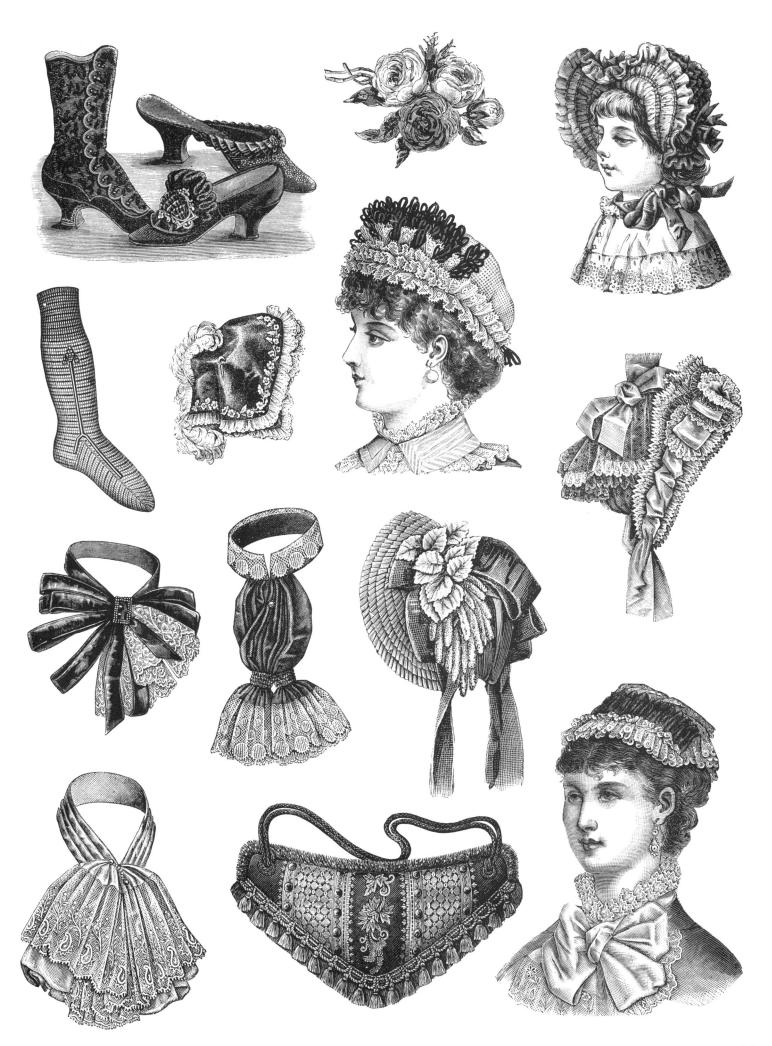

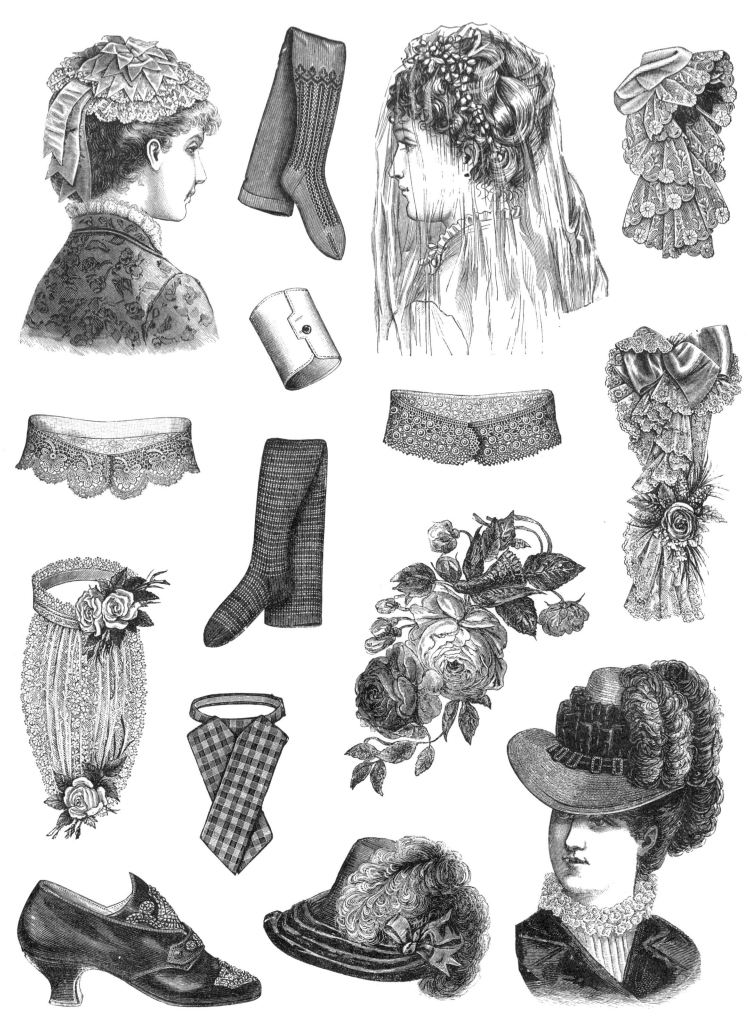

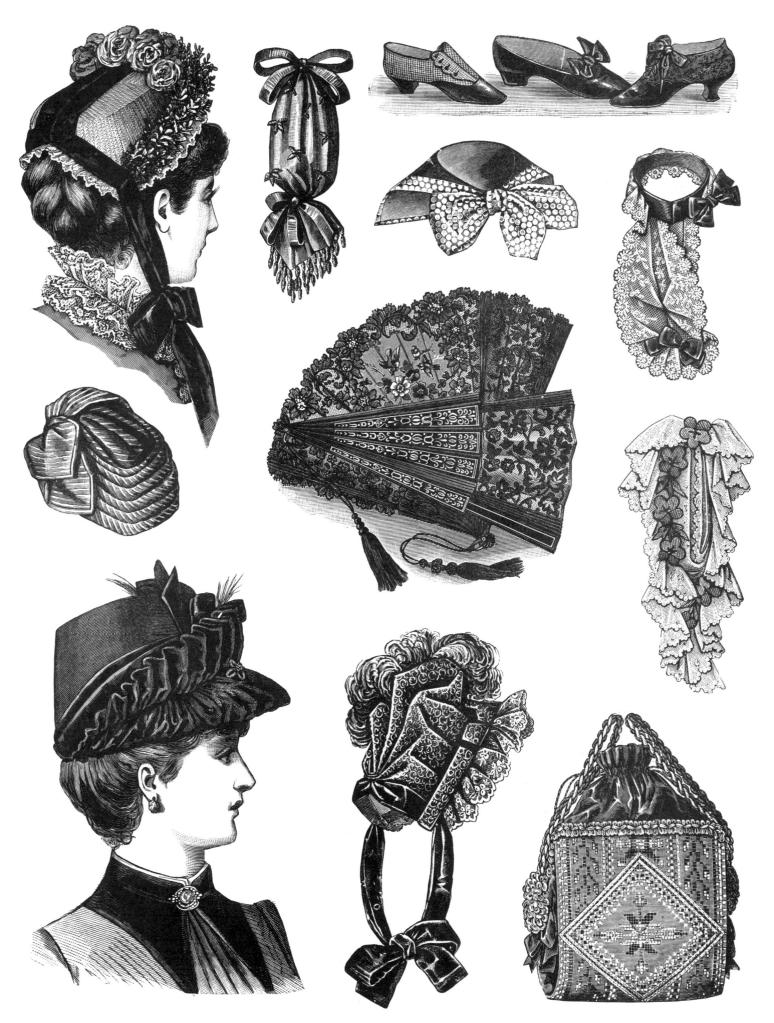

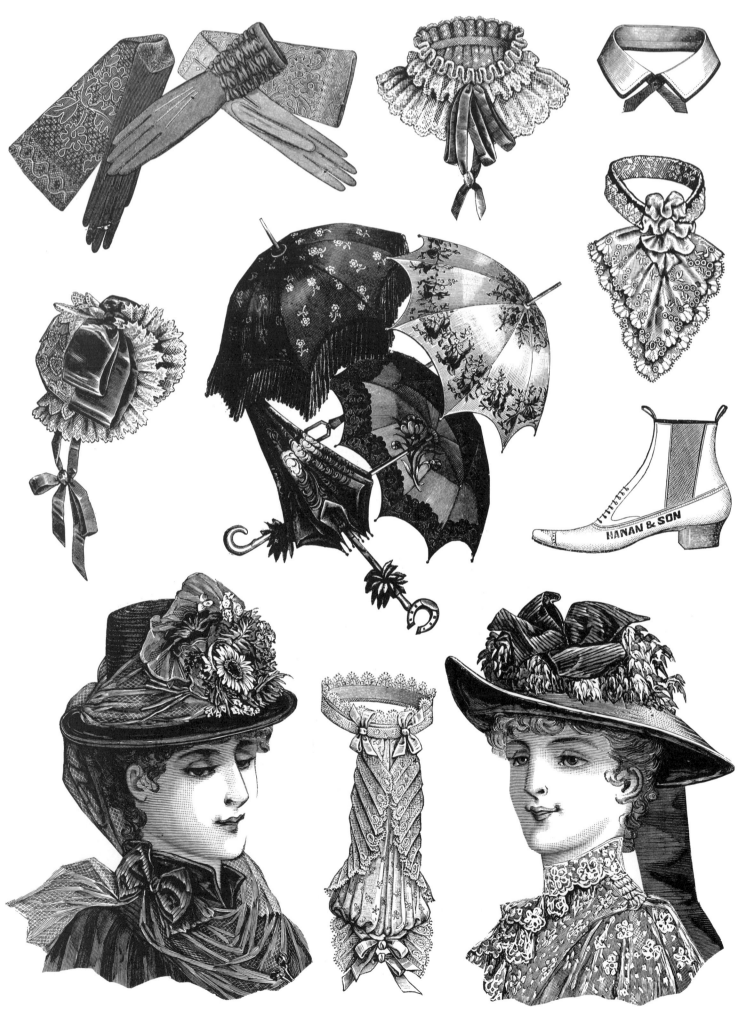

HANAN & SON

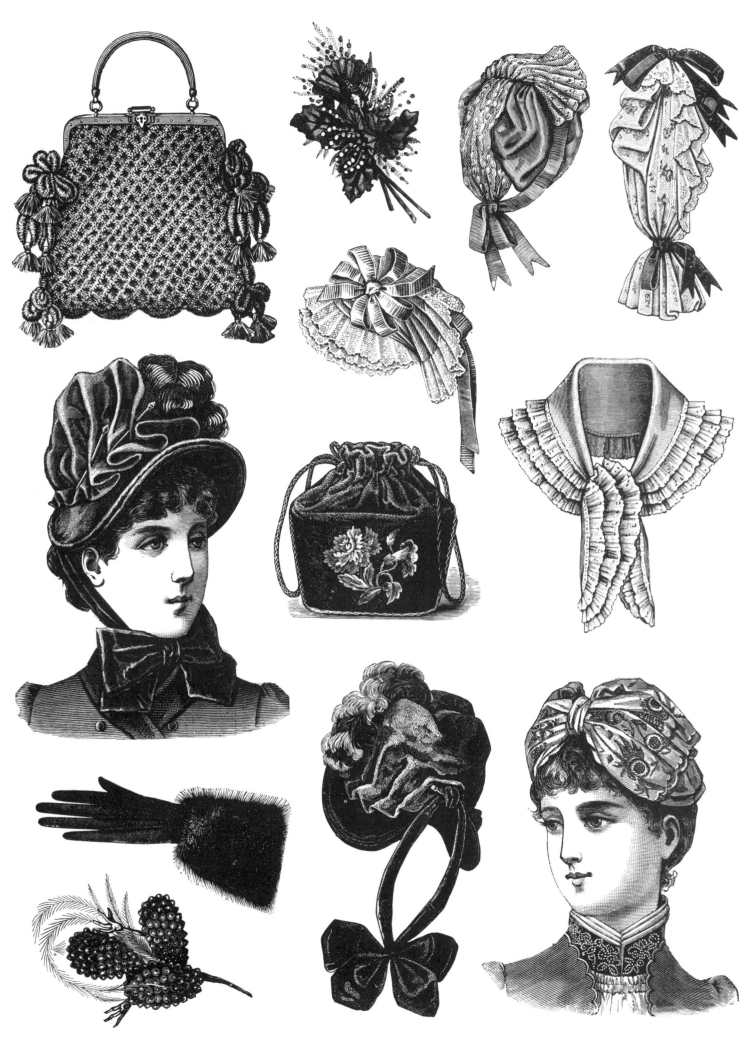

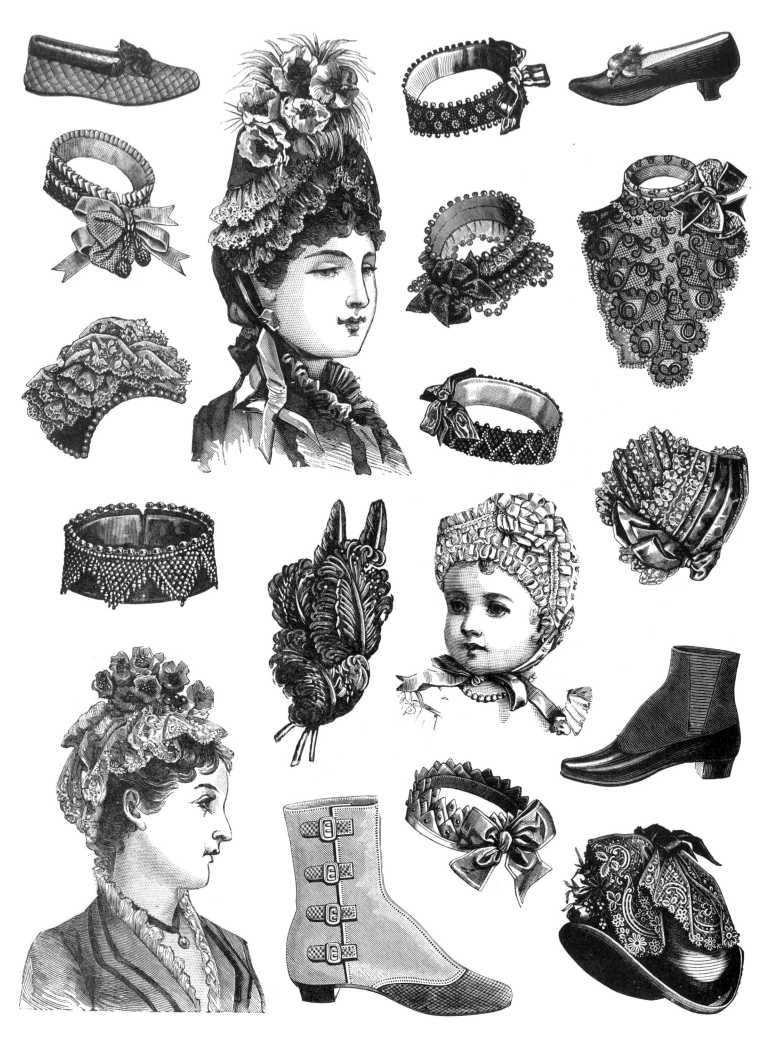

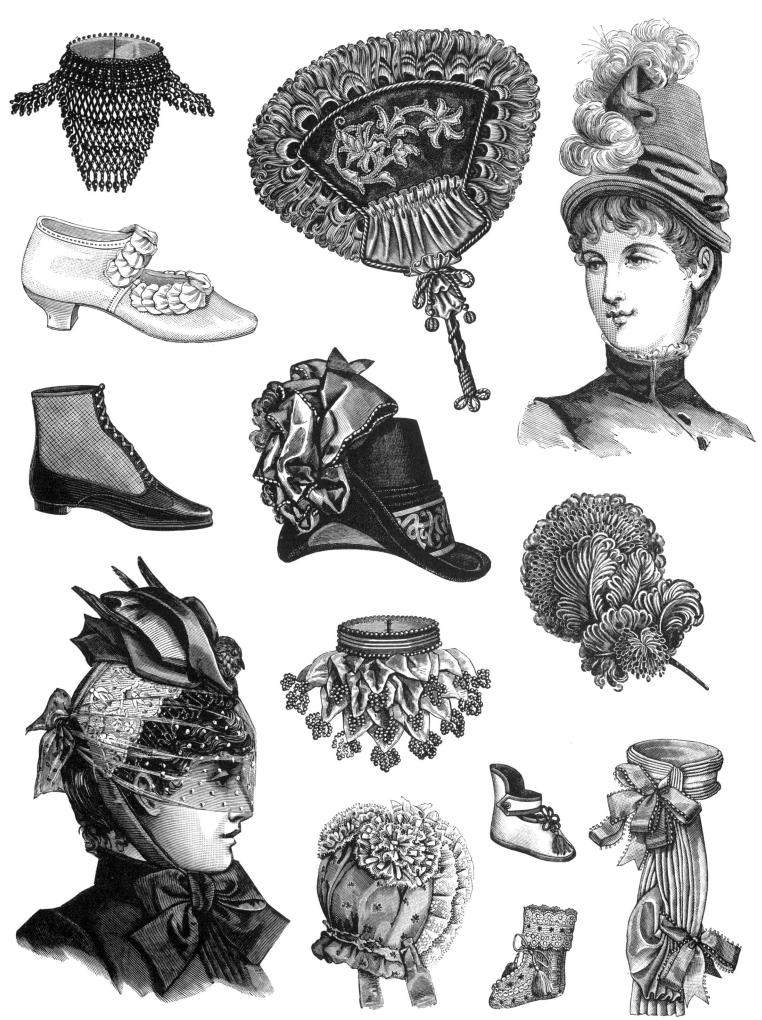

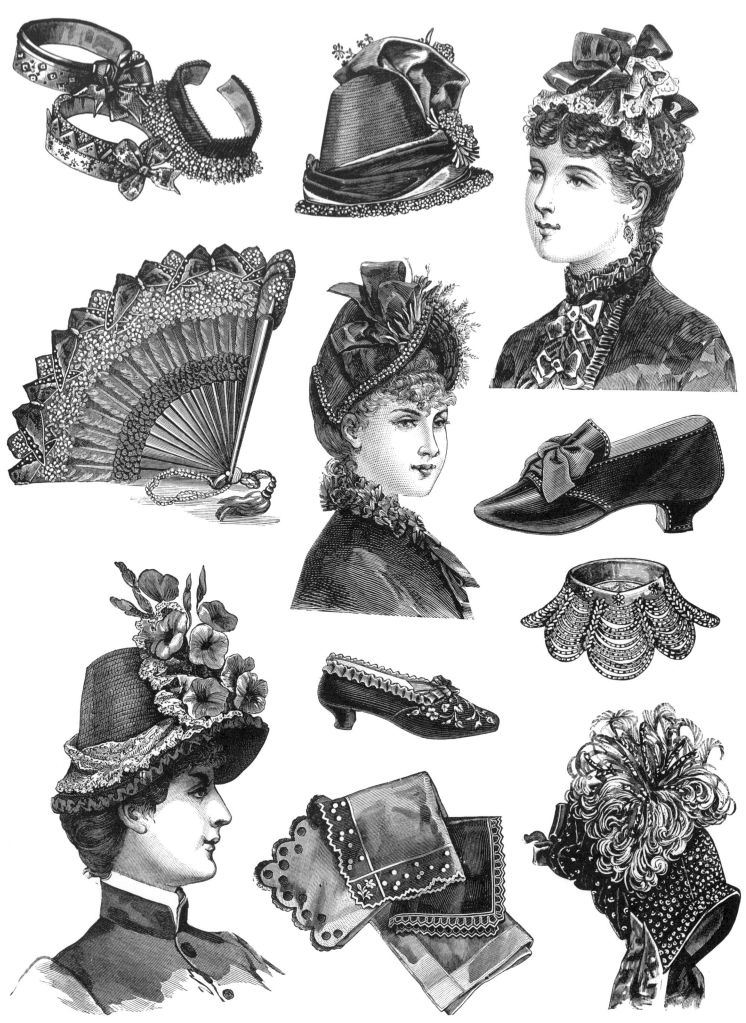

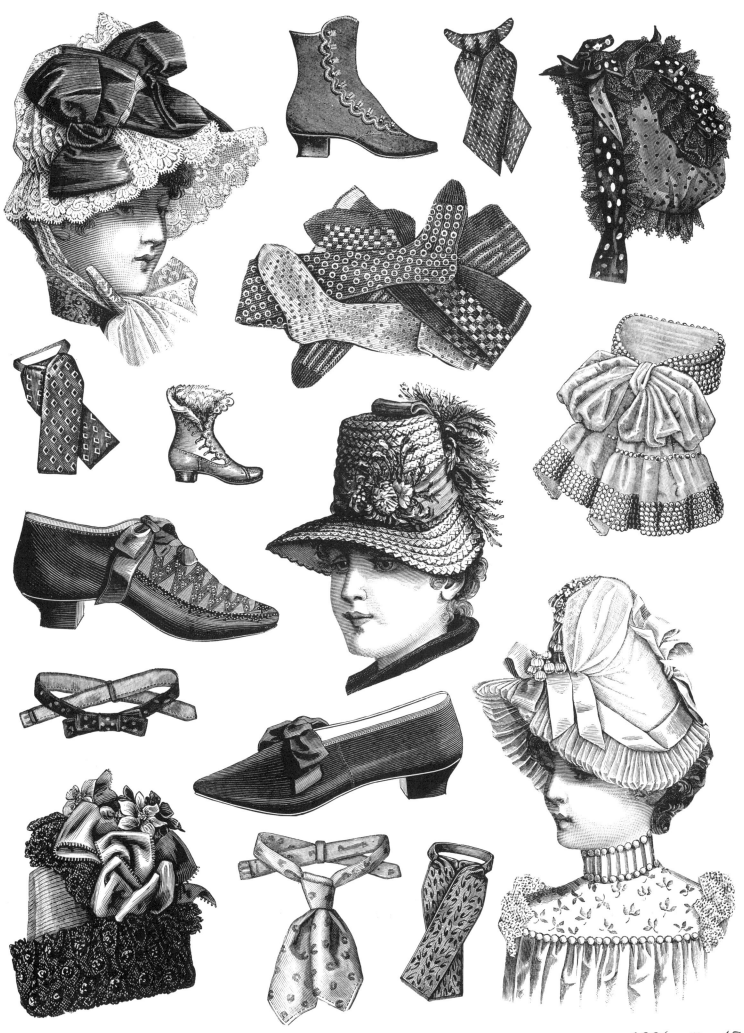

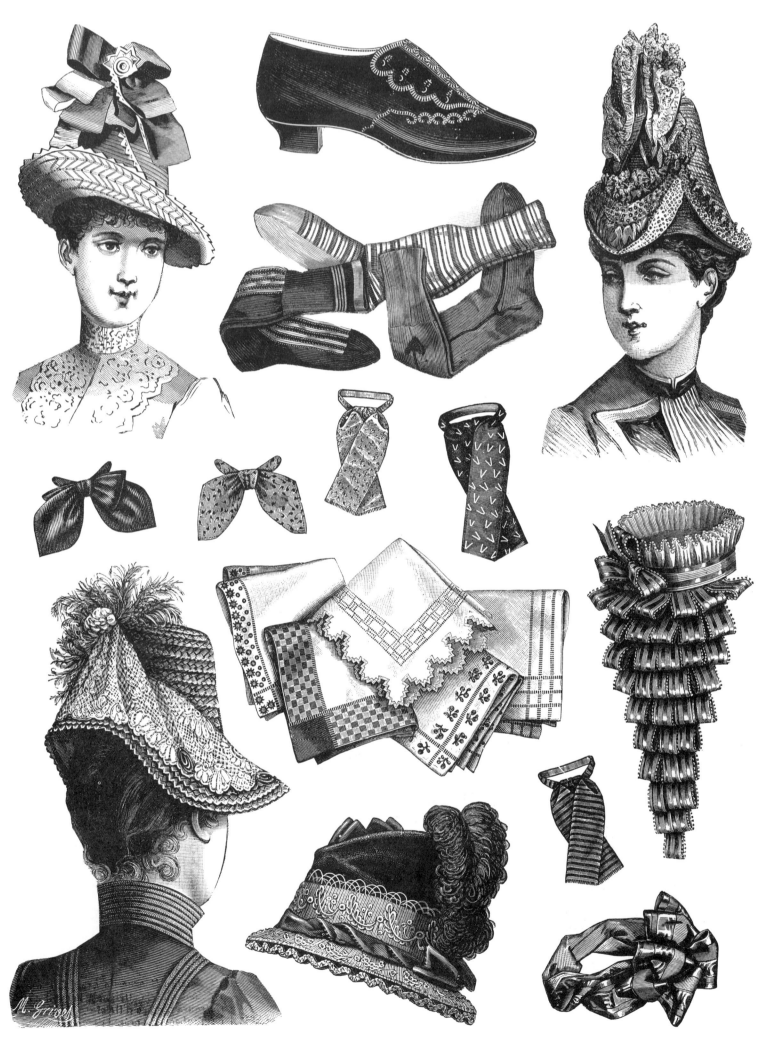

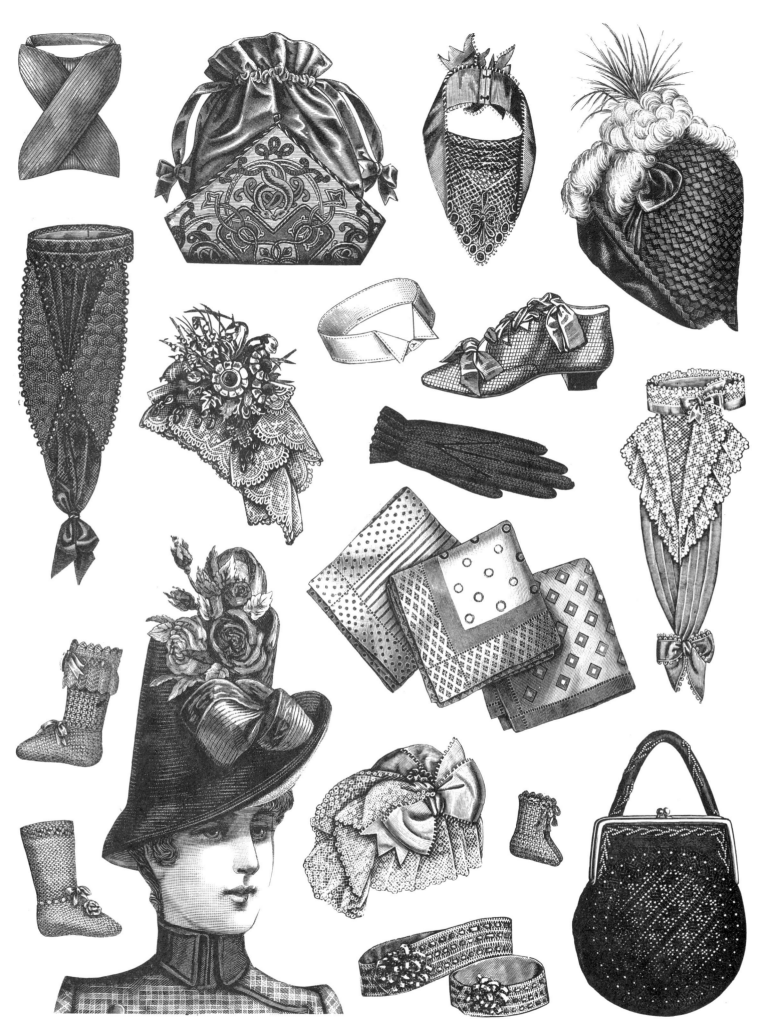

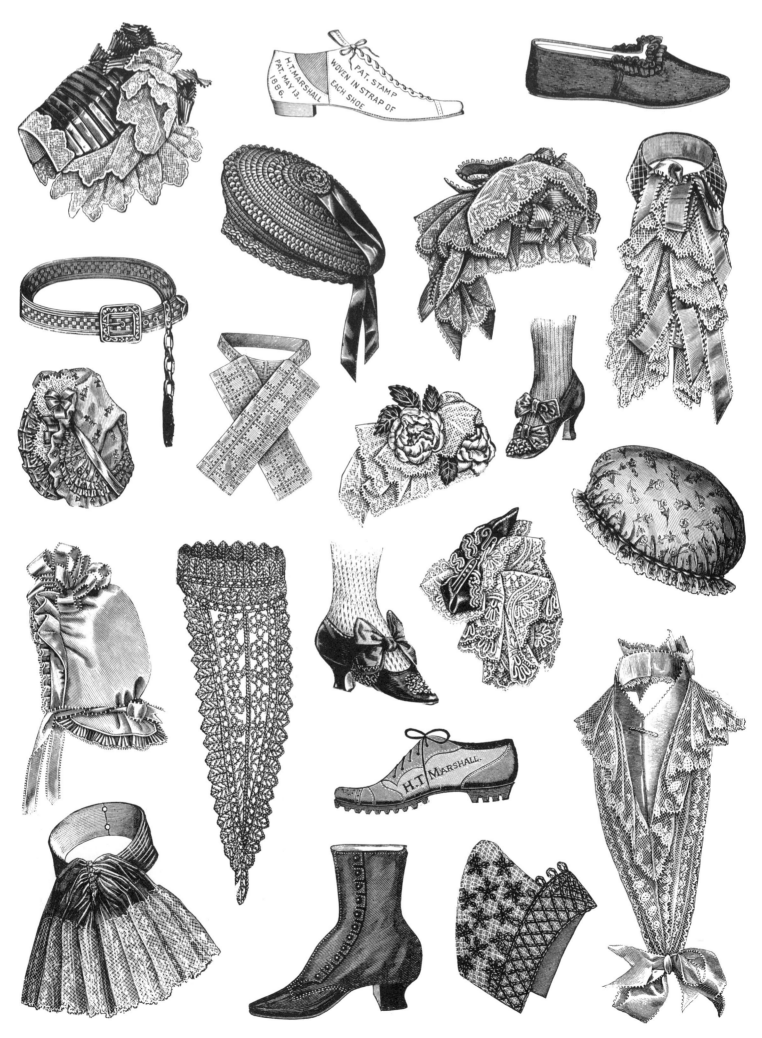

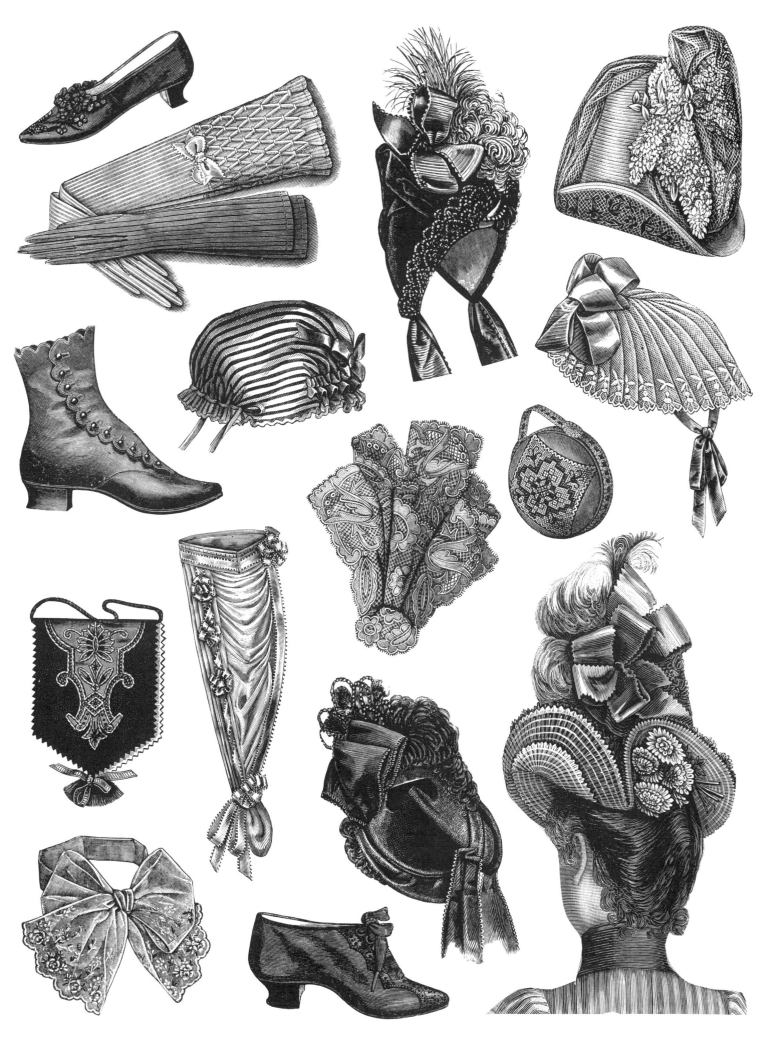

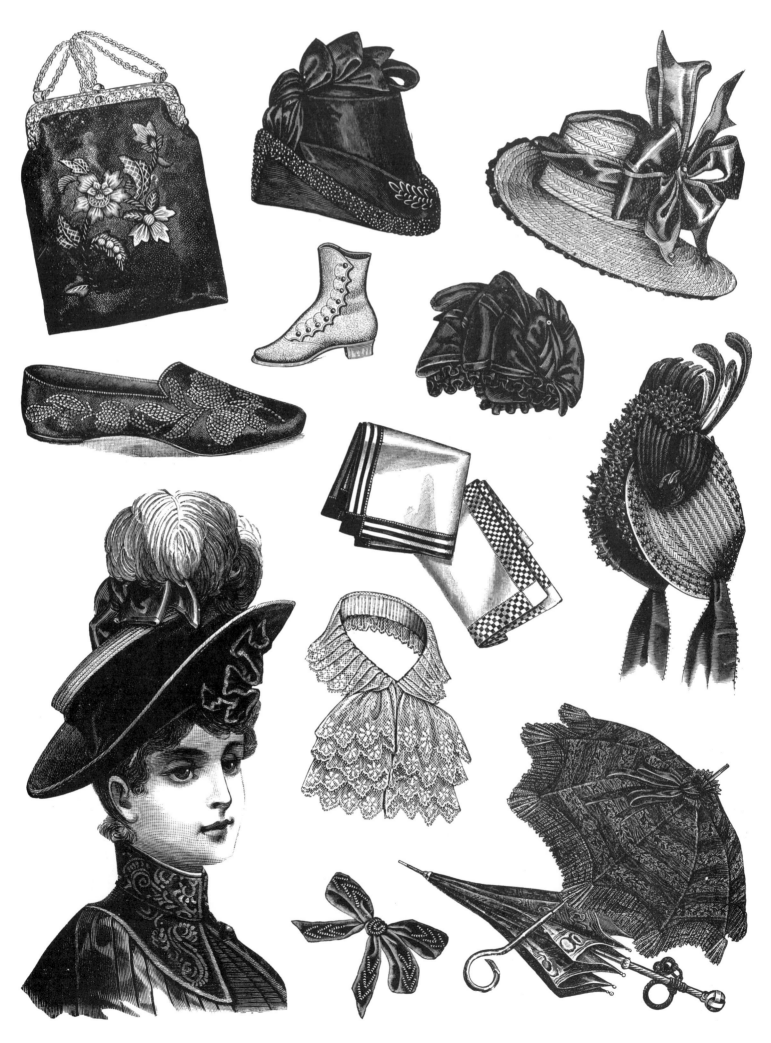

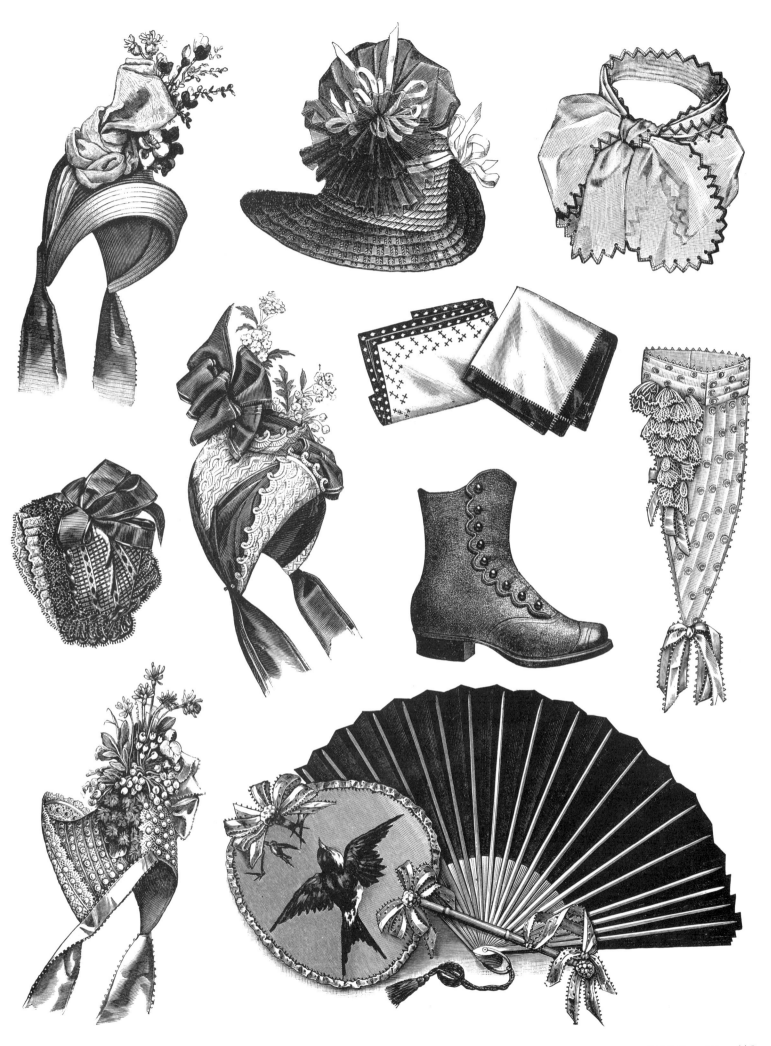

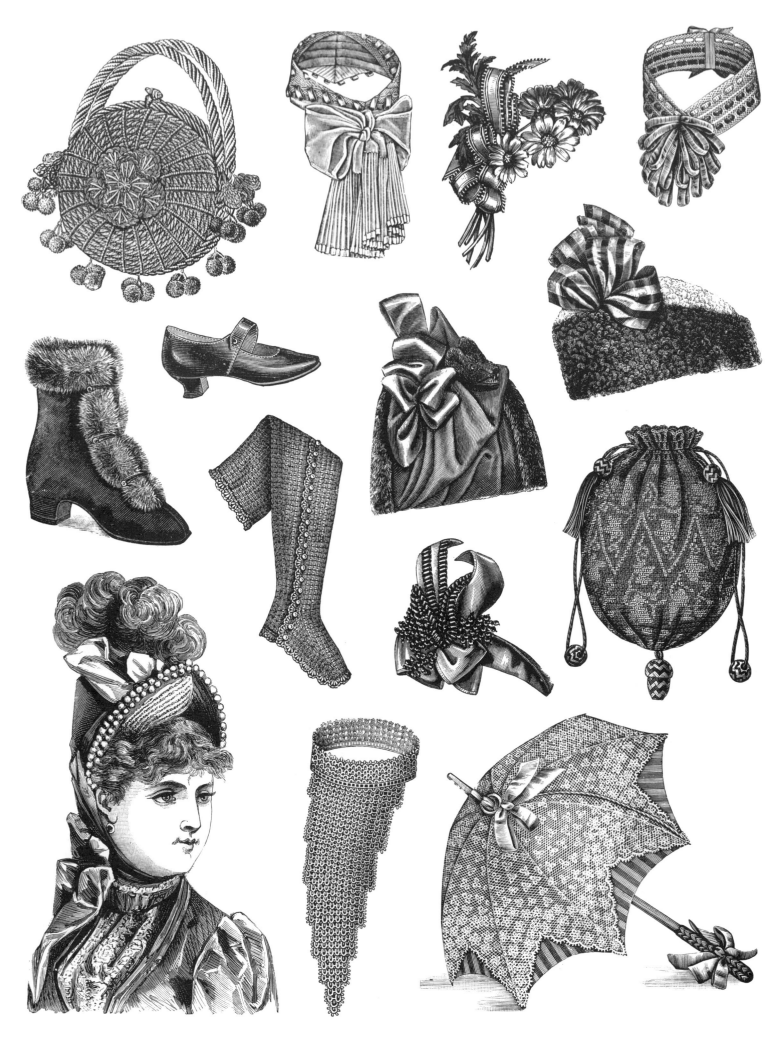

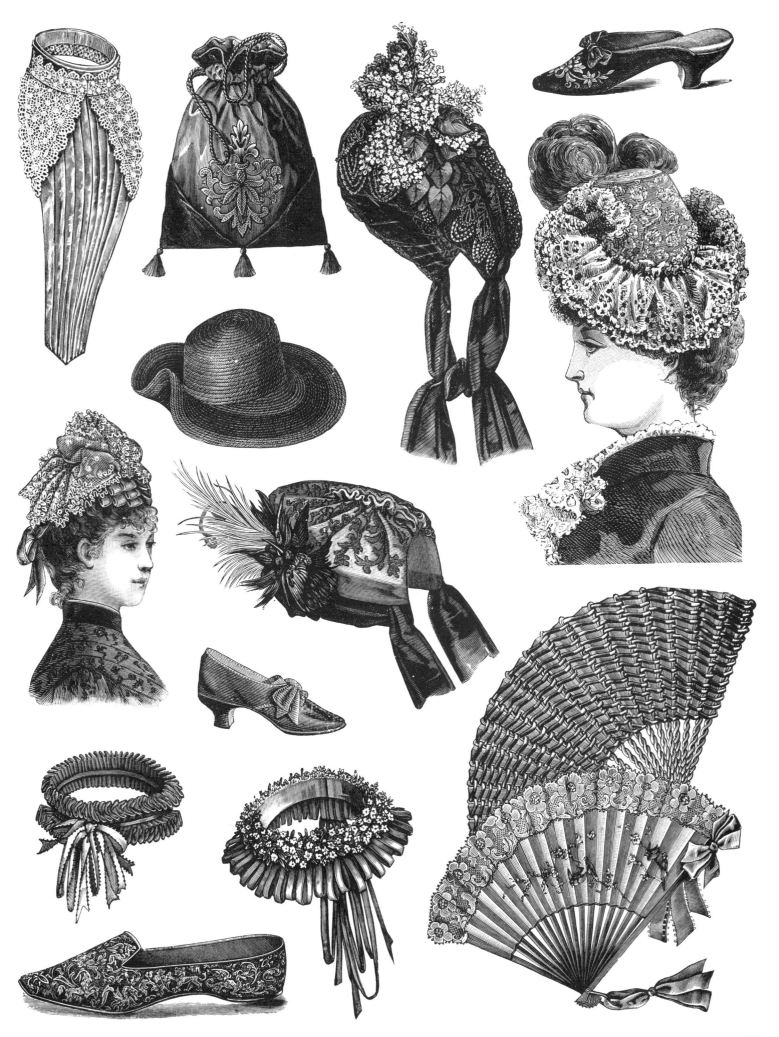

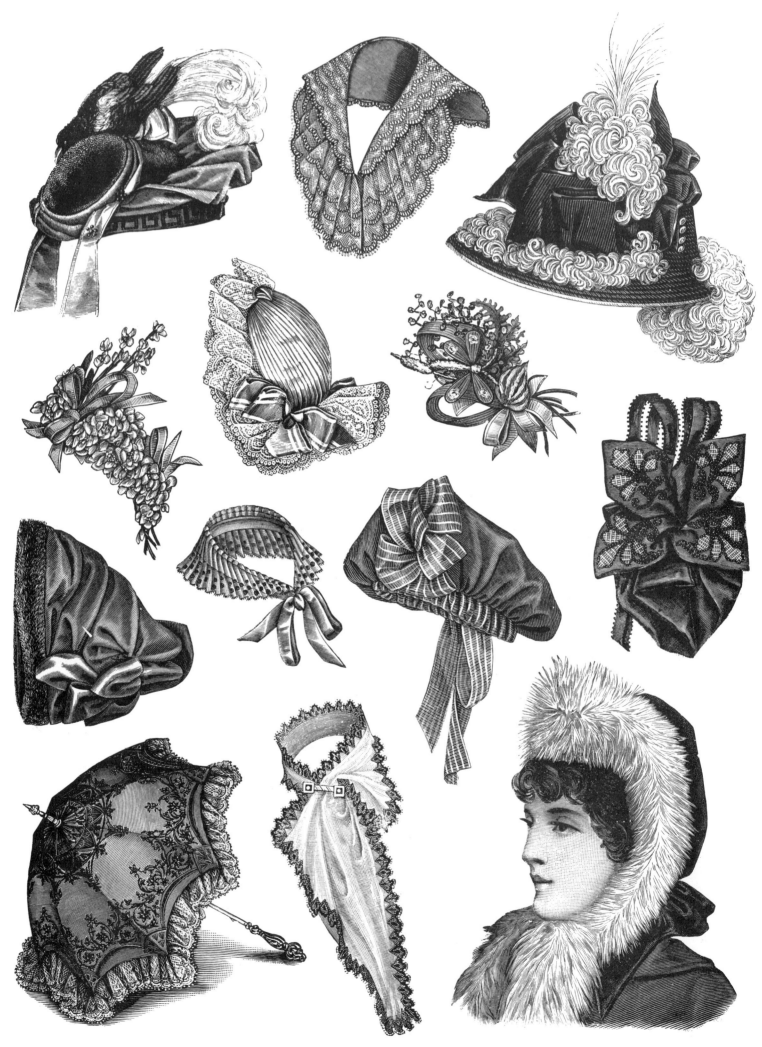

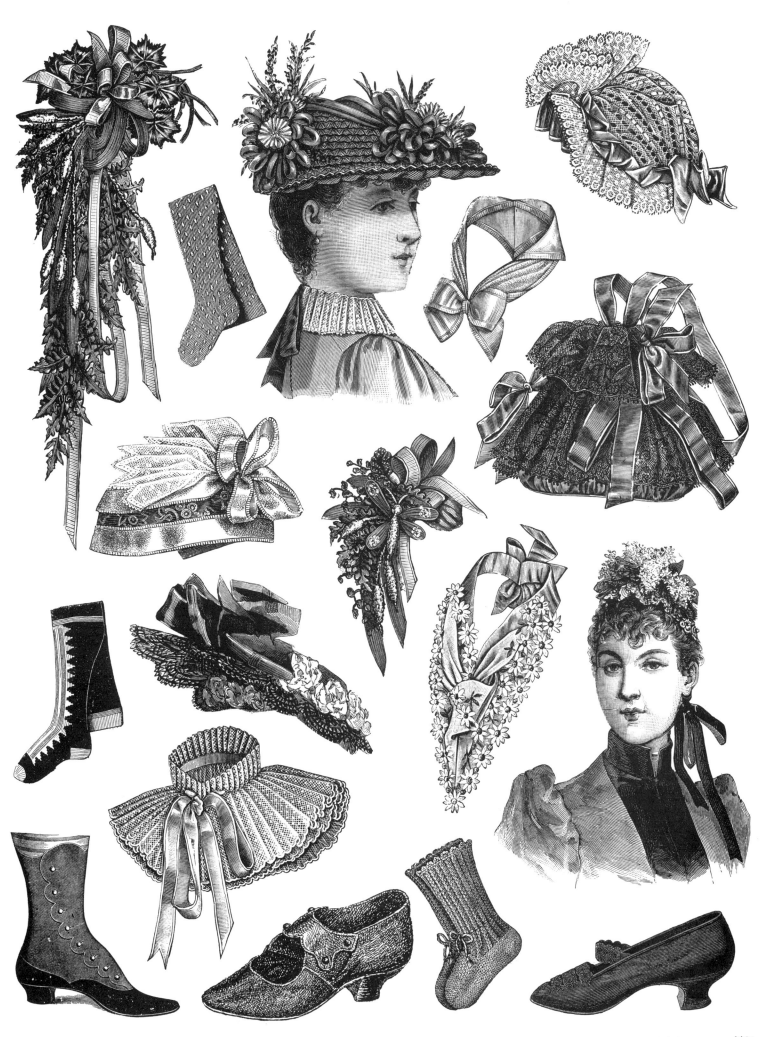

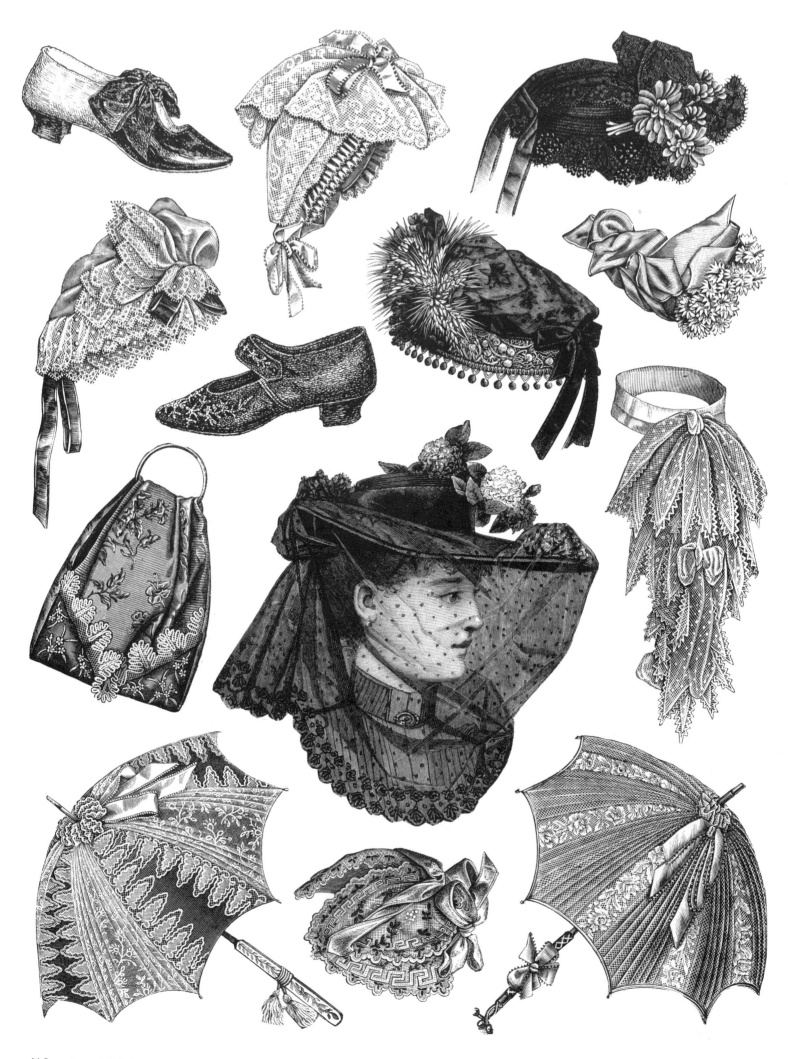

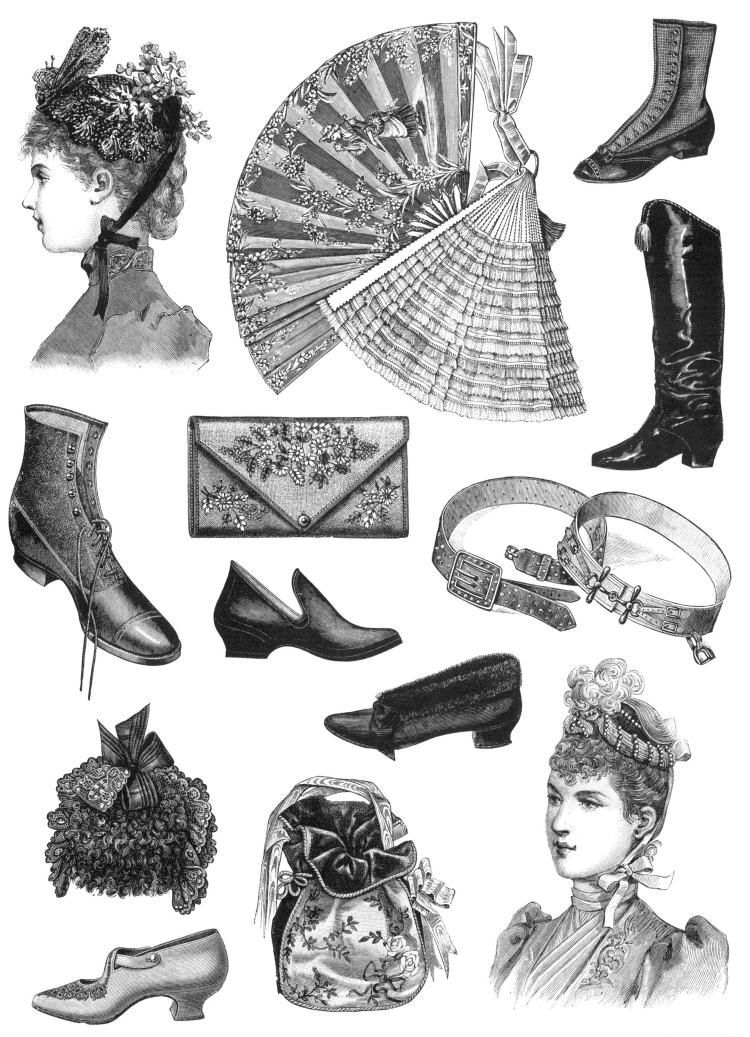

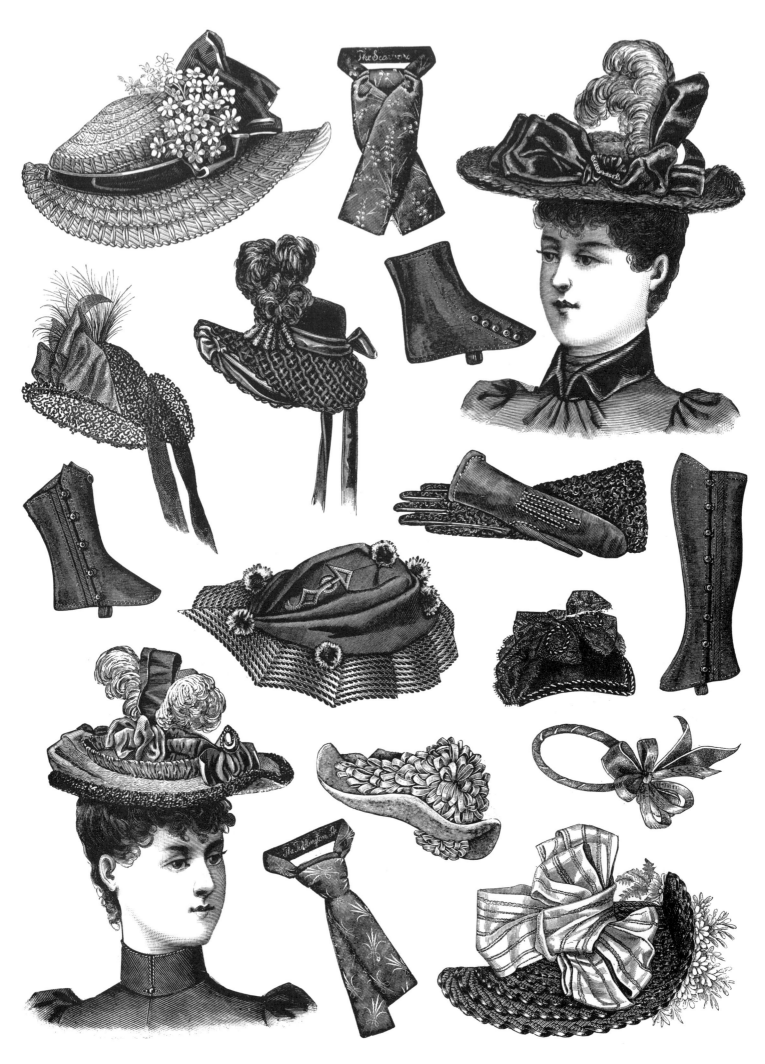

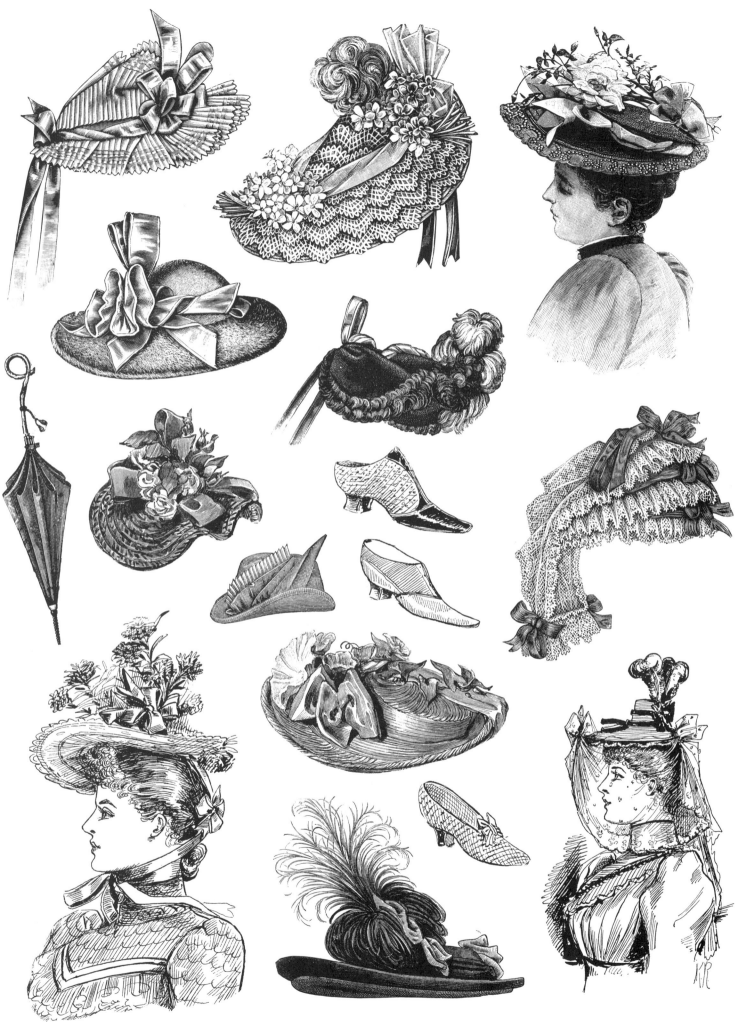

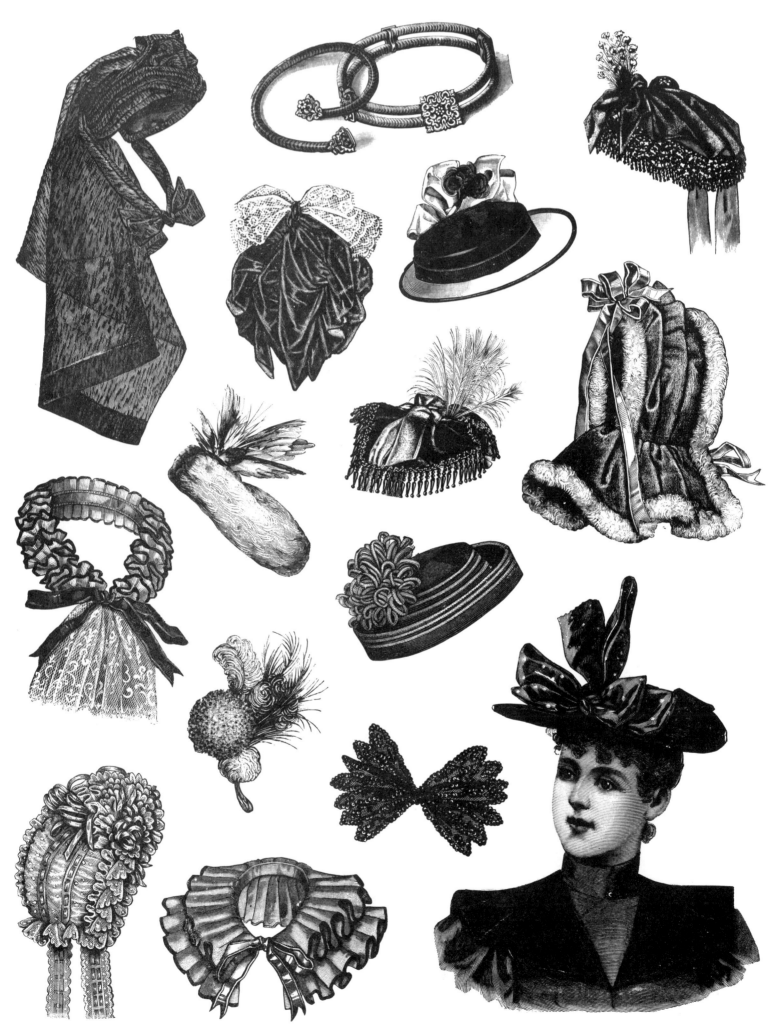

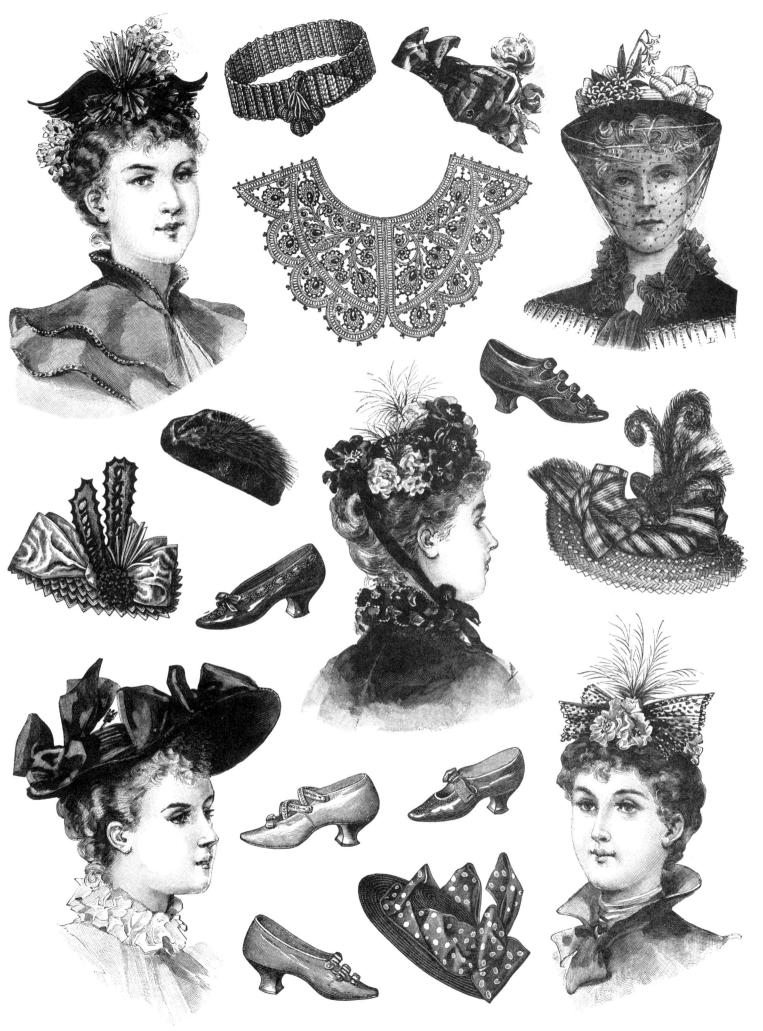

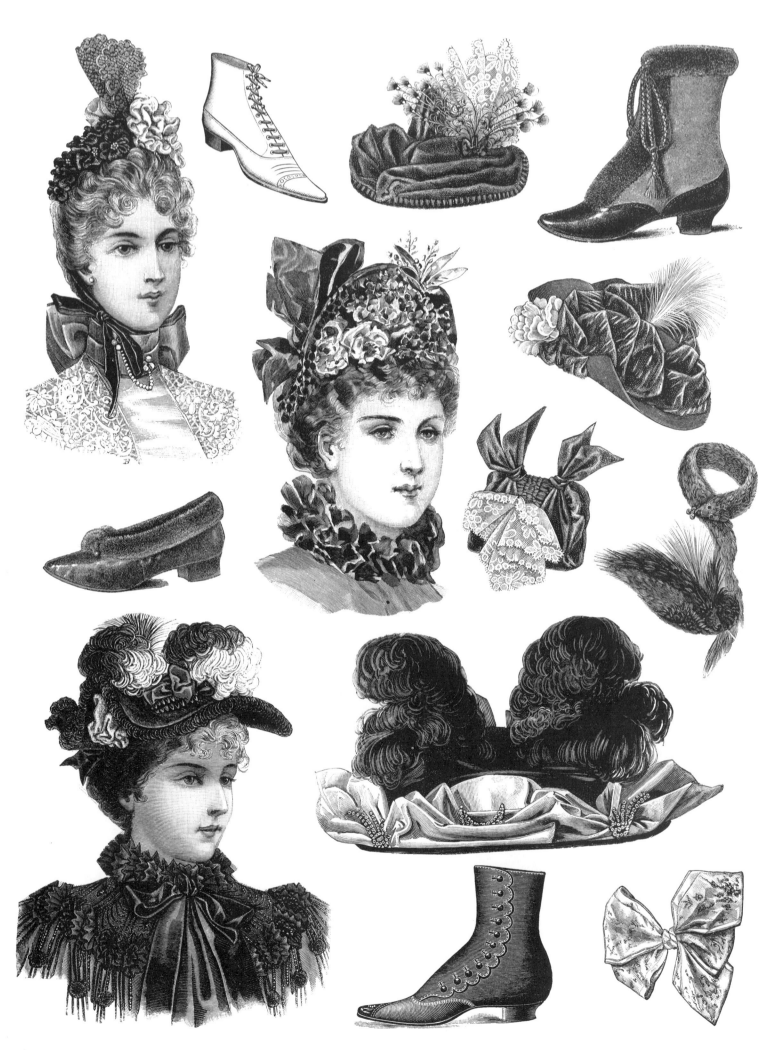

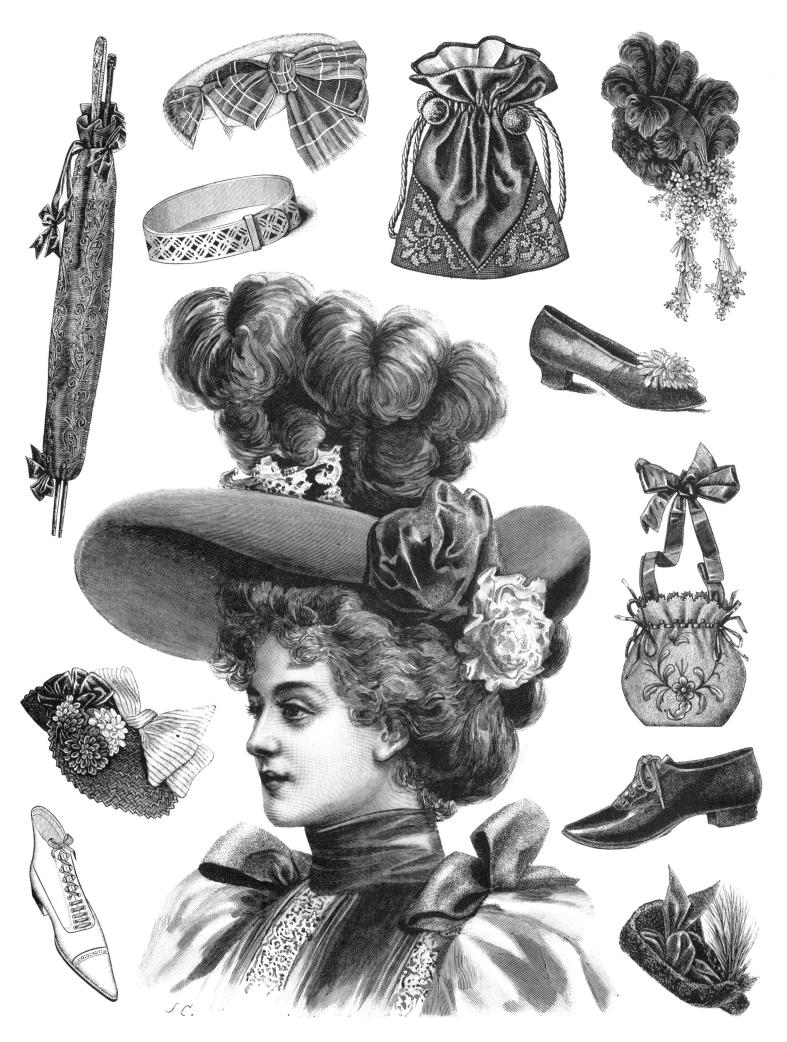

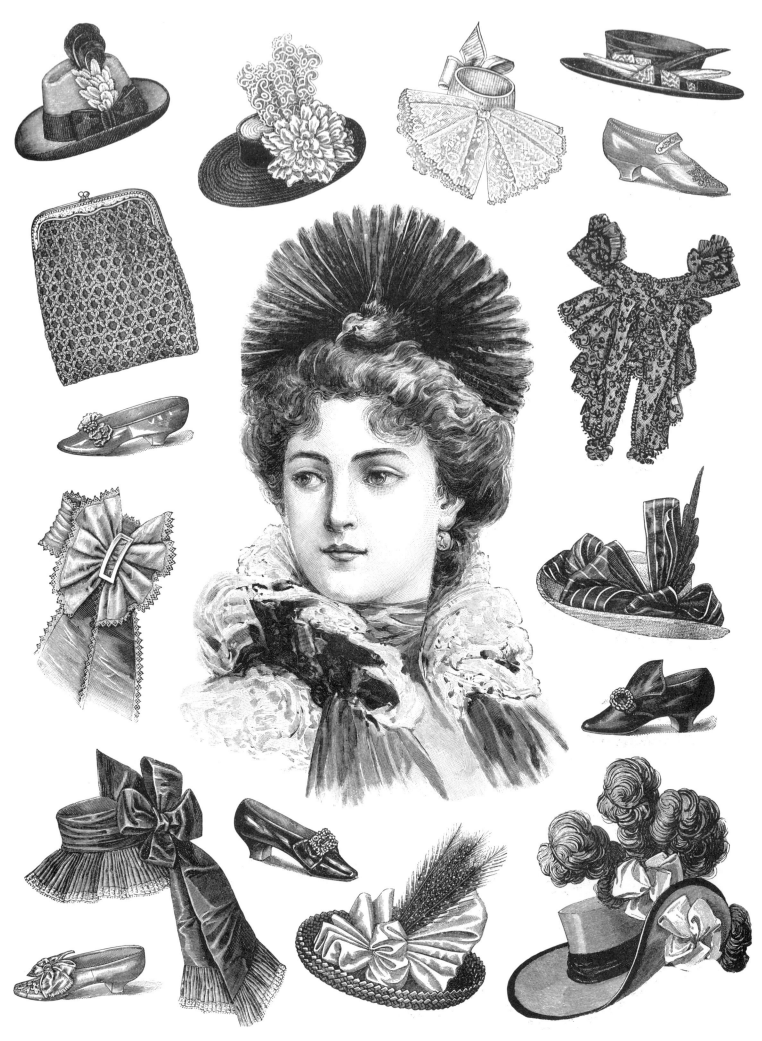

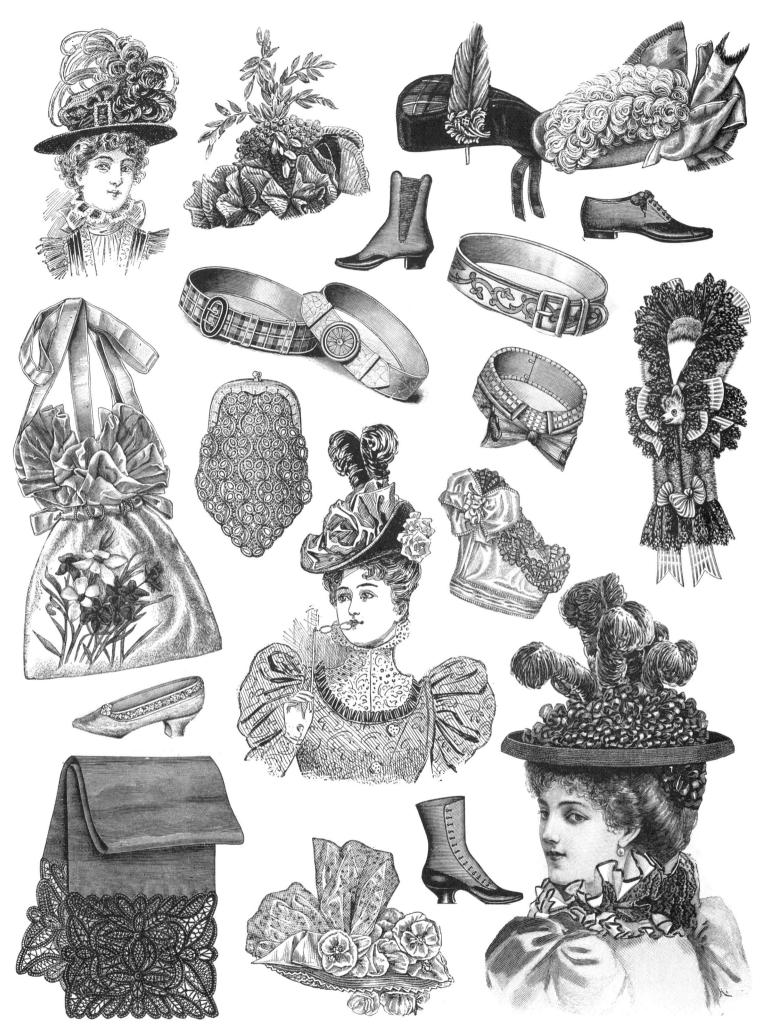

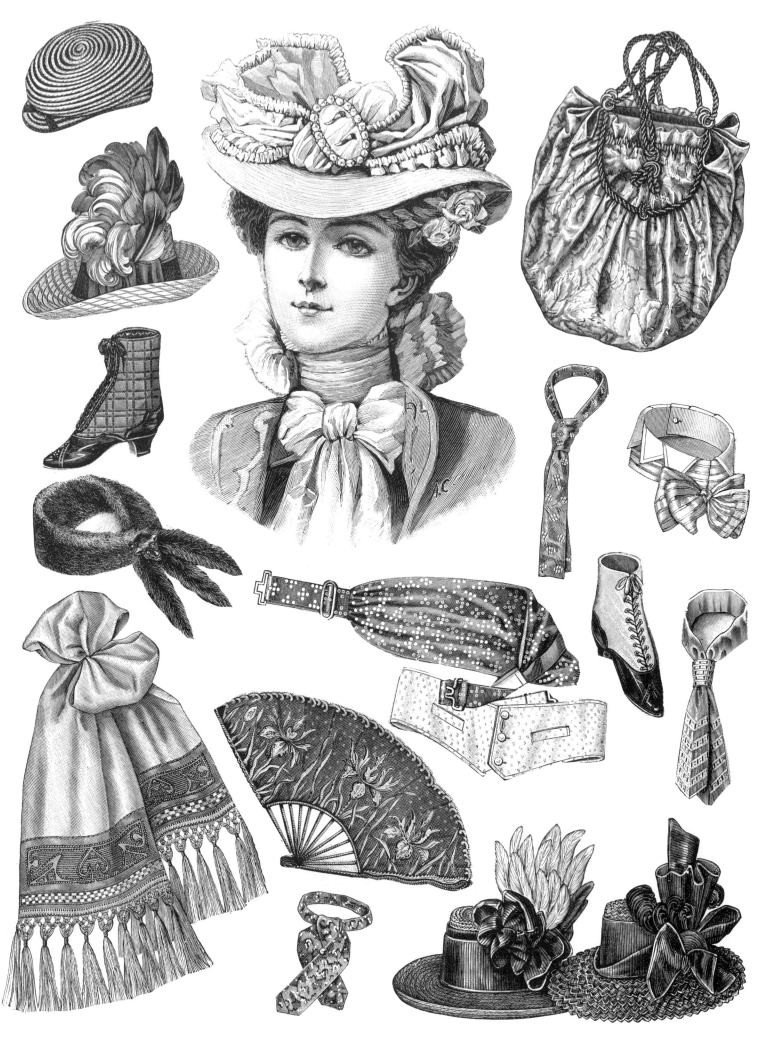

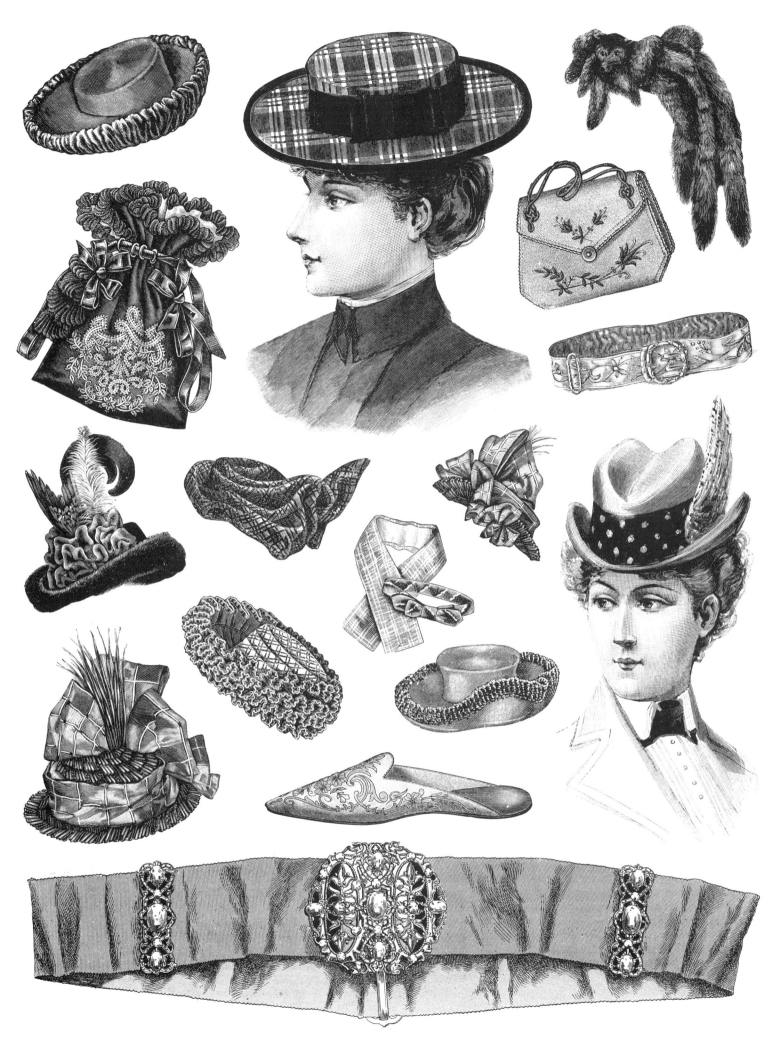

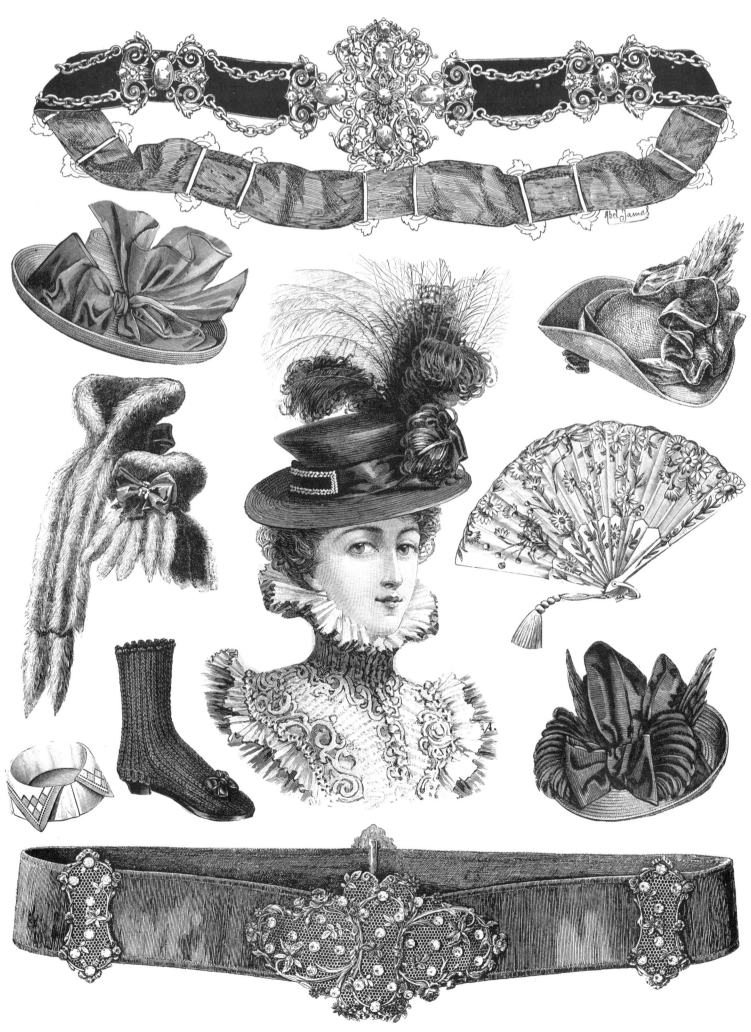

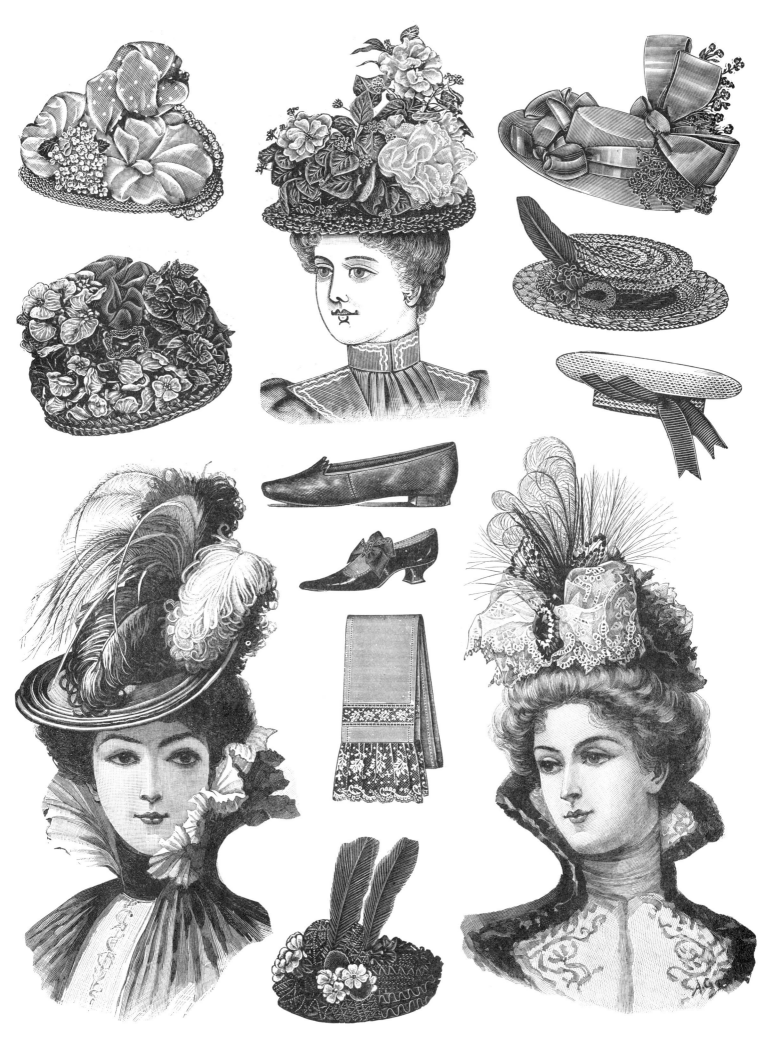

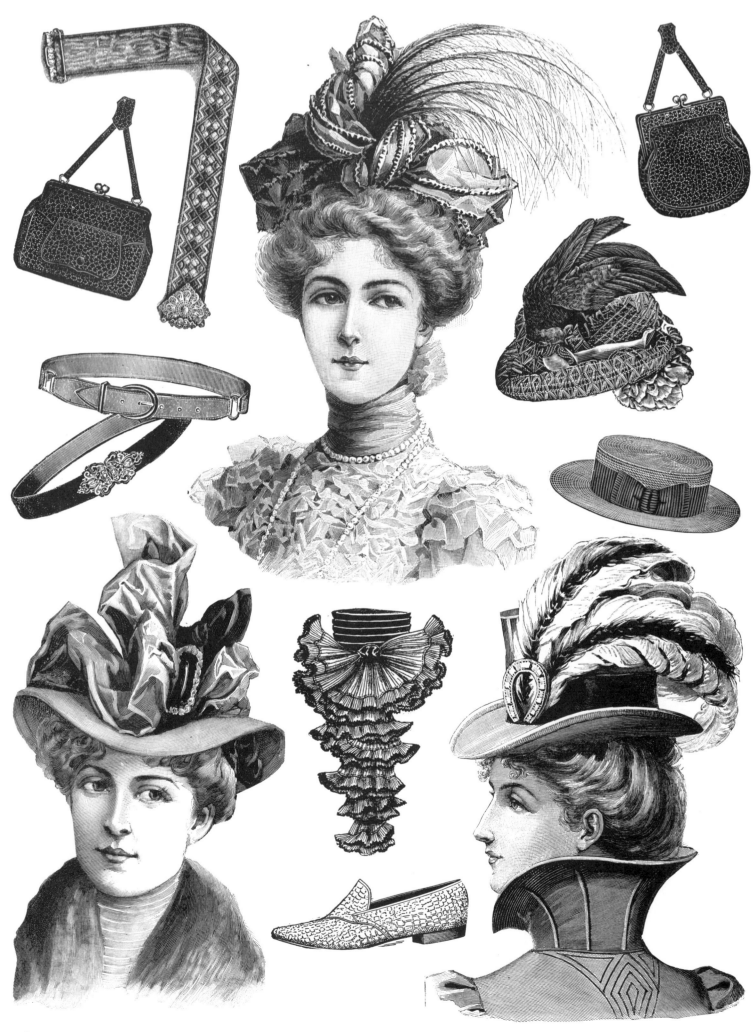

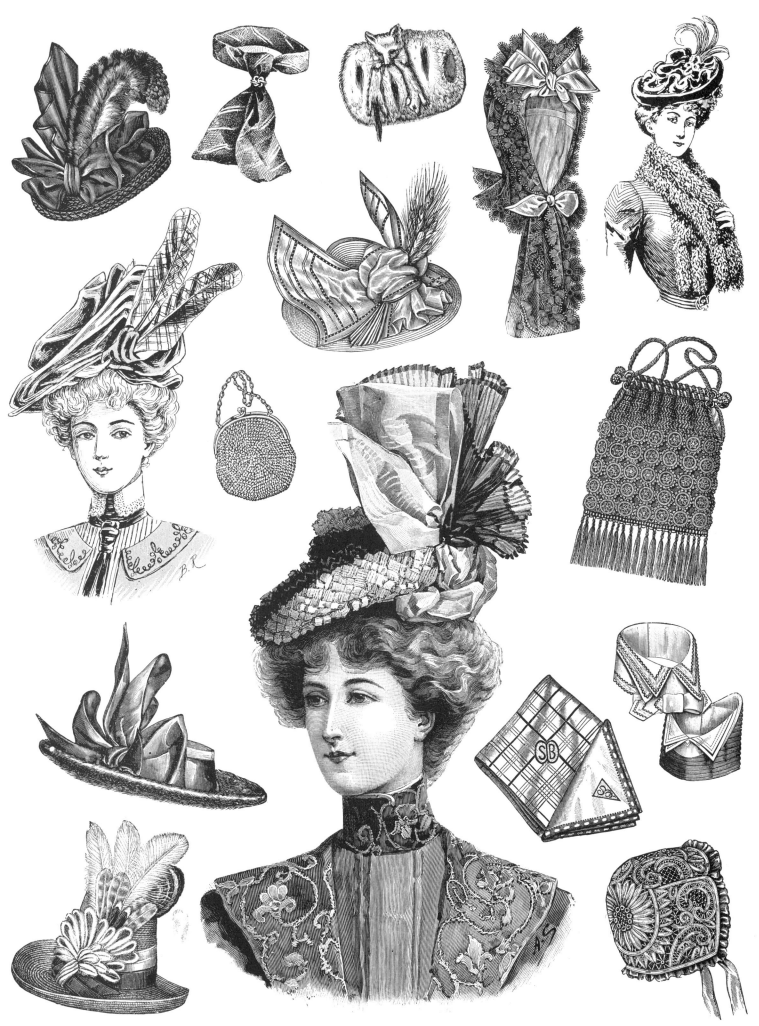

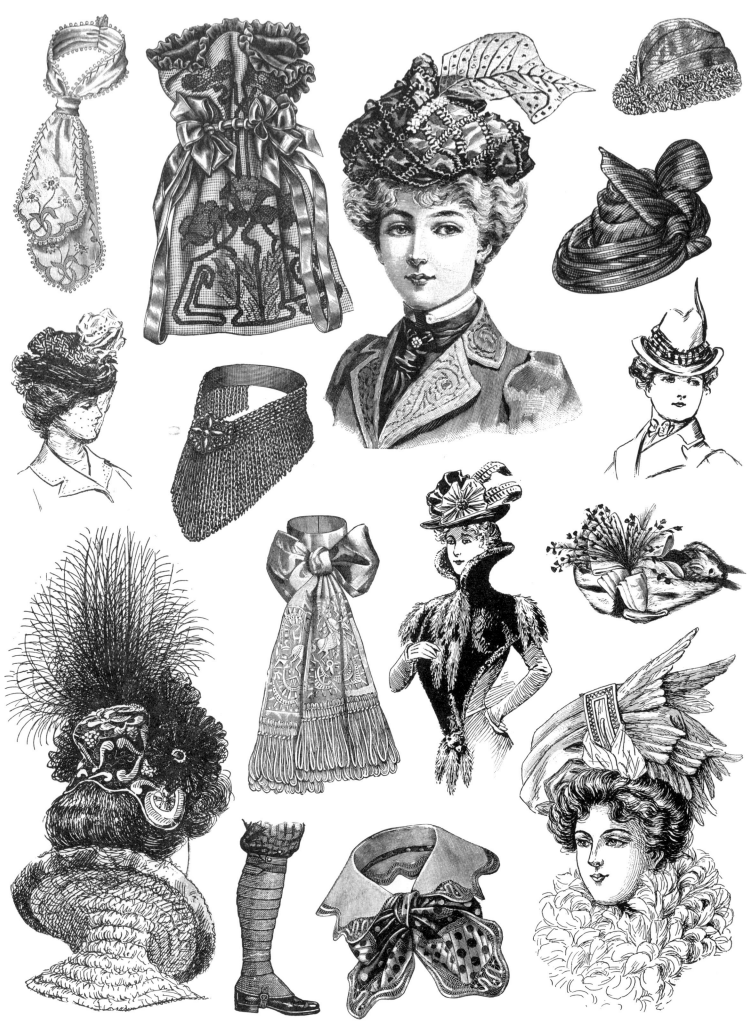

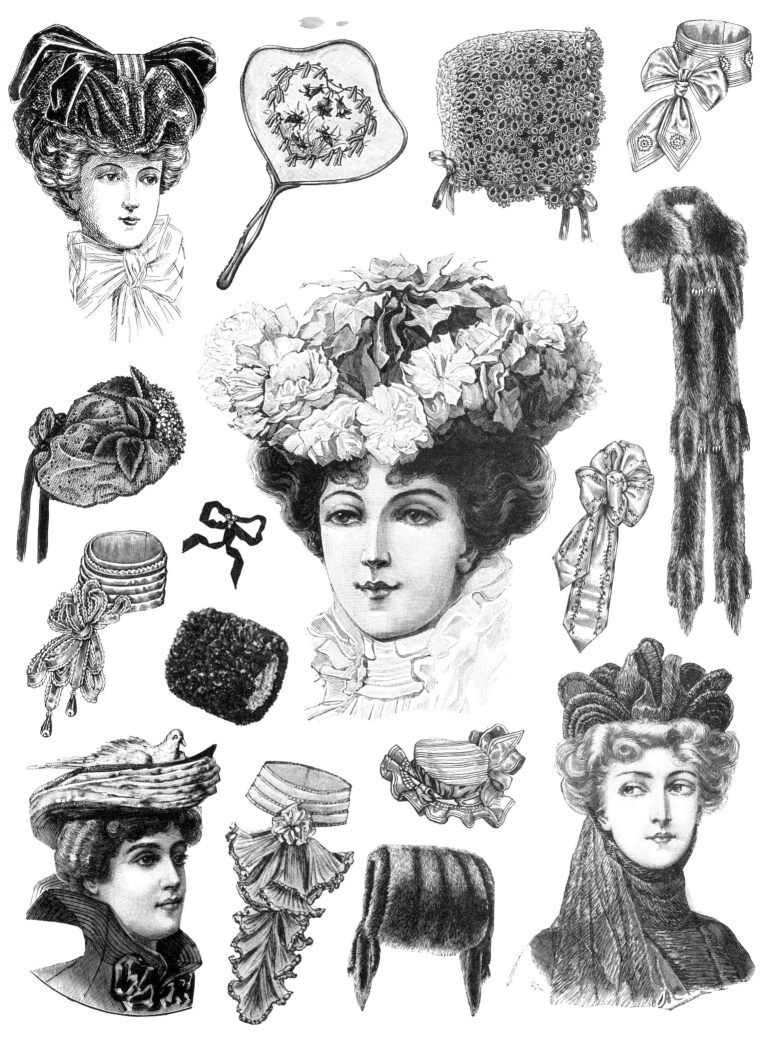

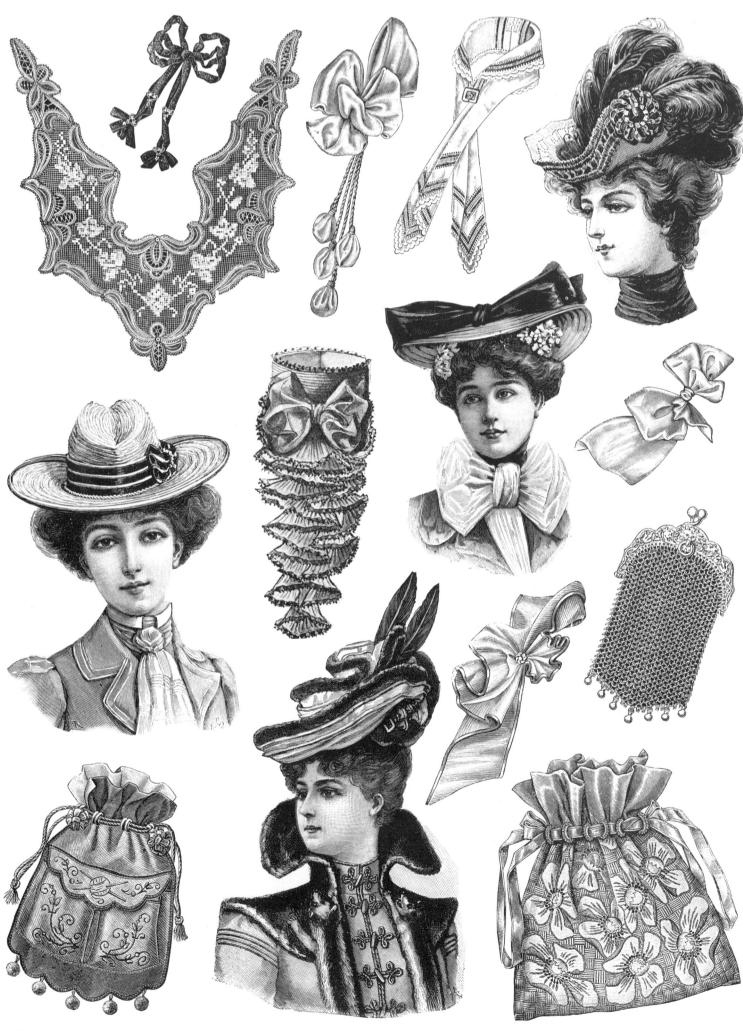

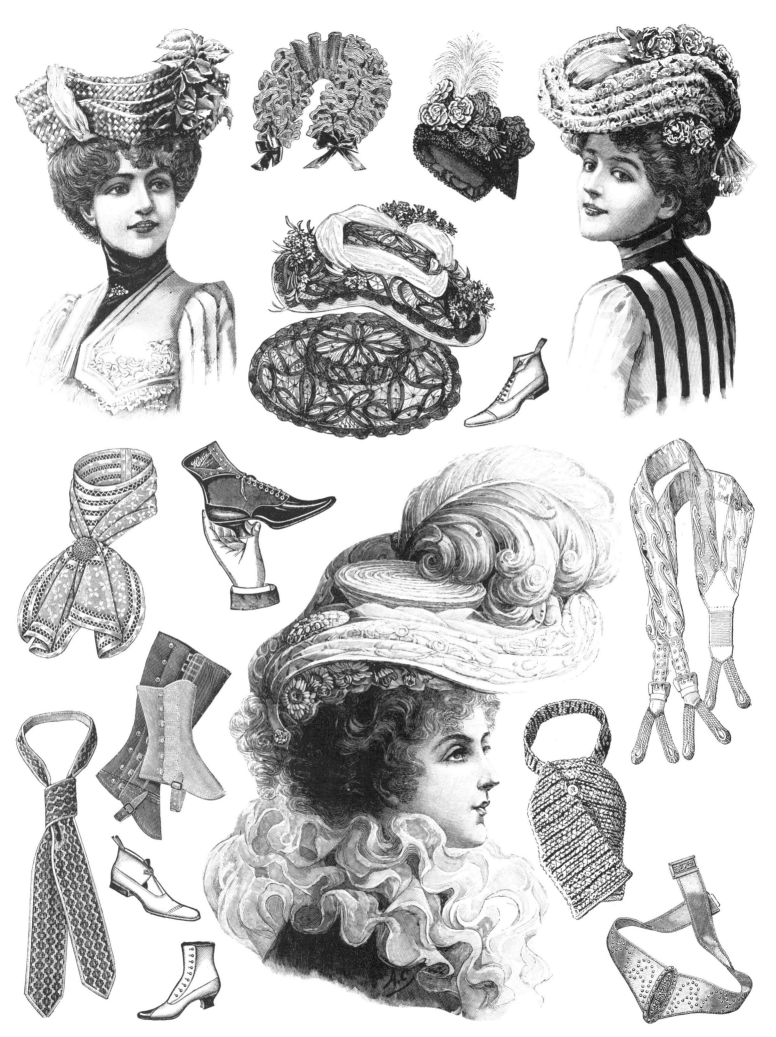

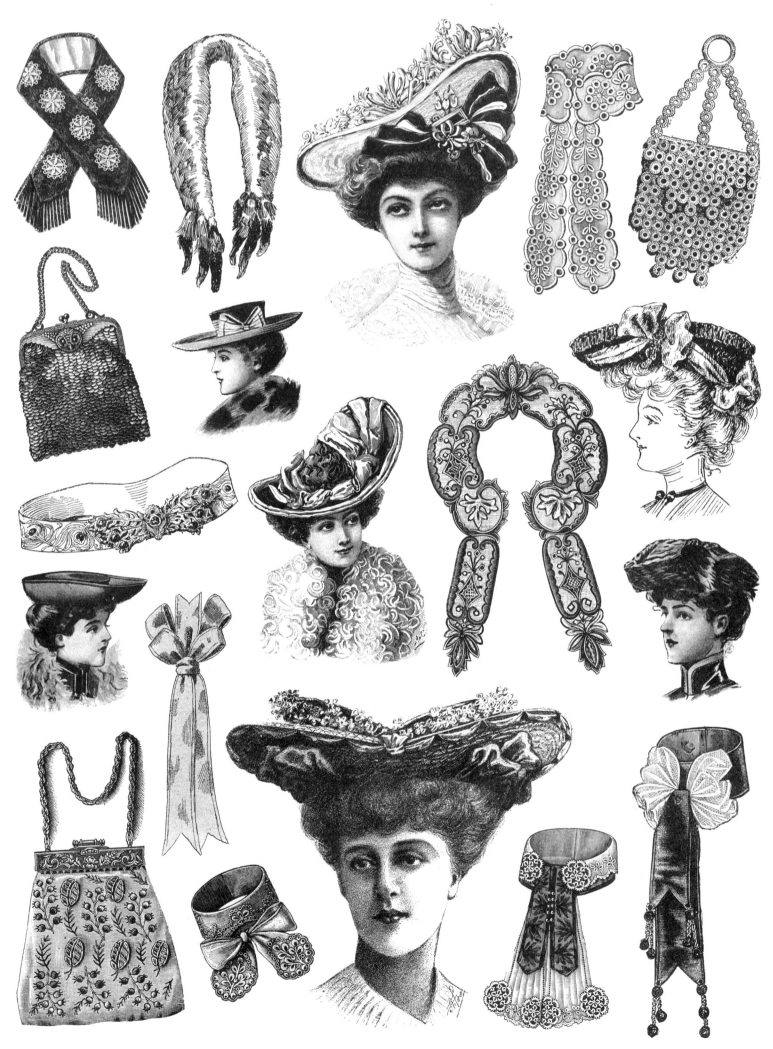

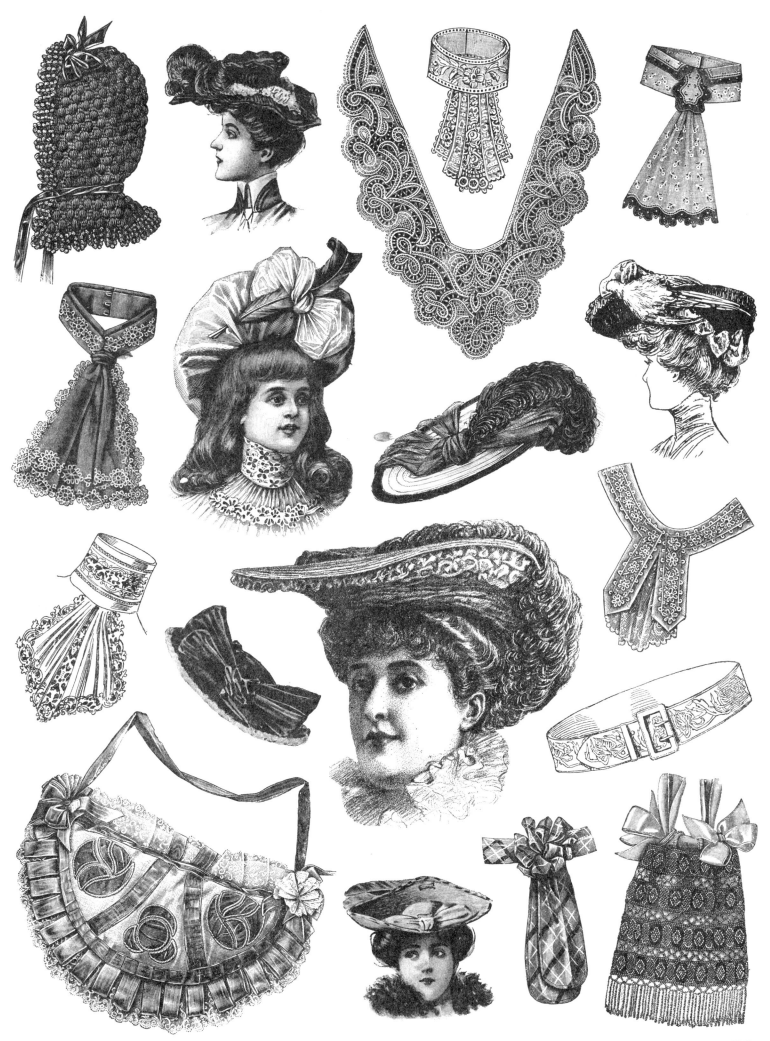

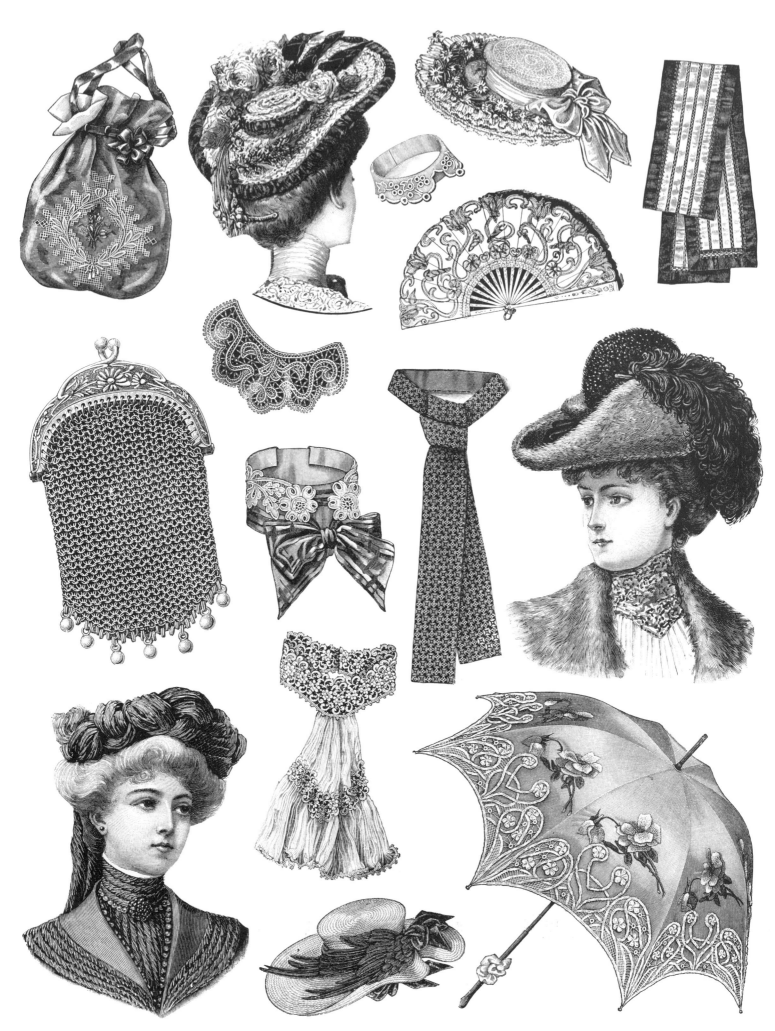

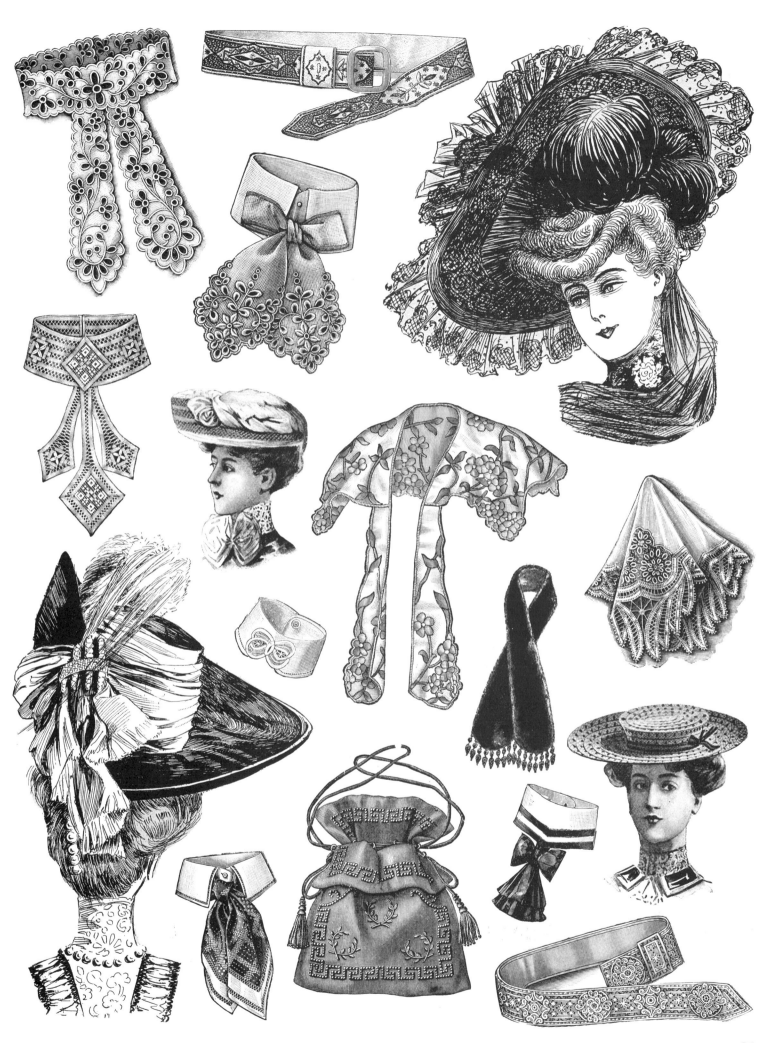

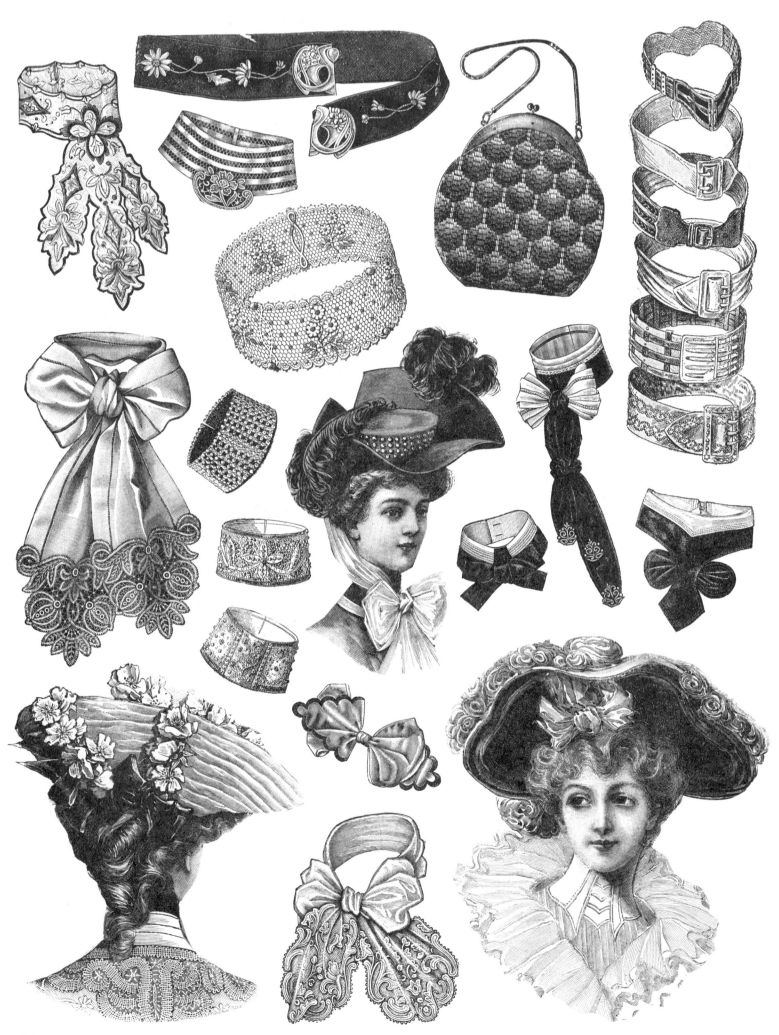

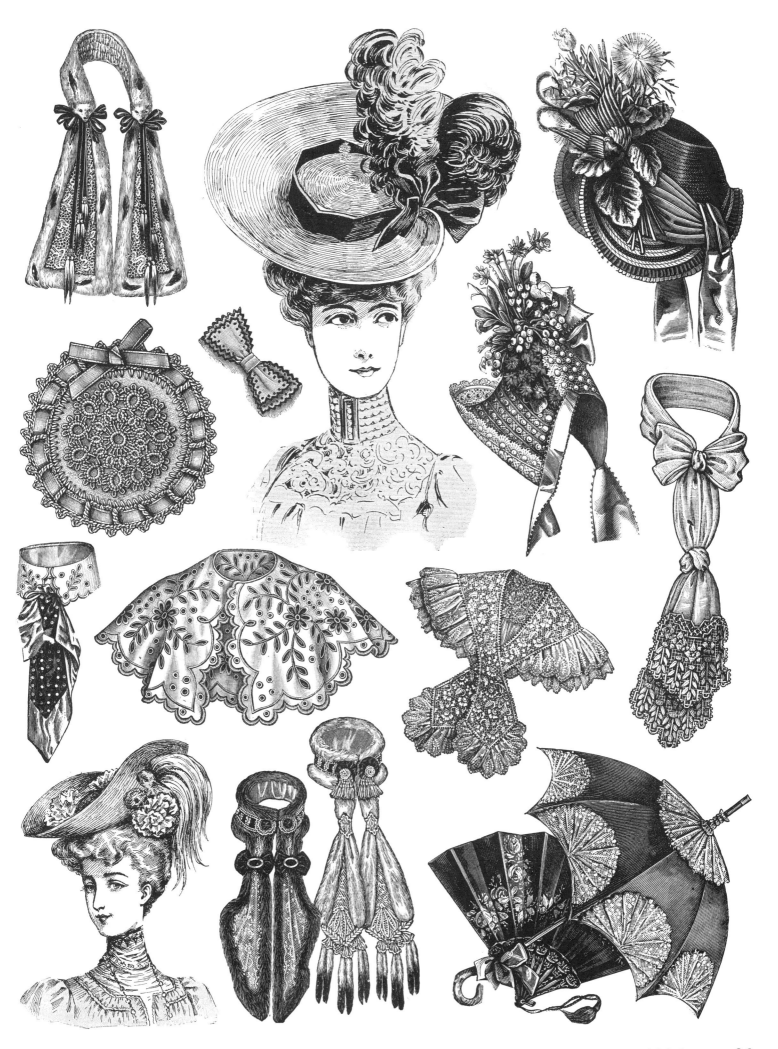

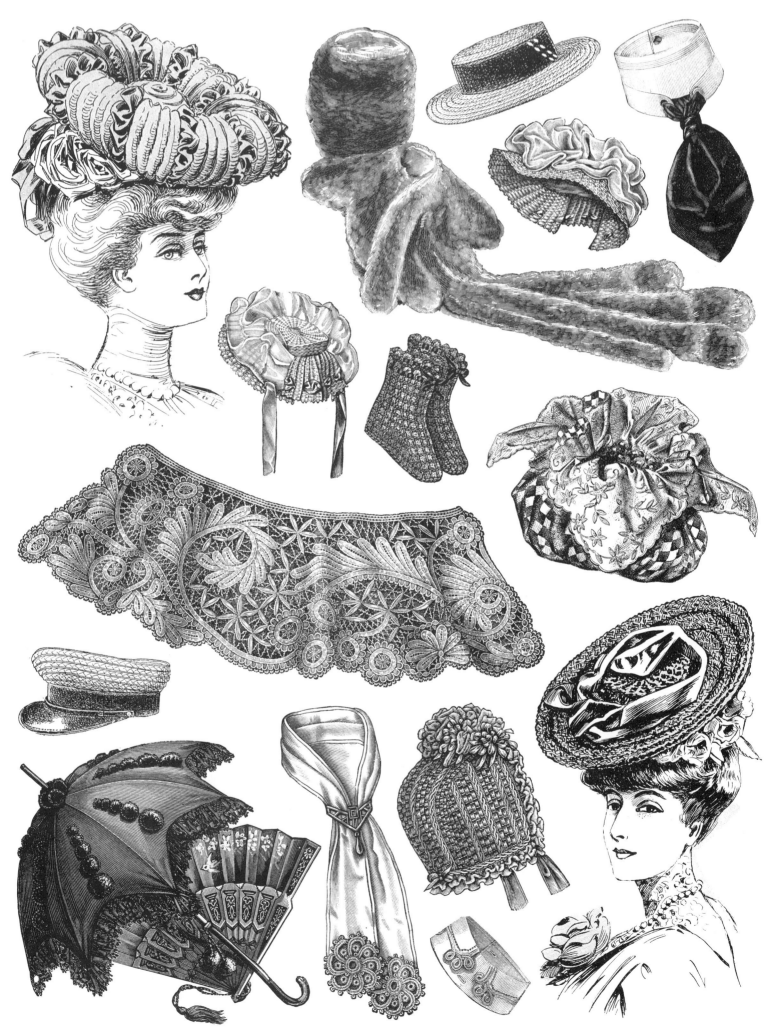

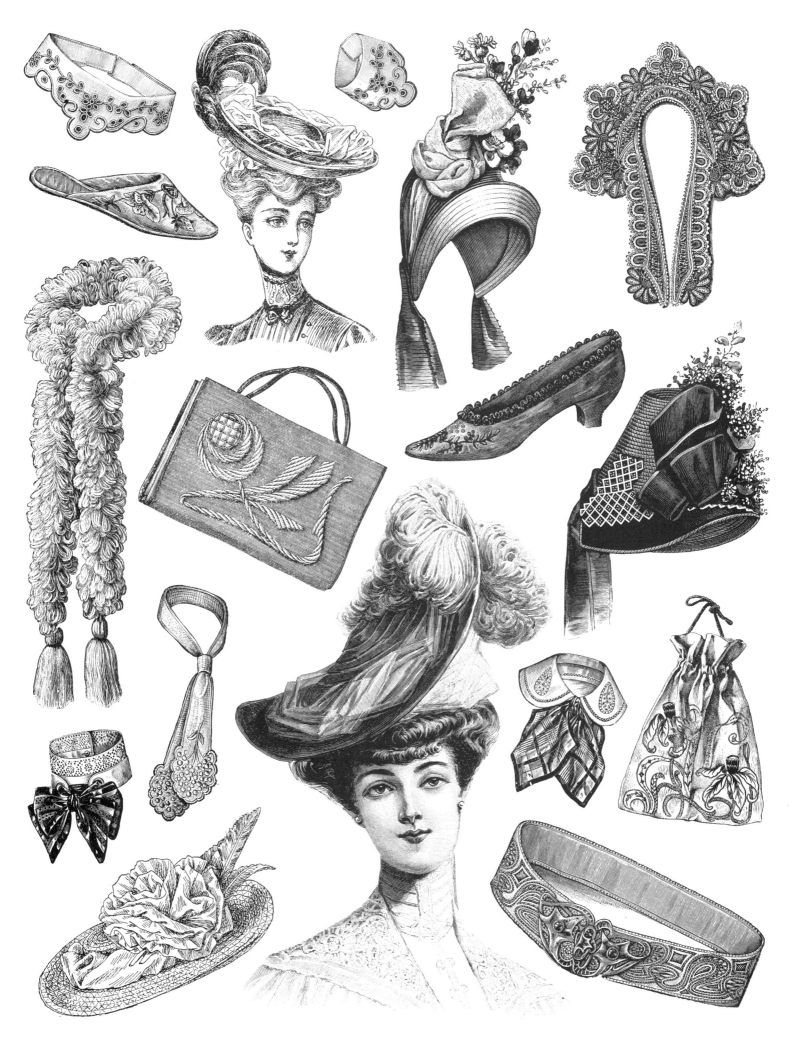

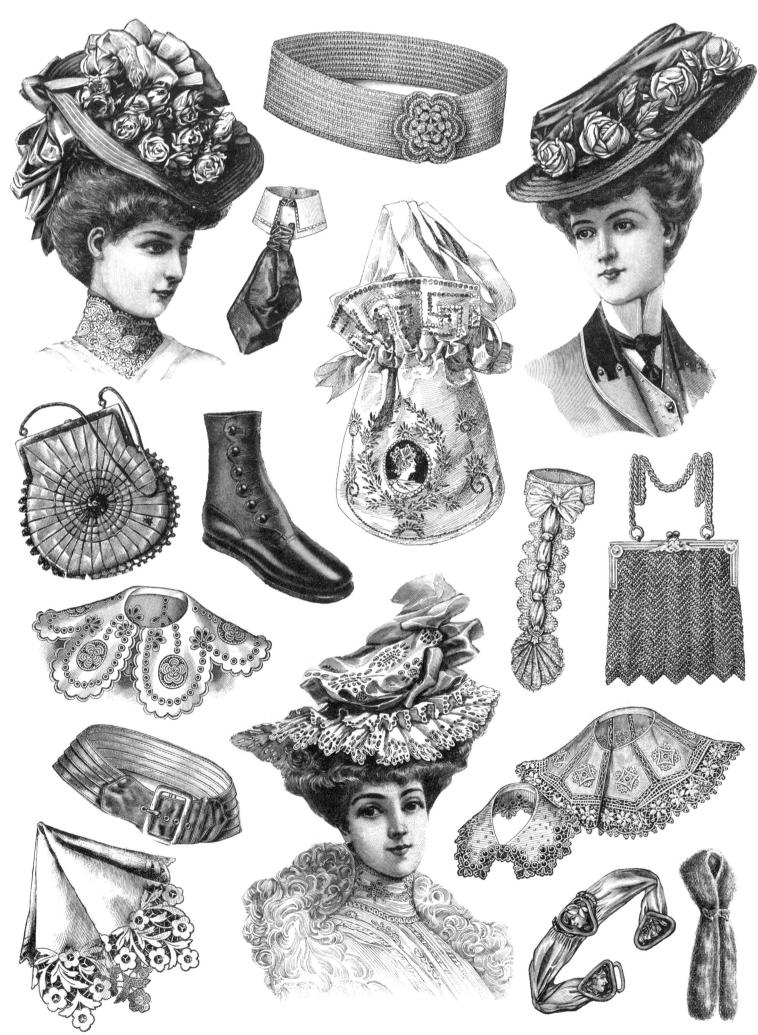

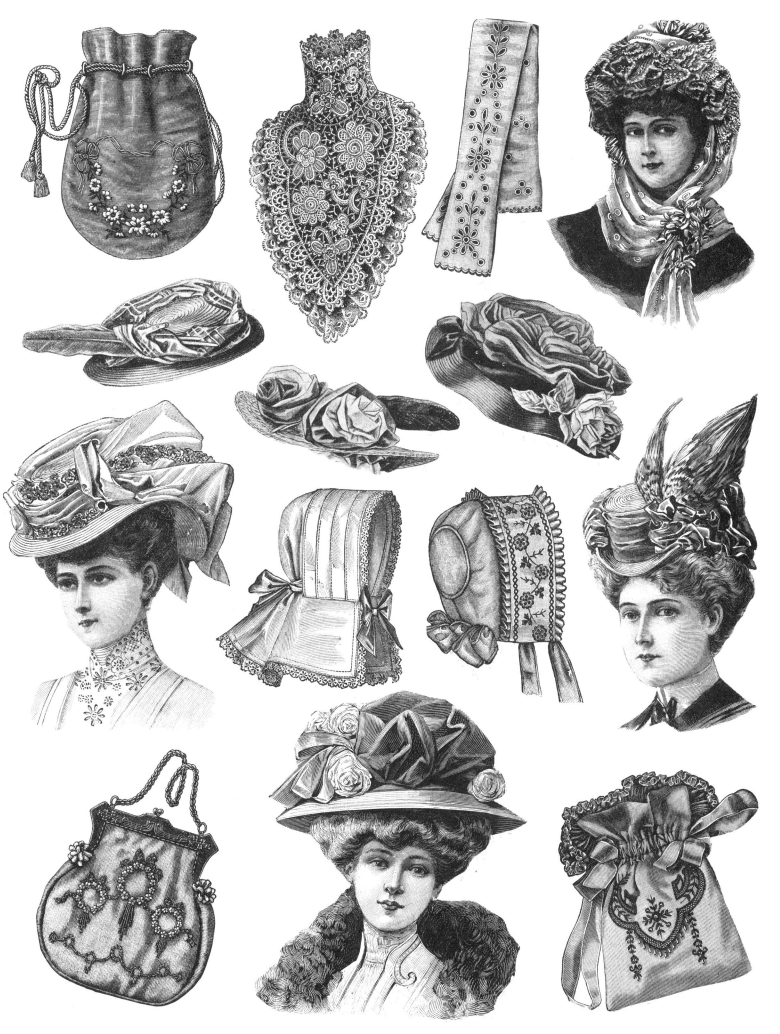

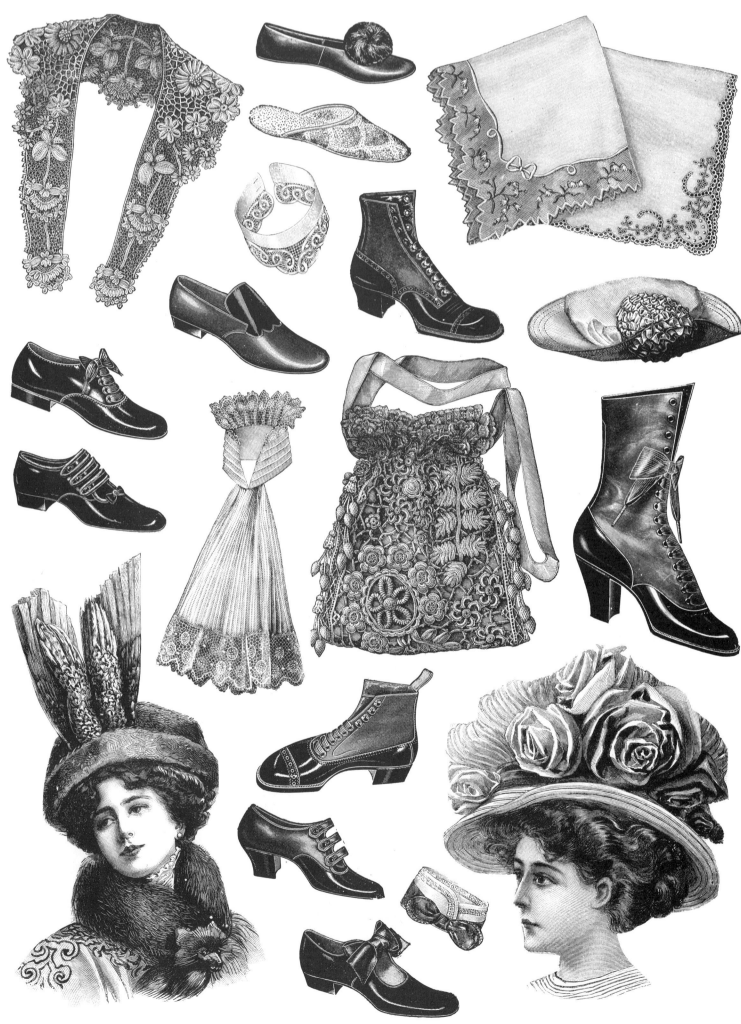

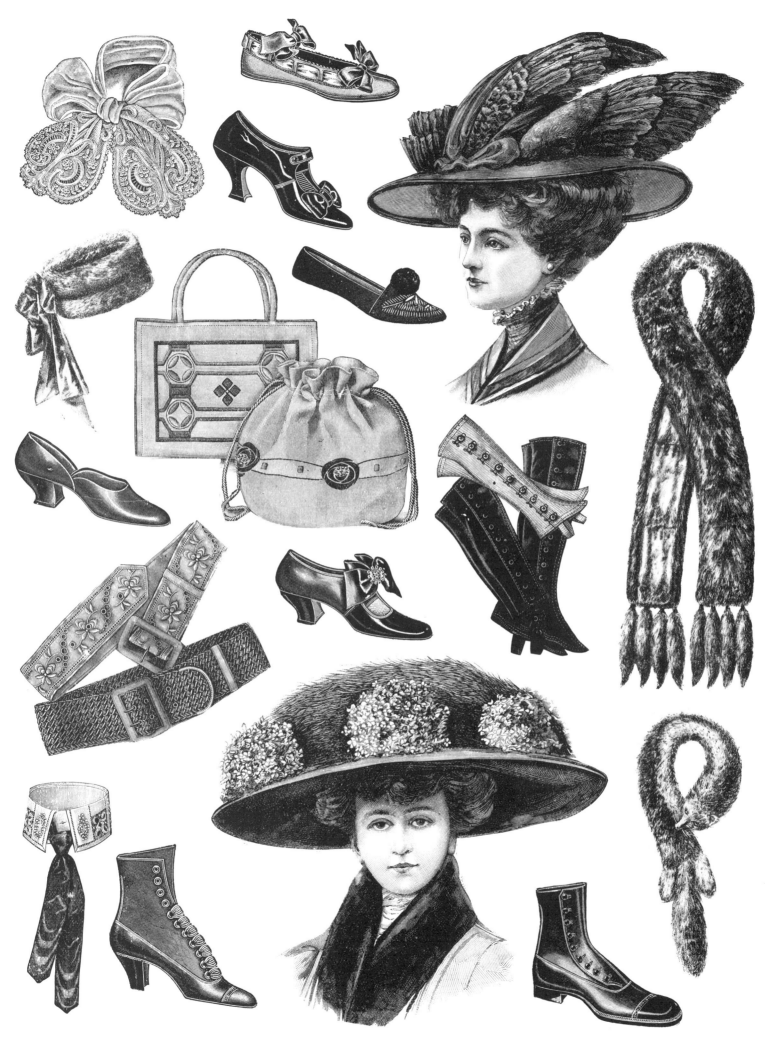

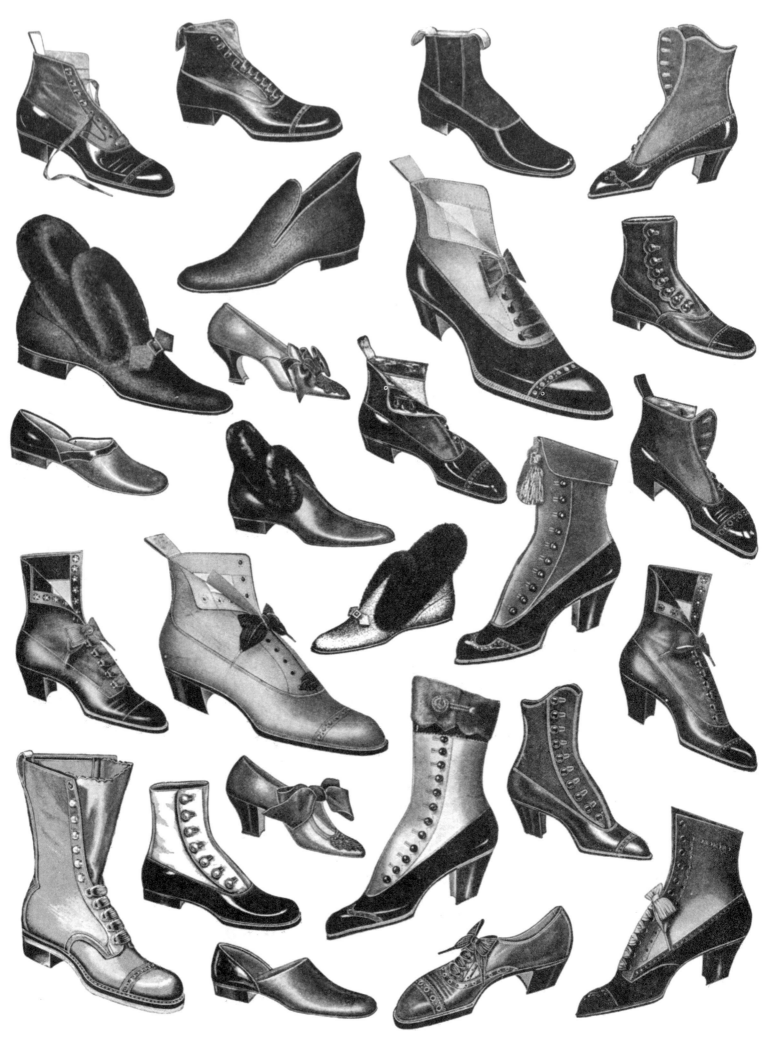

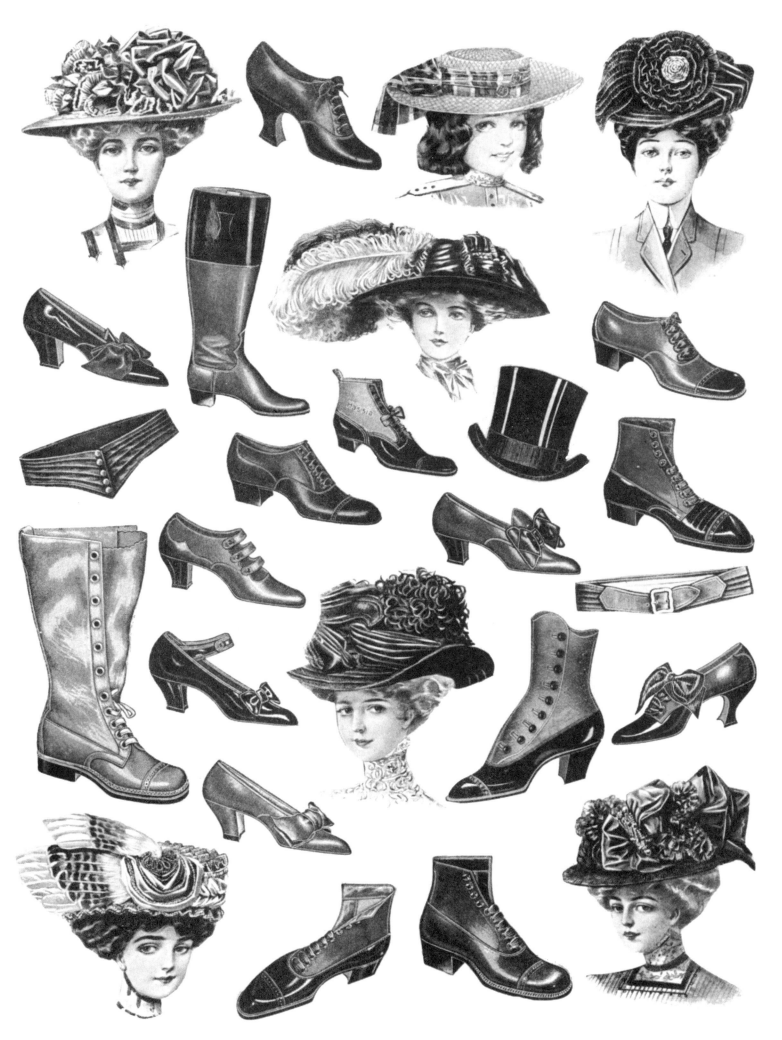

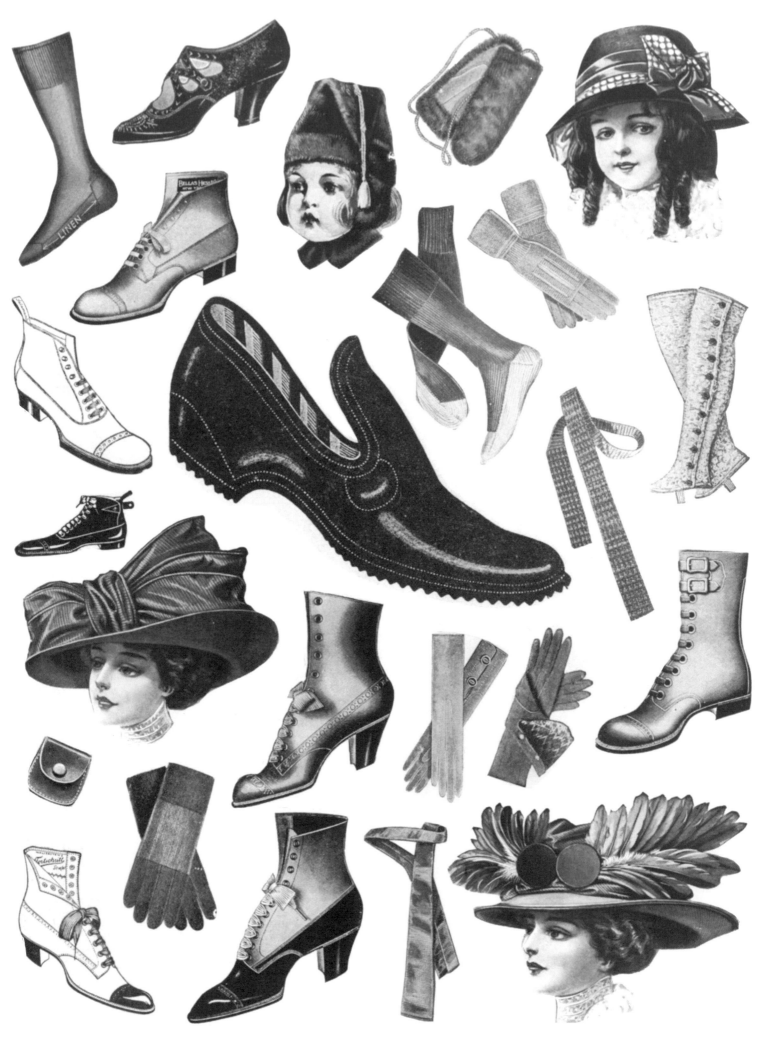

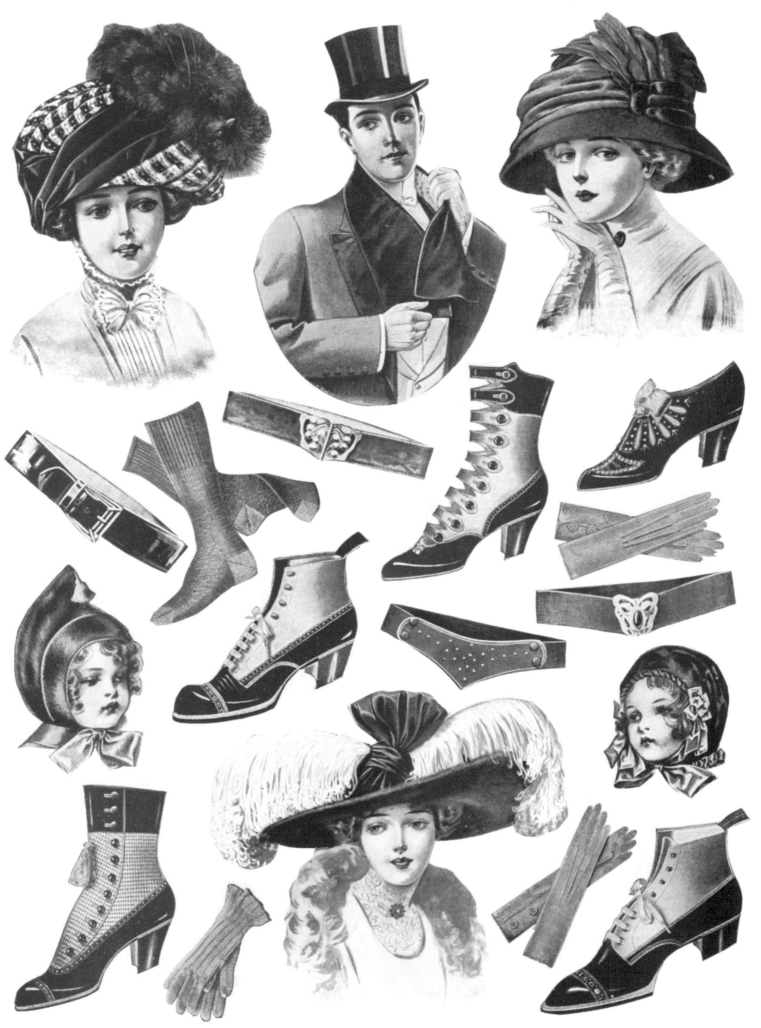

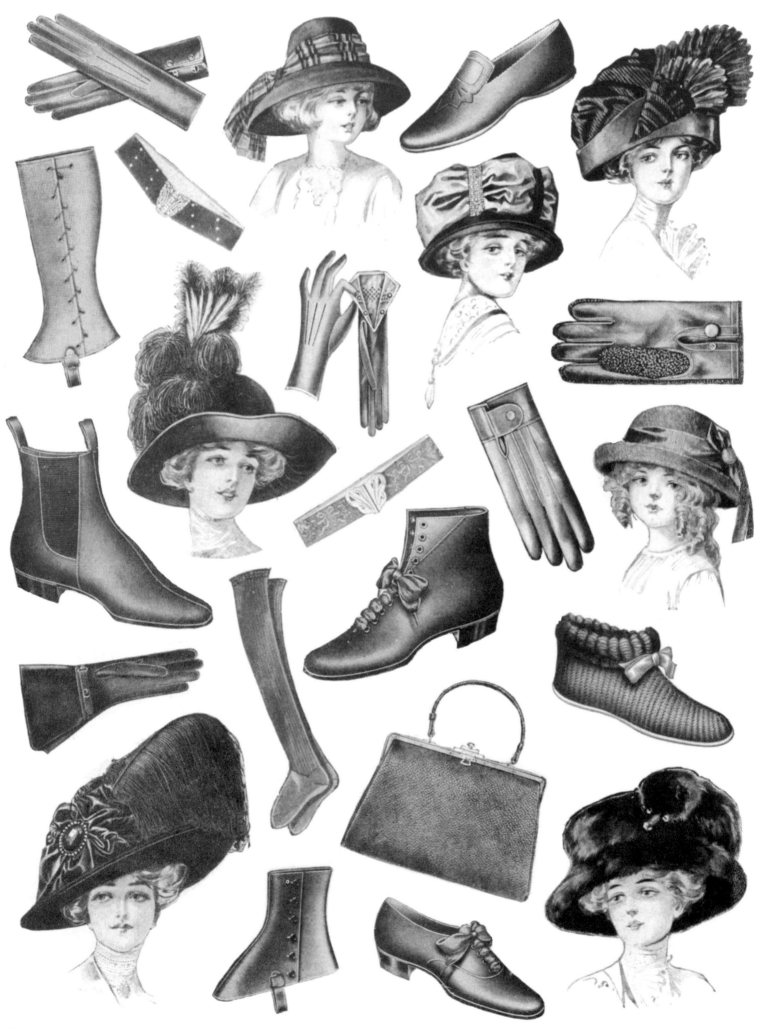

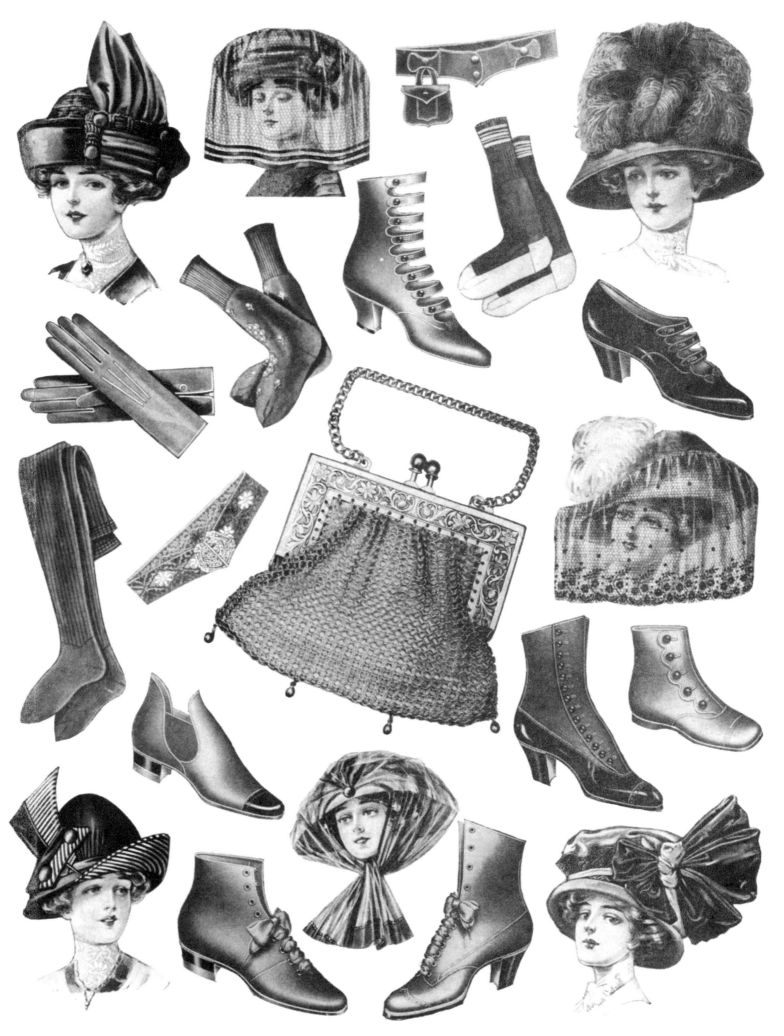

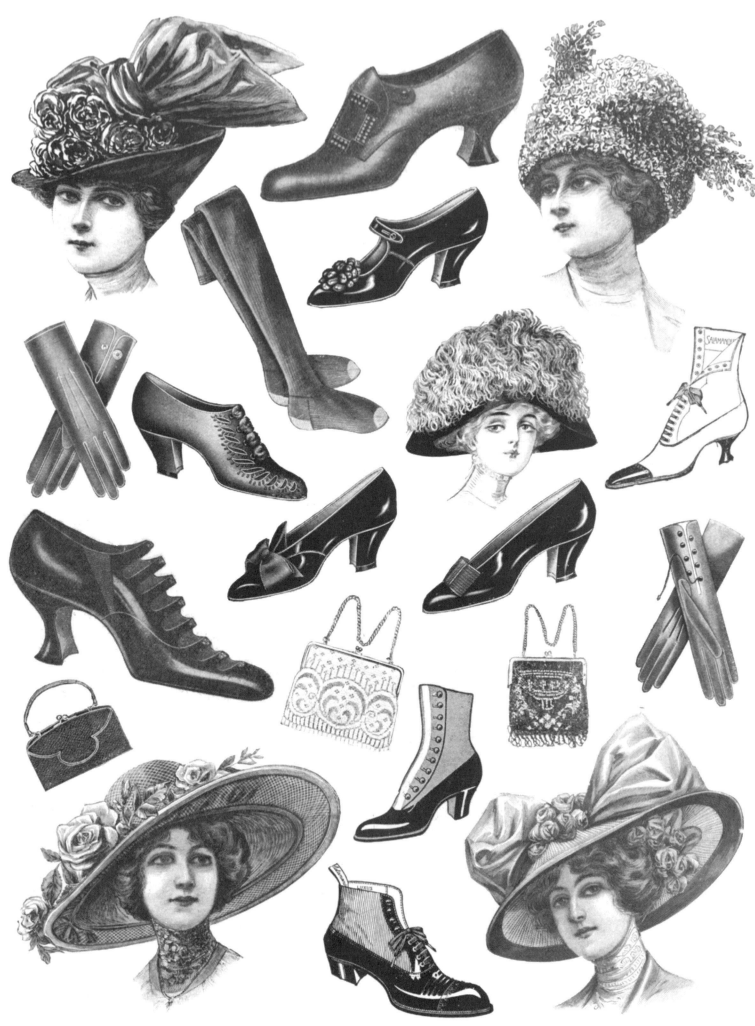

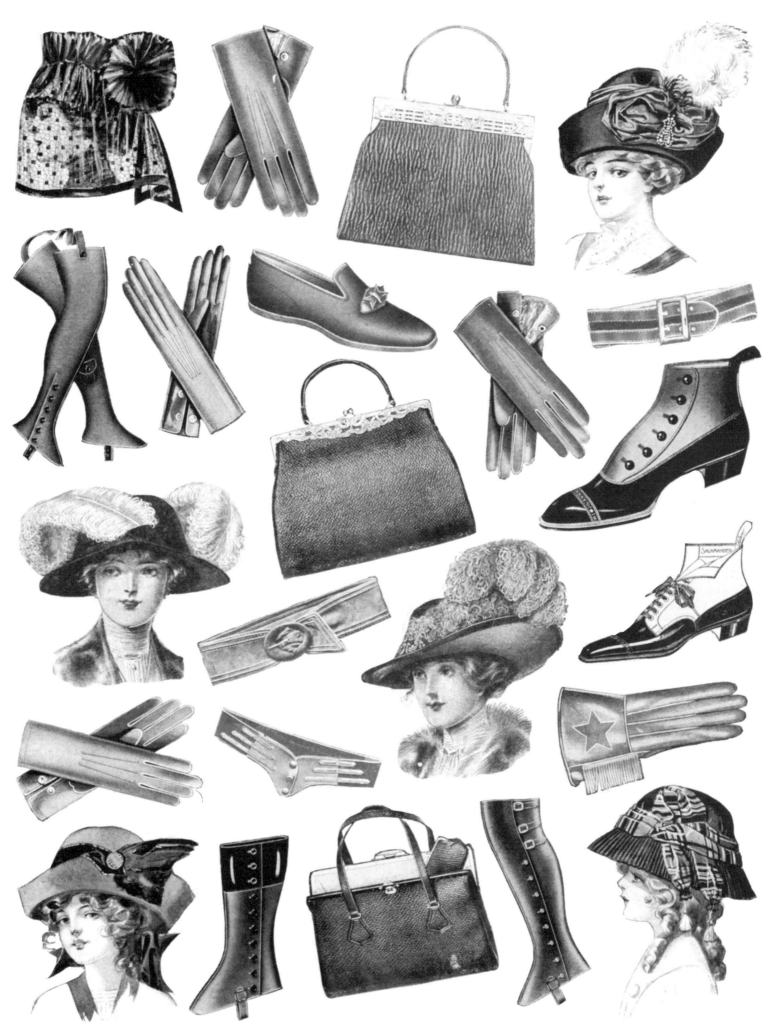

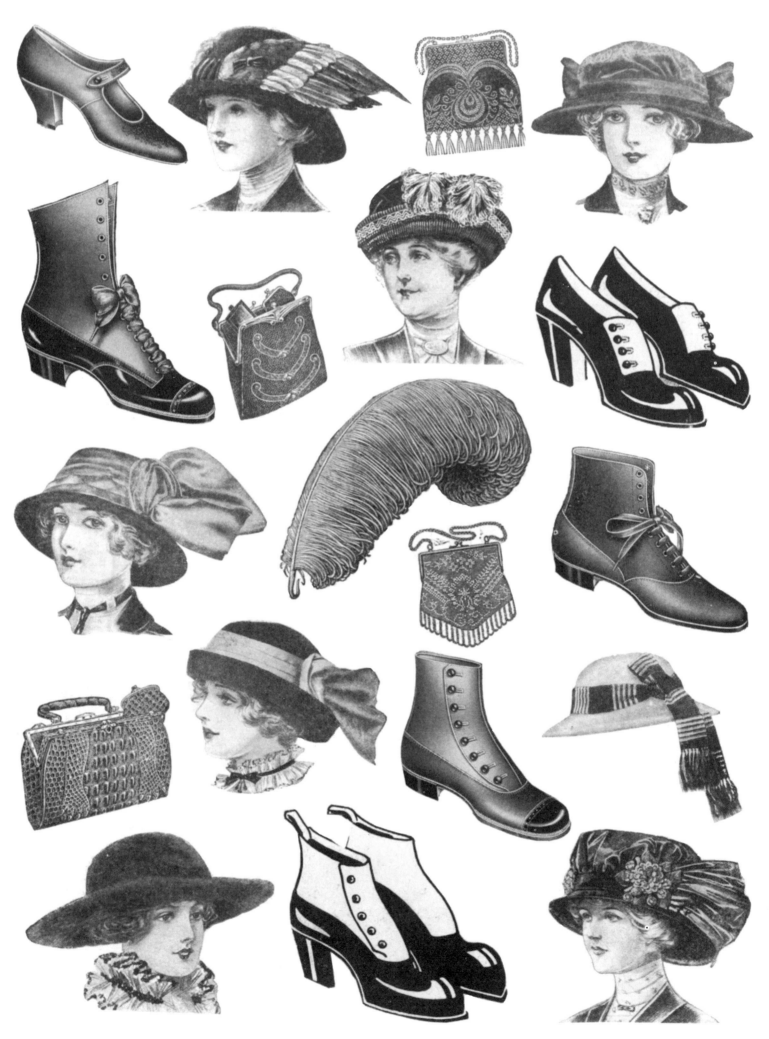

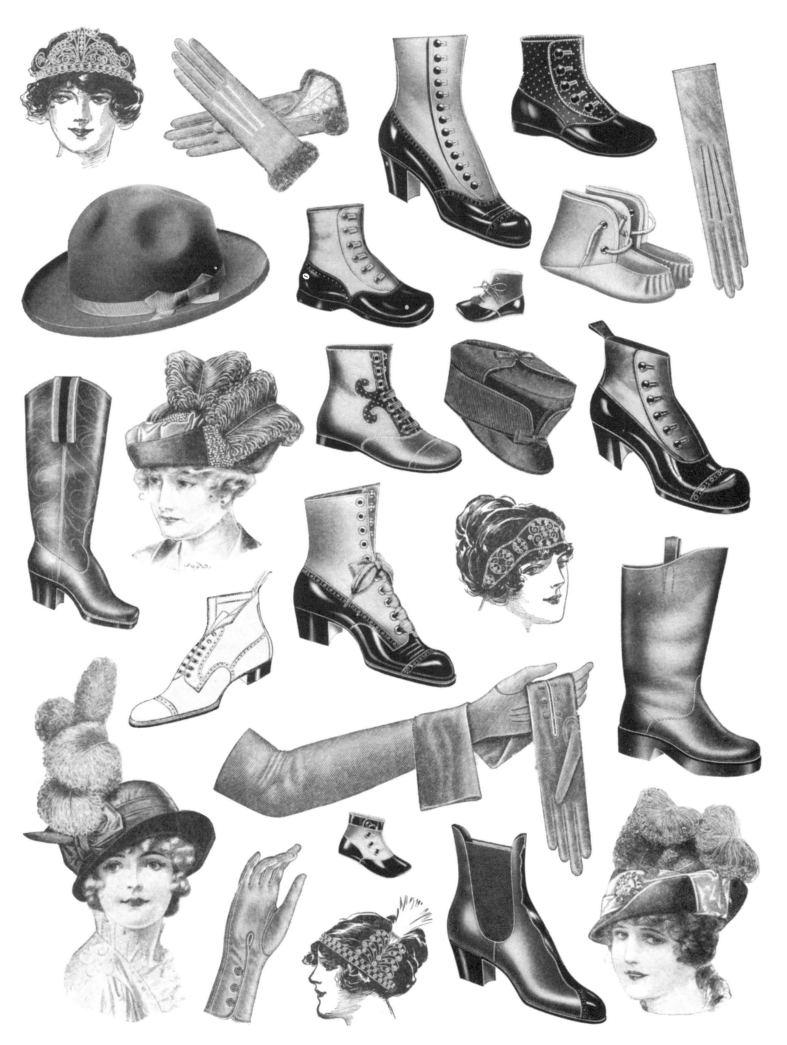

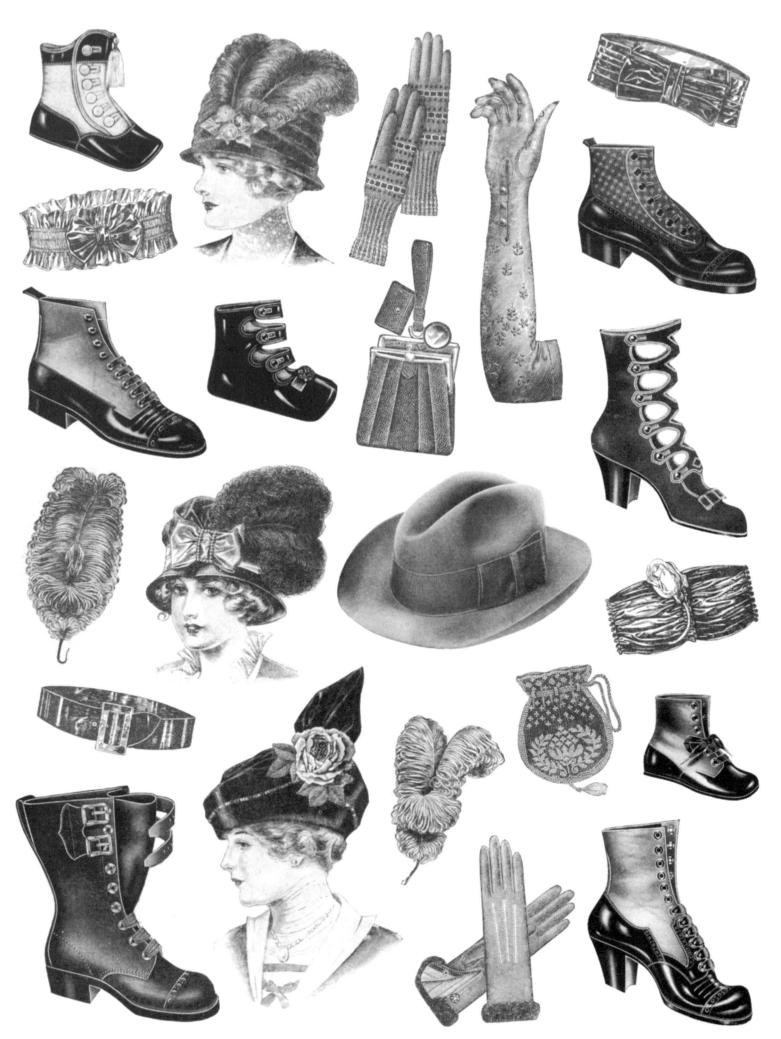

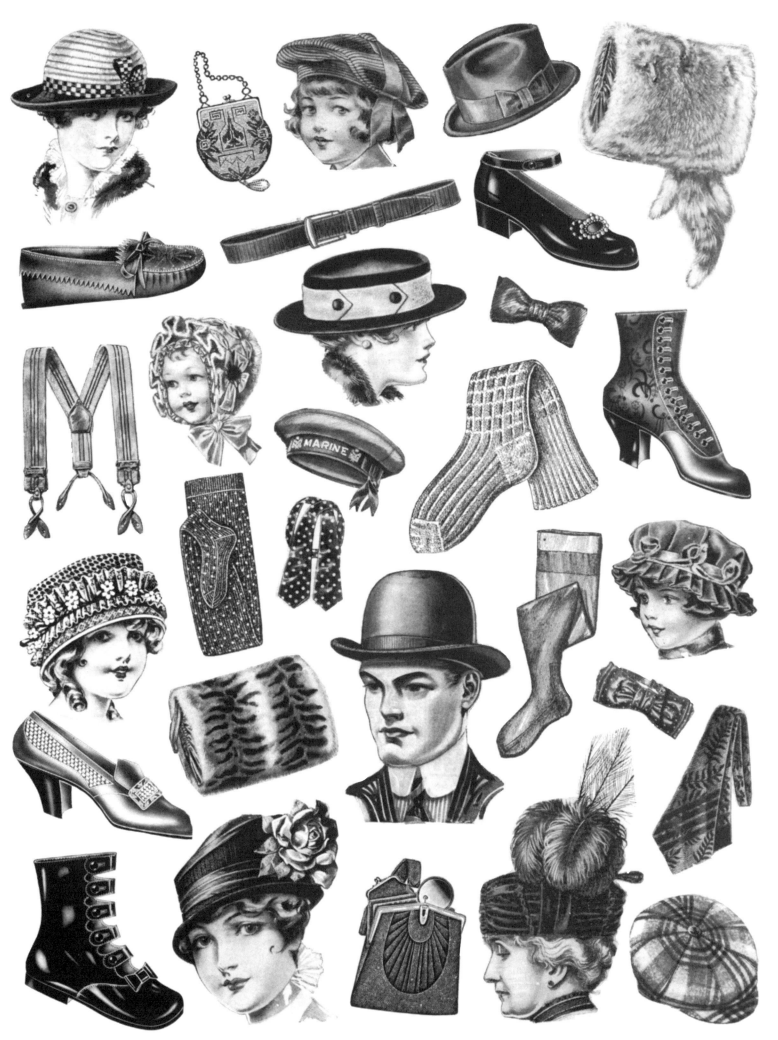

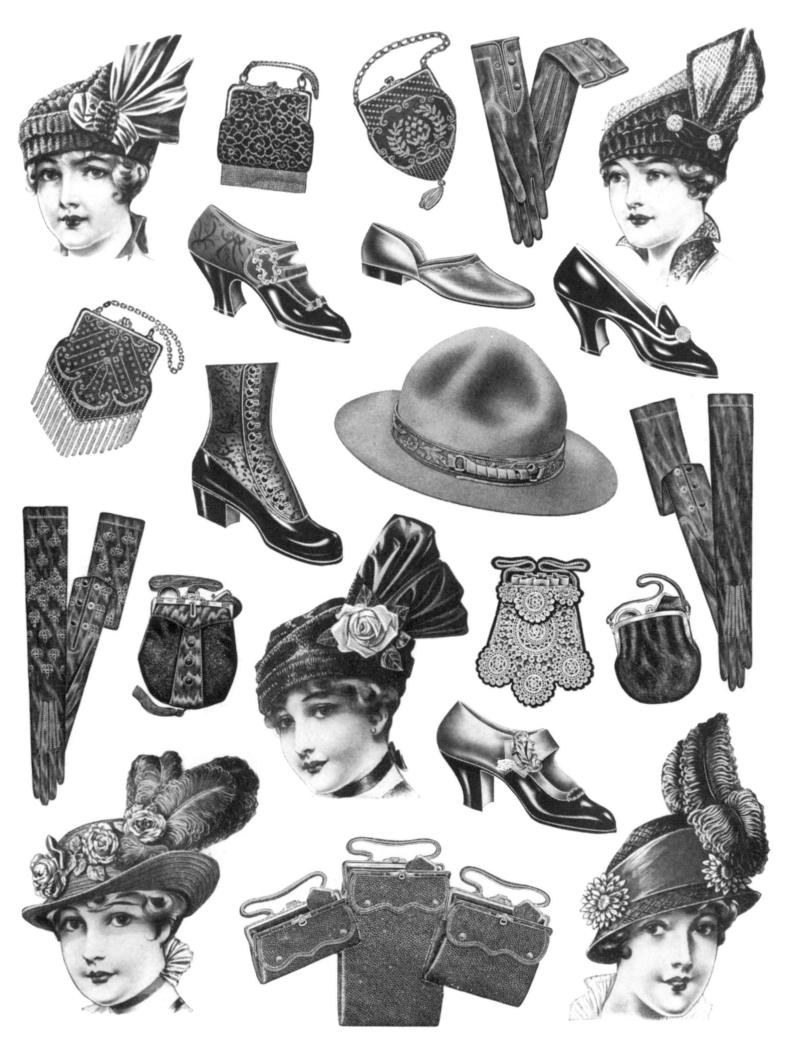

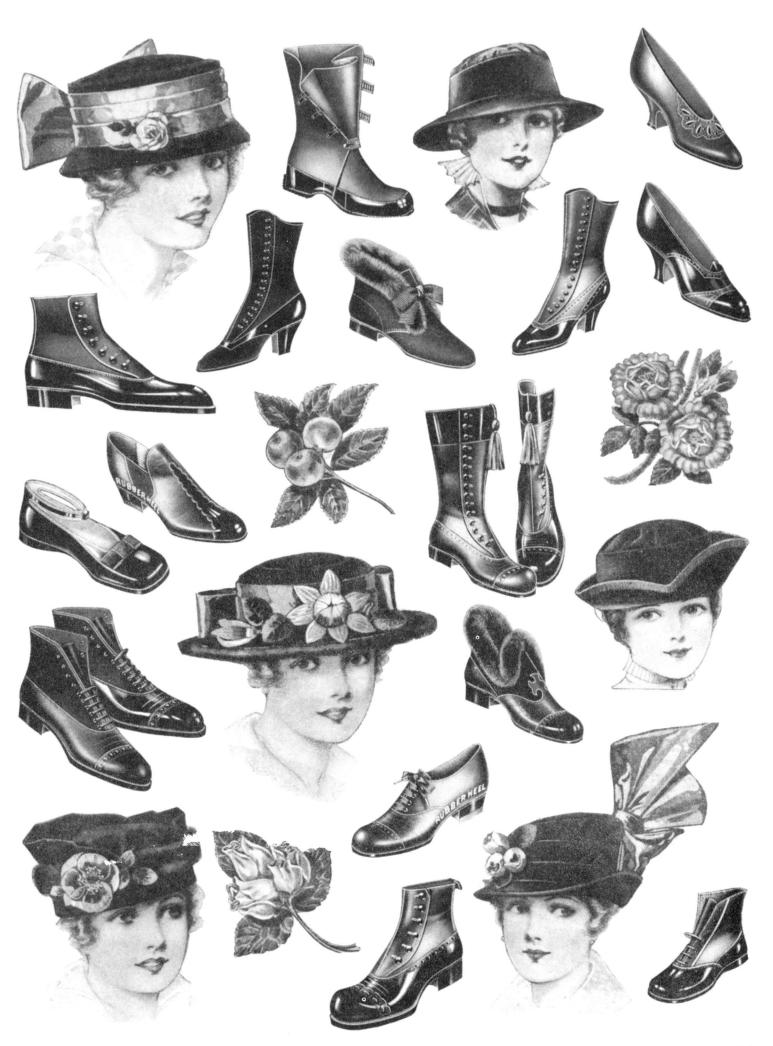

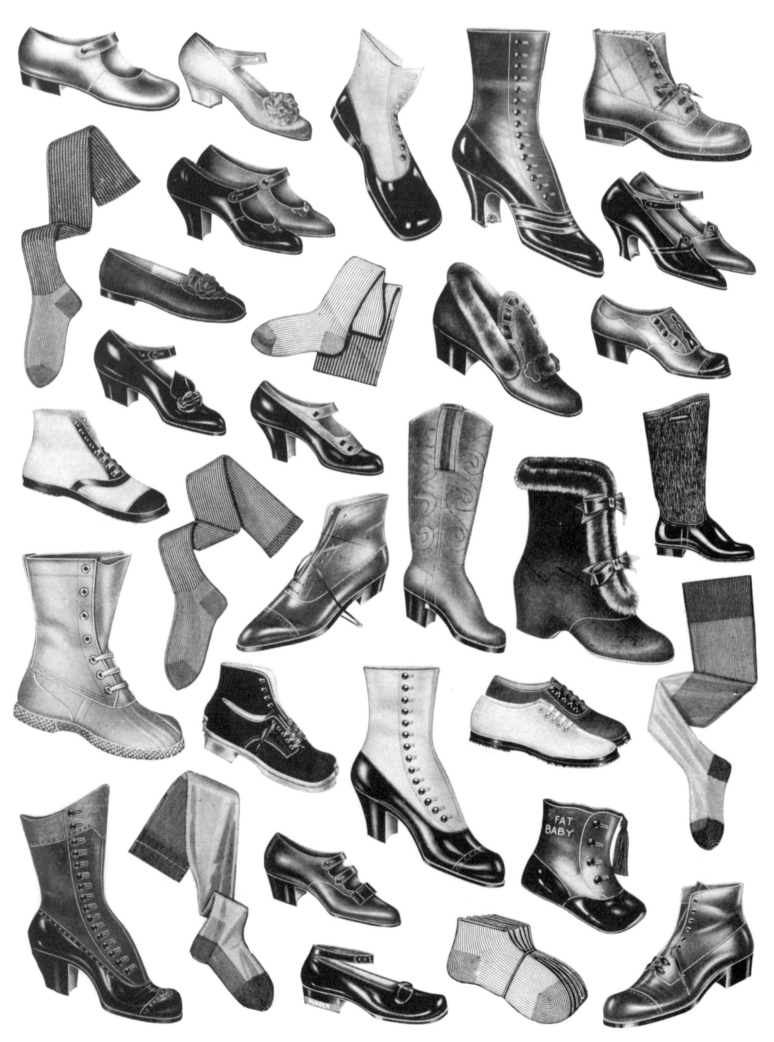

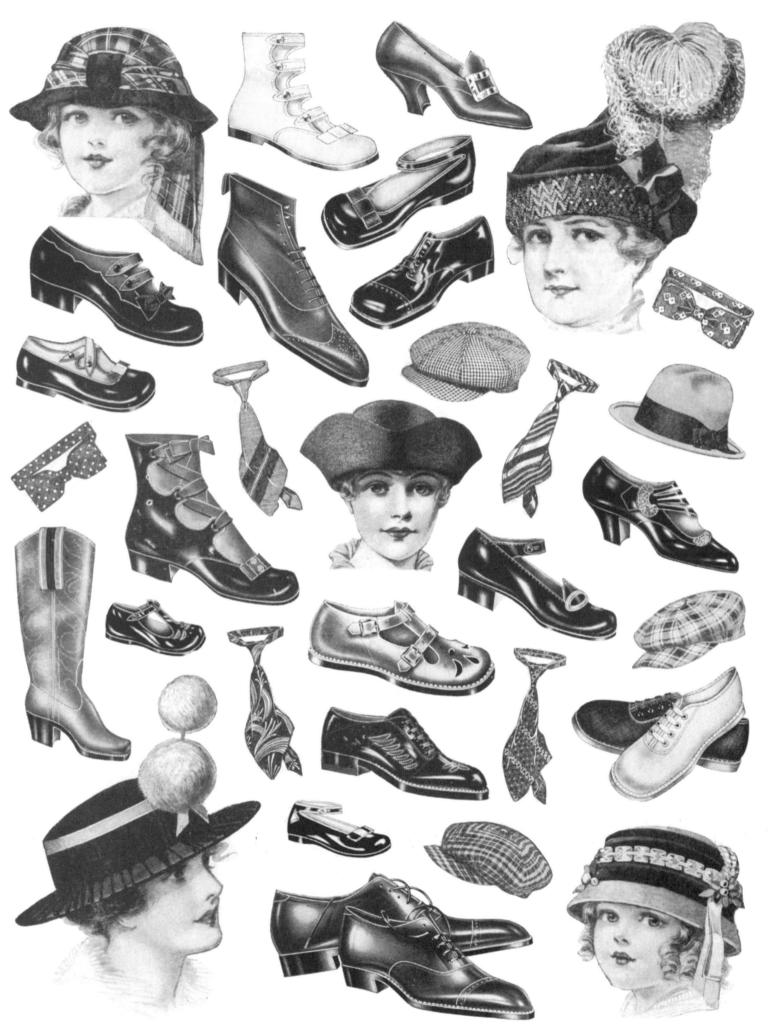

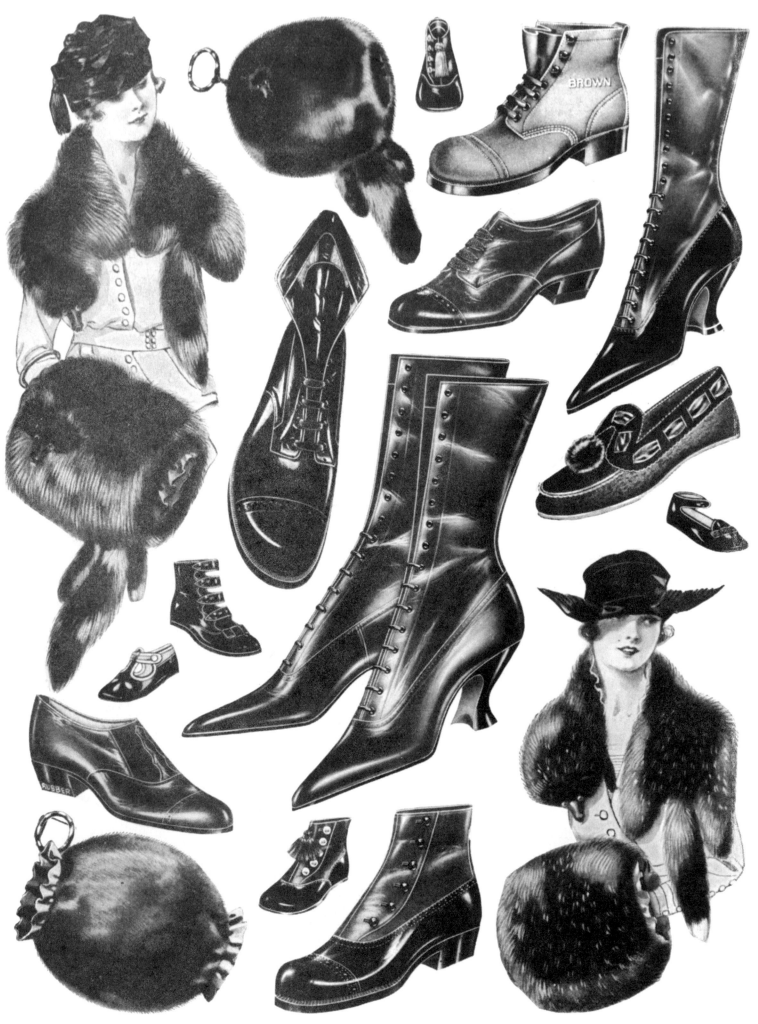

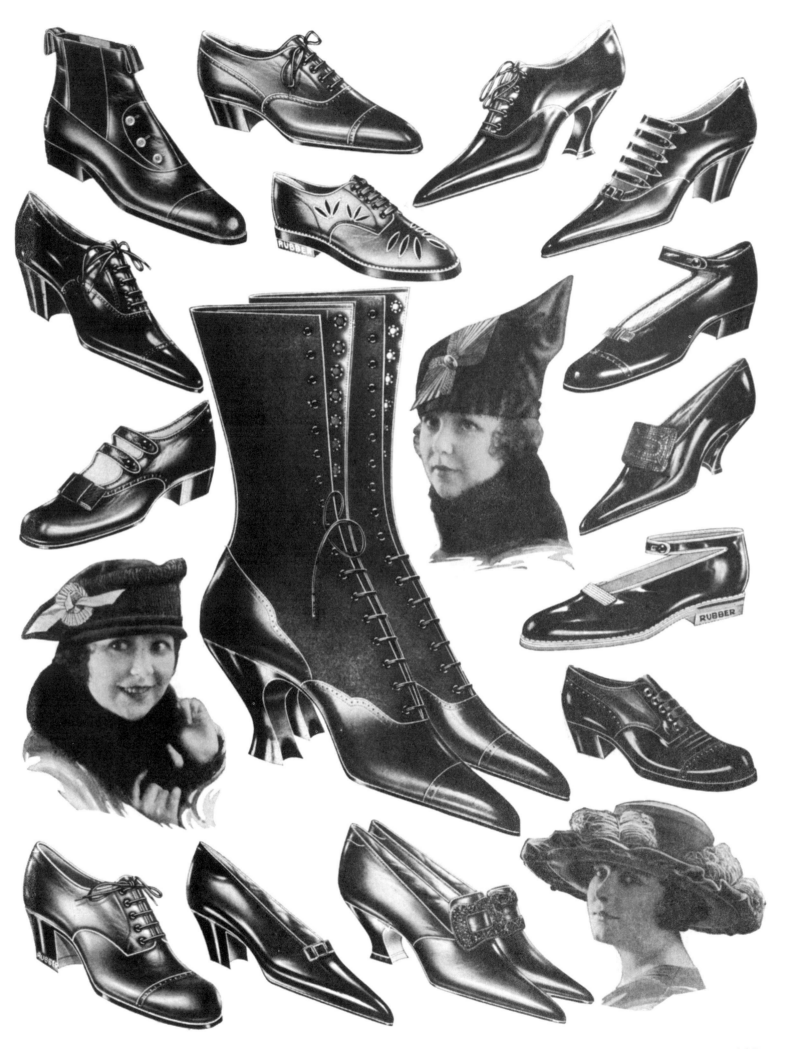

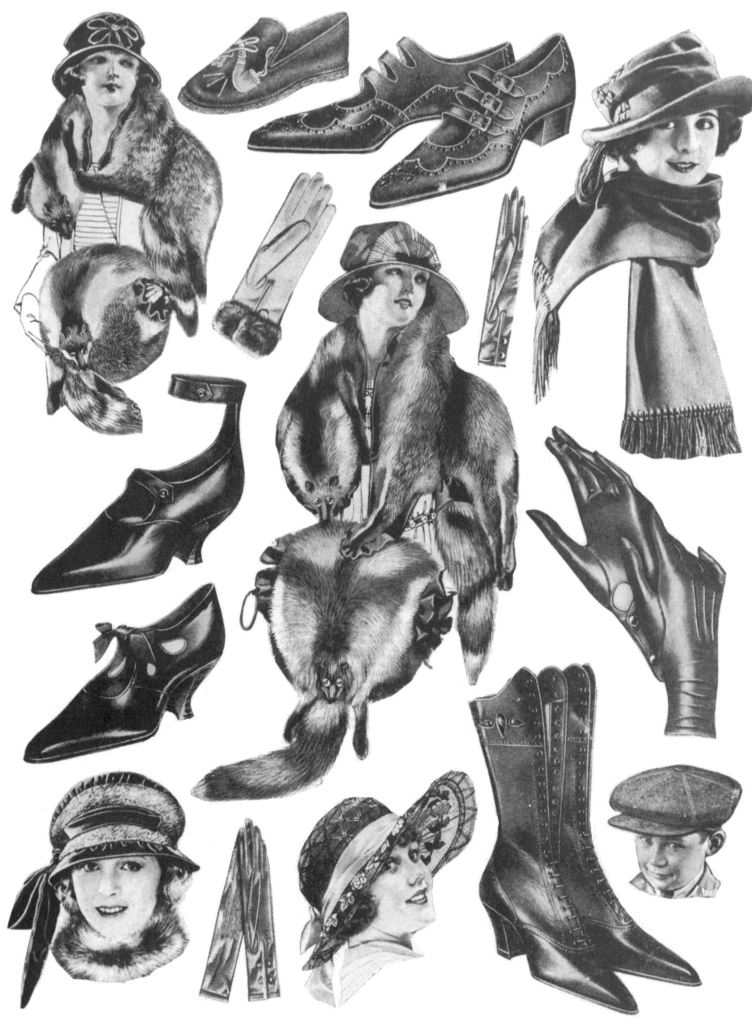

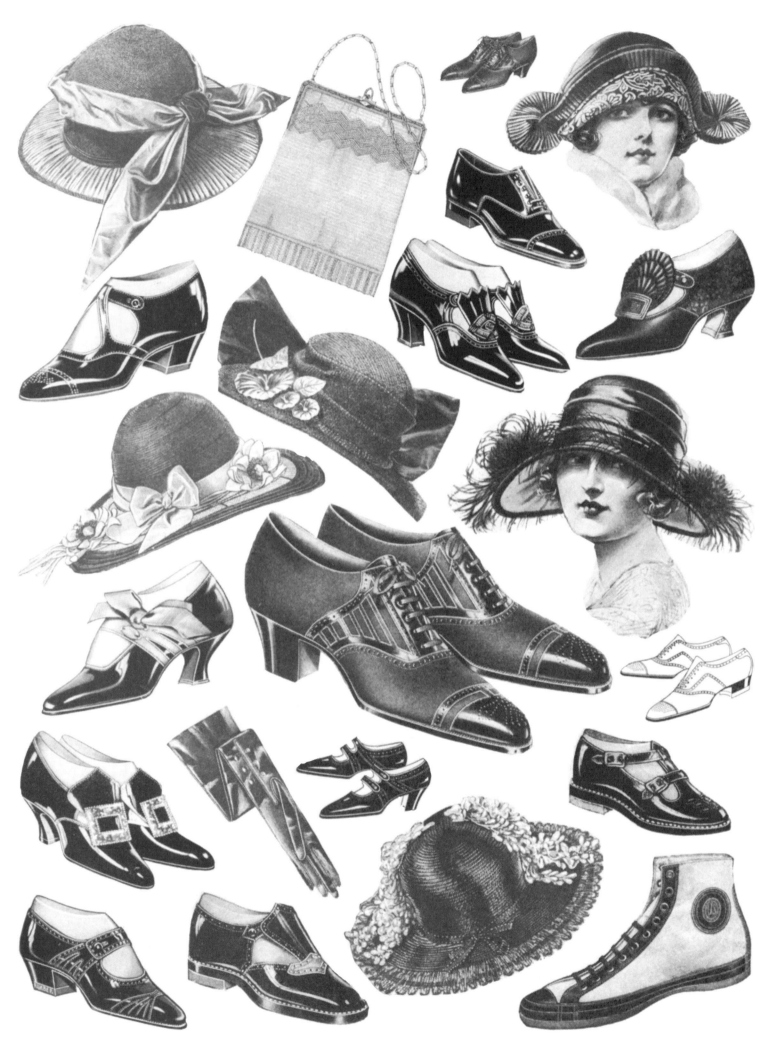

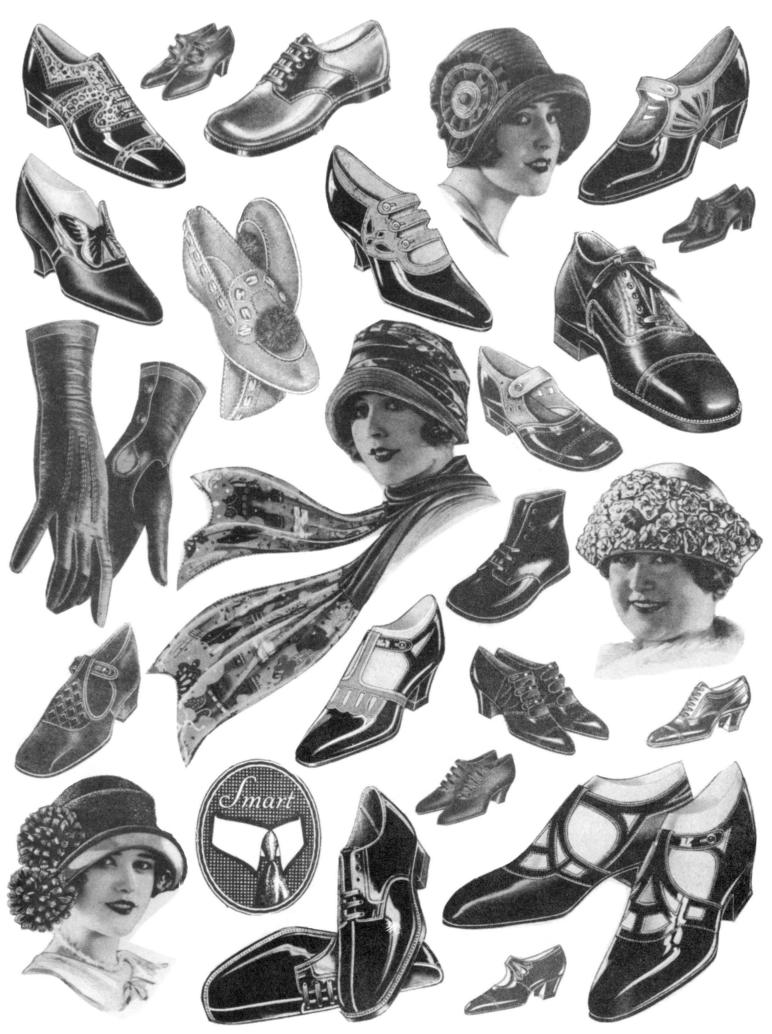

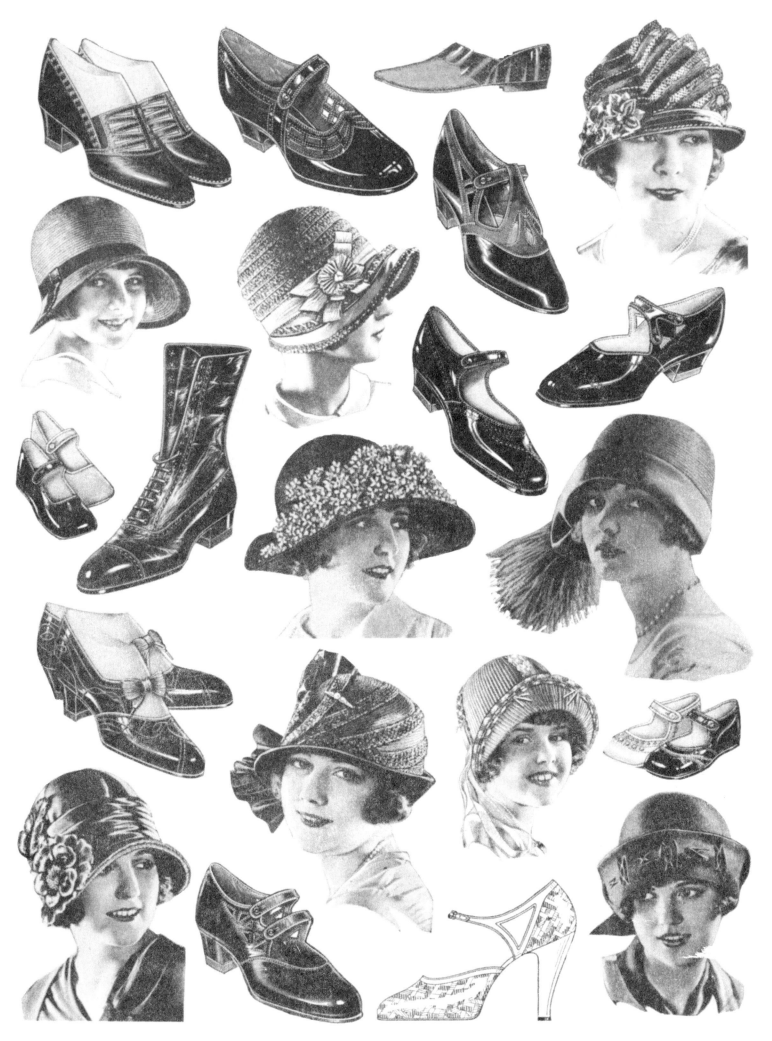

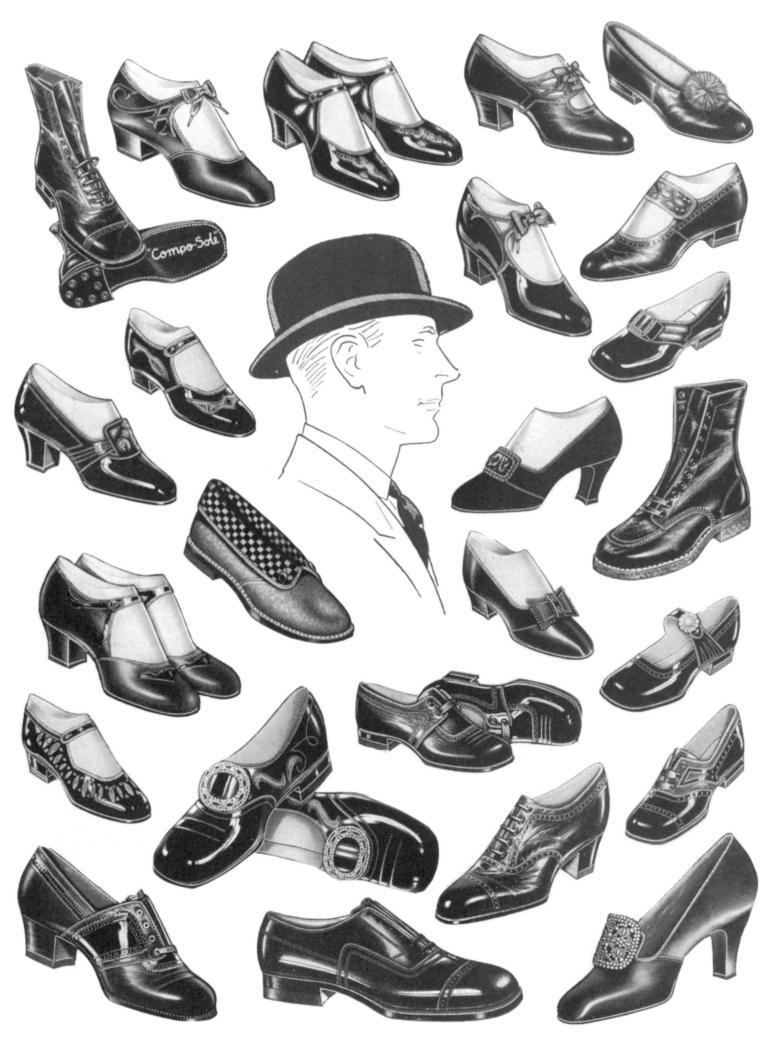

"Compo-Sole"

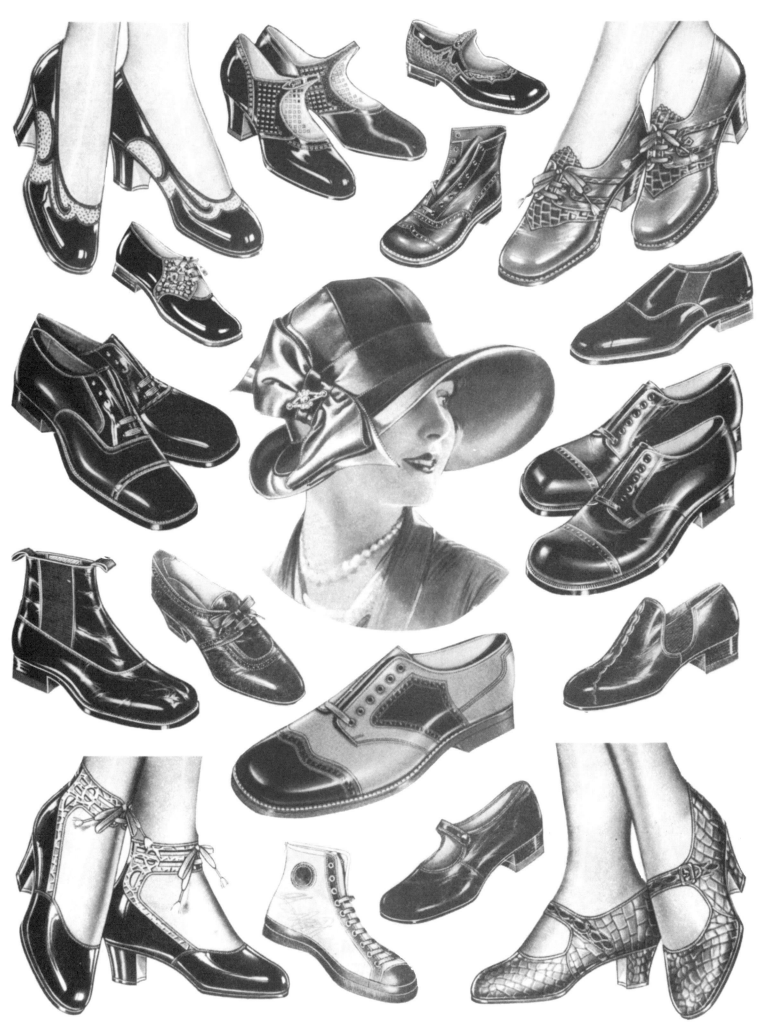

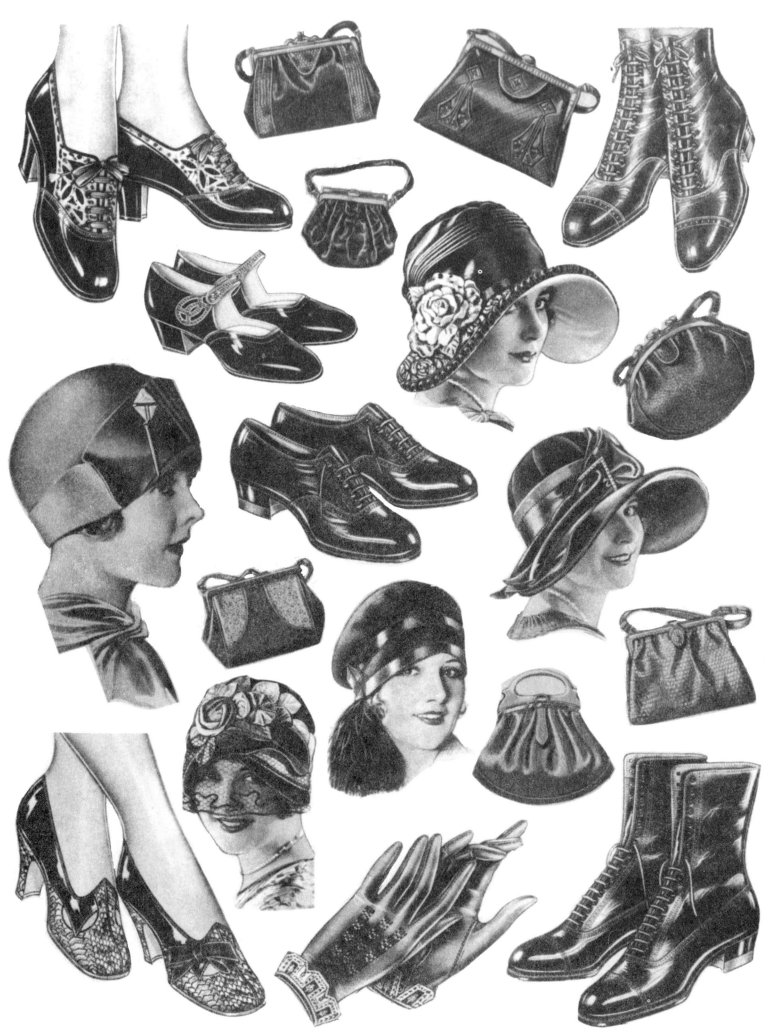

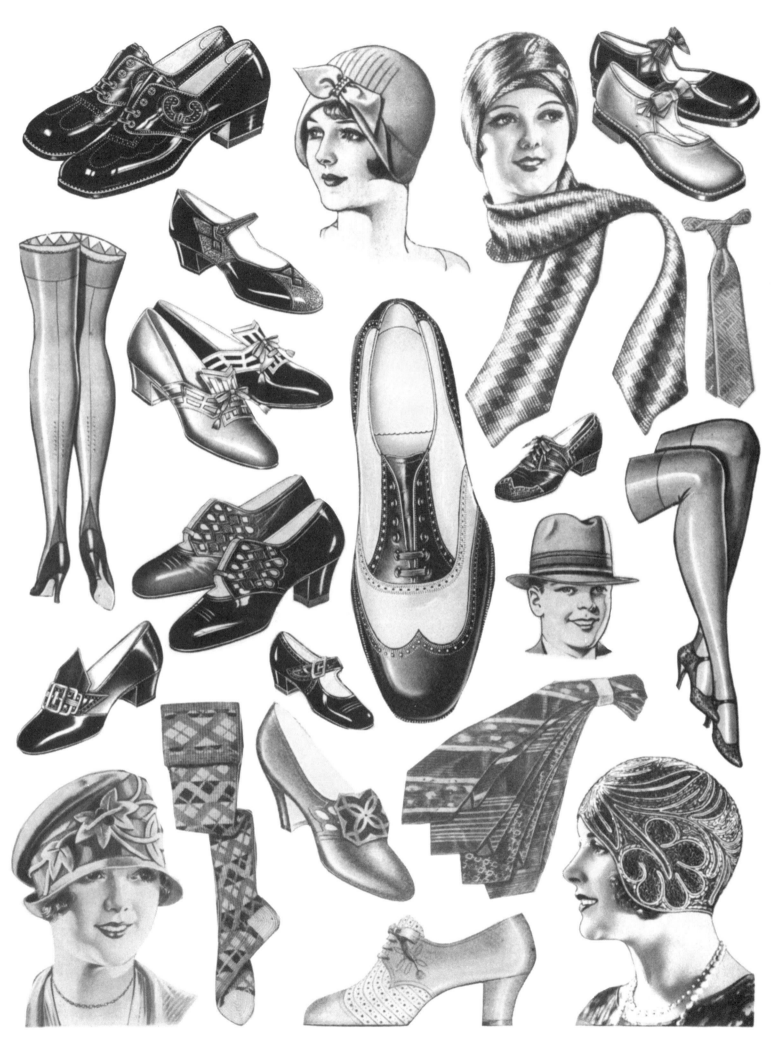

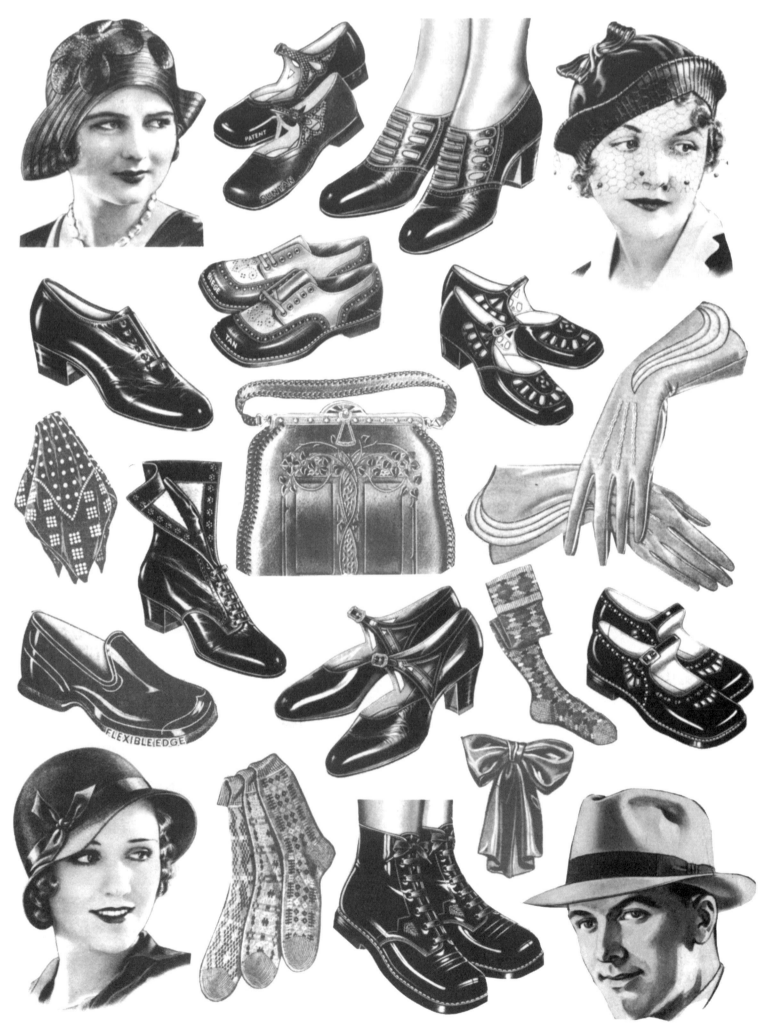

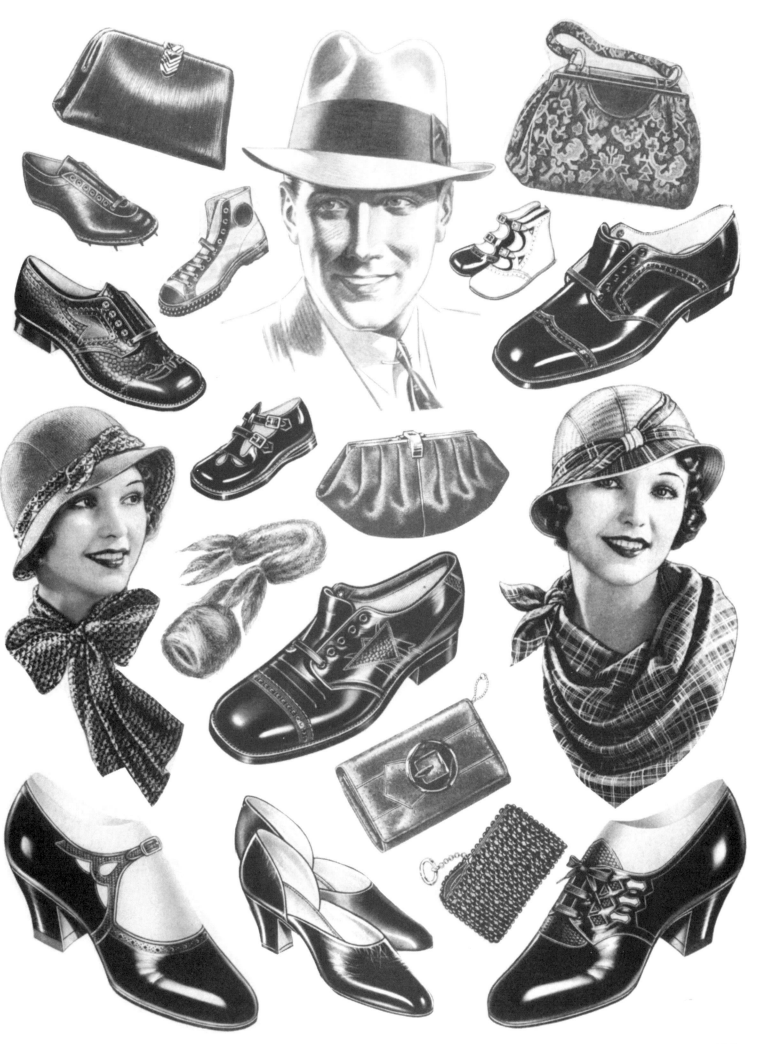

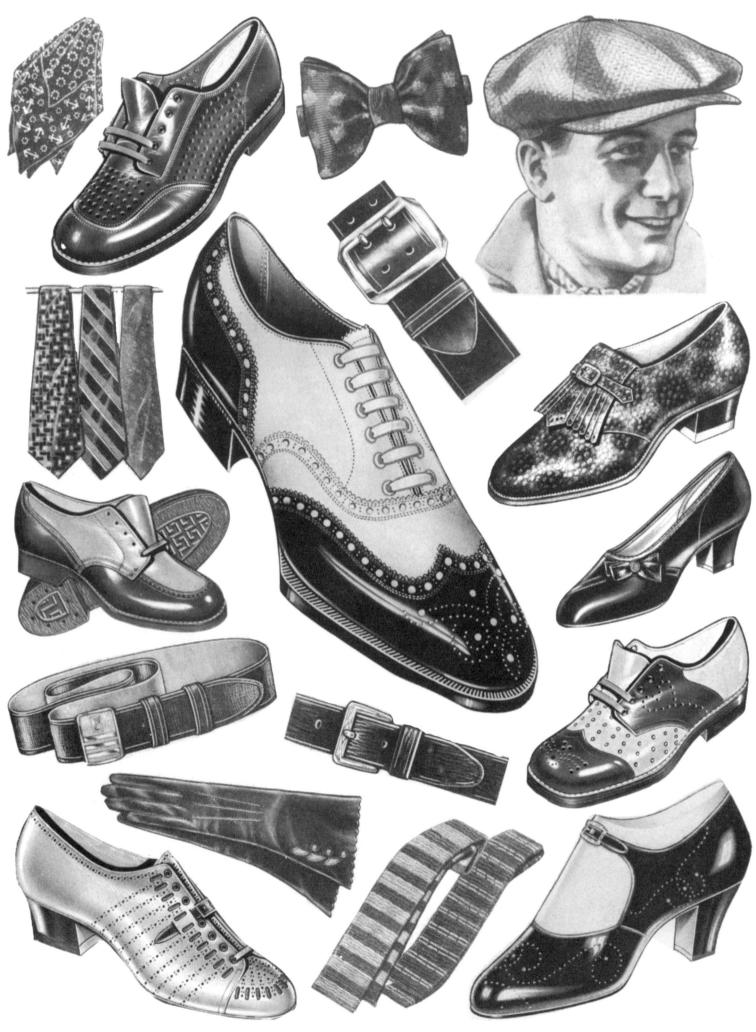

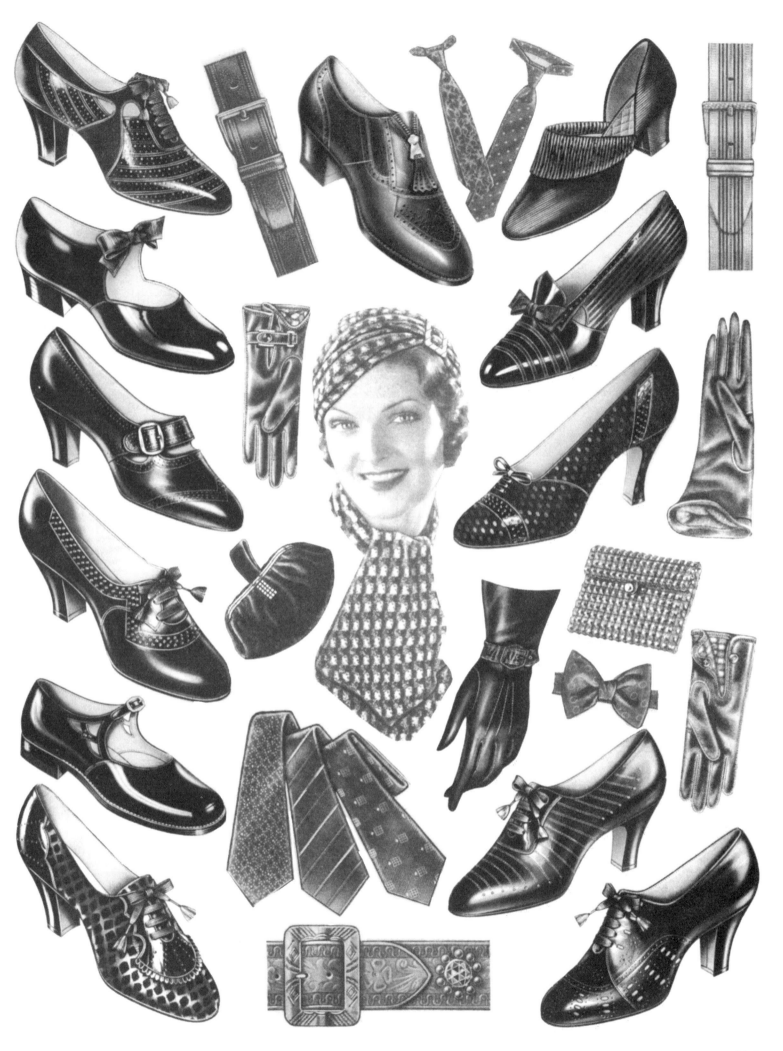

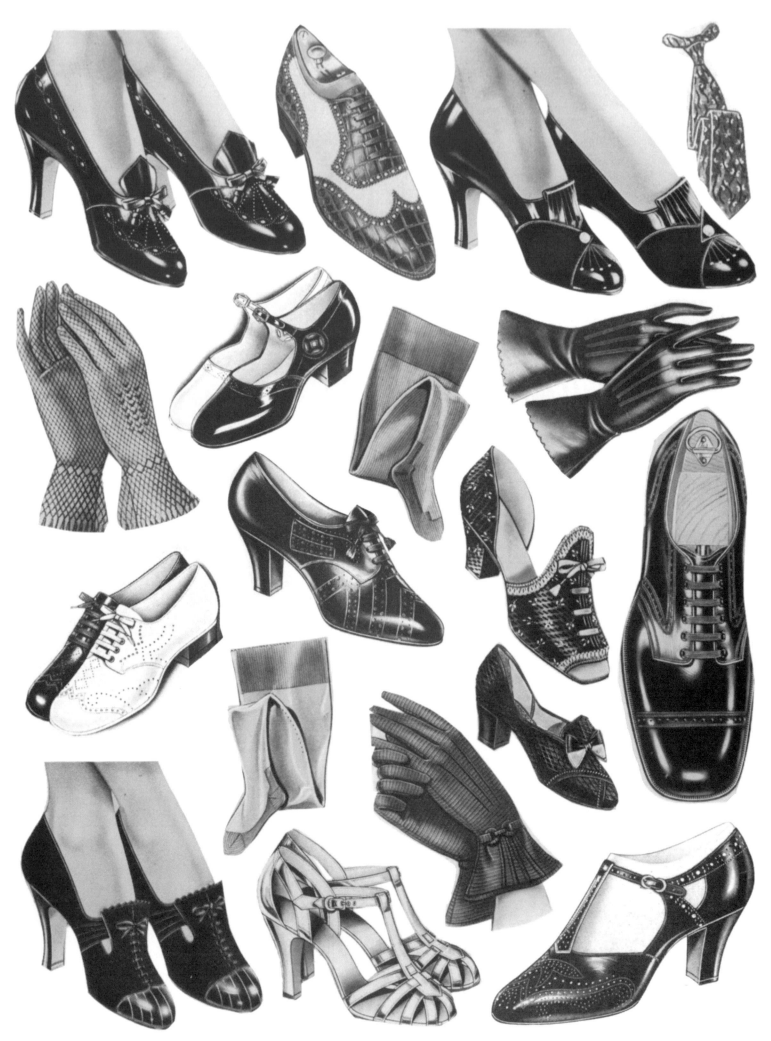

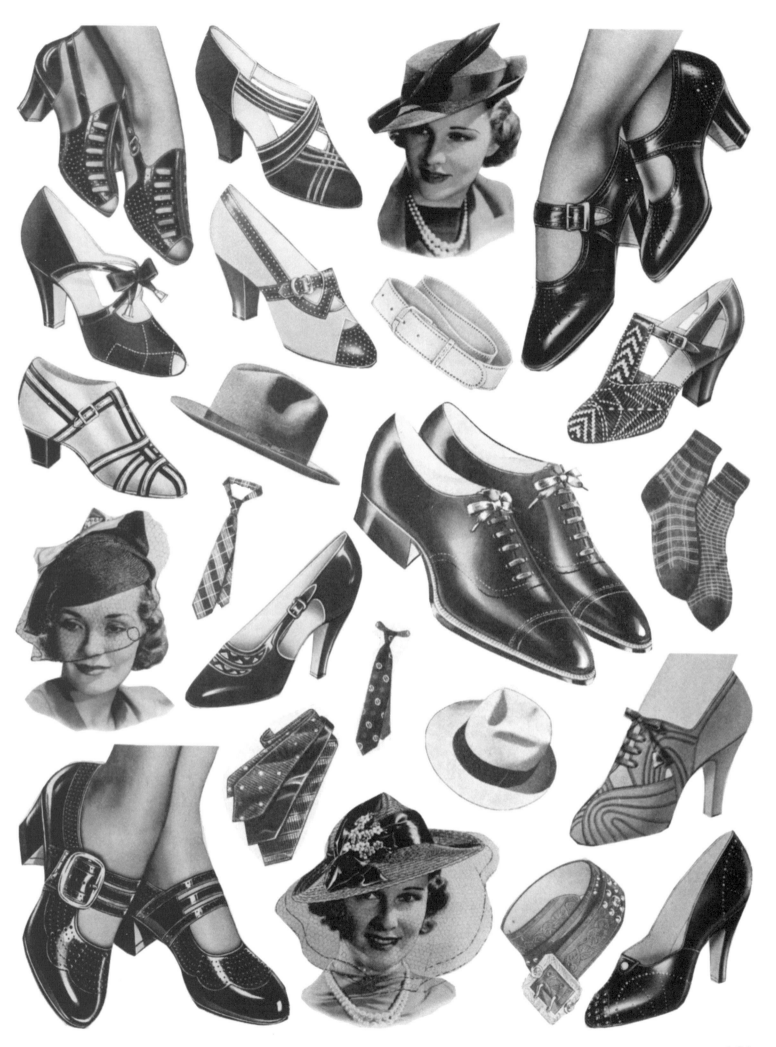

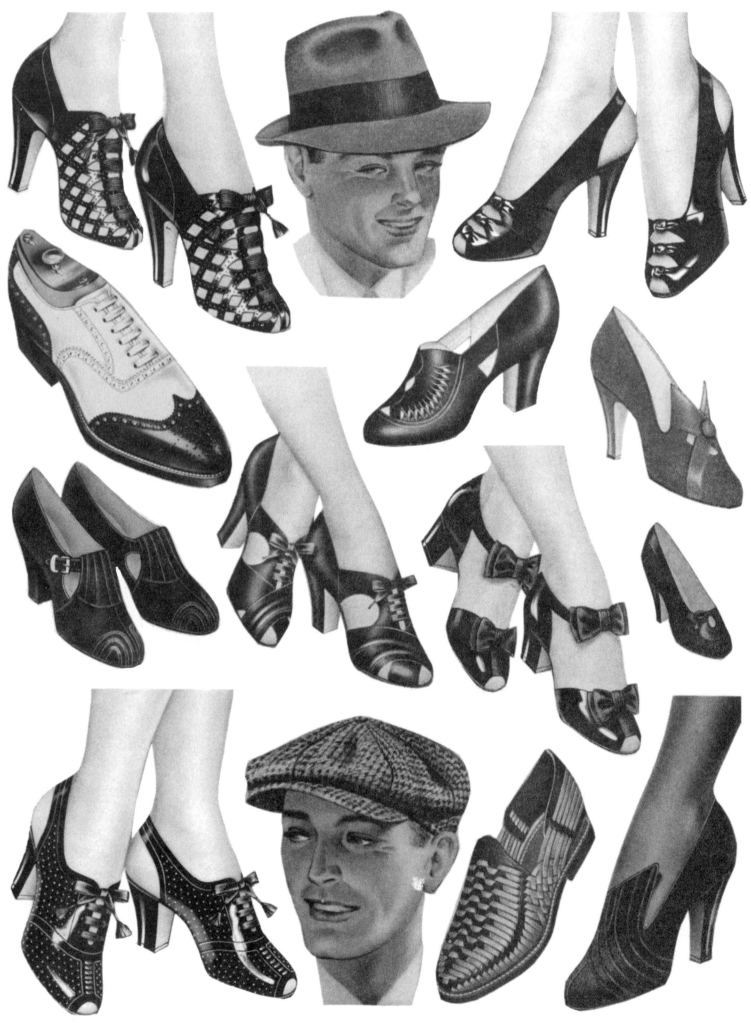

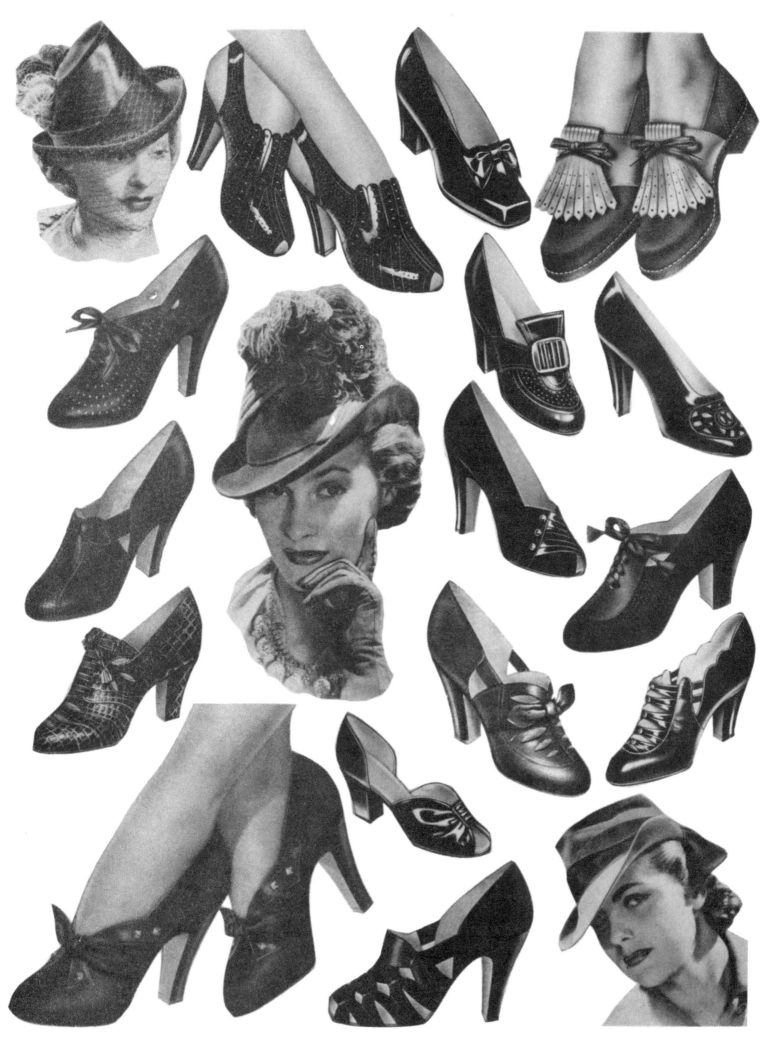